PLANET/
CUBA

PLANET/ CUBA

Art, Culture, and the Future of the Island

Rachel Price

VERSO

London • New York

First published by Verso 2015
© Rachel Price 2015

1 3 5 7 9 10 8 6 4 2

Verso
UK: 6 Meard Street, London W1F 0EG
US: 20 Jay Street, Suite 1010, Brooklyn, NY 11201
www.versobooks.com

Verso is the imprint of New Left Books

ISBN-13: 978-1-78478-121-7 (PB)
ISBN-13: 978-1-78478-124-8 (HC)
eISBN-13: 978-1-78478-122-4 (US)
eISBN-13: 978-1-78478-123-1 (UK)

British Library Cataloguing in Publication Data
A catalogue record for this book is available from the British Library

Library of Congress Cataloging-in-Publication Data
Price, Rachel, 1975–
Planet/Cuba / Rachel Price.
pages cm
ISBN 978-1-78478-121-7 (paperback)—ISBN 978-1-78478-124-8 (hardcover)— ISBN
978-1-78478-122-4 (ebook)
1. Arts, Cuban—21st century—Themes, motives. 2. Arts and society—Cuba—History—
21st century. I. Title.
NX525.A1P75 2015
709.7291'0905—dc23
2015020394

Typeset in Minion by Hewer Text UK Ltd, Edinburgh, Scotland
Printed in the US by Maple Press

Contents

Acknowledgments

Many people helped me with the research and conception of this book. My deepest thanks go first and foremost to all of the artists and writers who have shared their work with me, and without whom the book would not exist.

I also wish to thank the following colleagues, friends, and institutions for their assistance in locating relevant works and archives, or for comments on portions of the book: Adrian López Denis, Ahmel Echeverría, Alberto Toscano, Anke Birkenmaier, Anya Zilberstein, the Archivo Veigas, Ariana Hernández-Reguant, Armando Fernández, Beatriz Gago, Bettina Funcke, Javier Guerrero, Biblioteca Nacional José Martí, Caridad Tamayo, Dan Whittle, Eduardo González, Erick Mota, Ernesto Oroza, Evelyn Pérez, Frenzy, the Fundación Antonio Núñez Jiménez, Gabriela Nouzeilles, Gavin Arnall, Gean Moreno, Gerardo Muñoz, Gloria Gómez, Irene Small, Jacques Khalip, Jenny Rhee, Jim Brittingham, Jorge Enrique Lage, Jorge Marturano, José Ramón Sánchez, Joshua Dubler, Kevin Beovides, Lázaro Gómez, Lester Álvarez, Lizabel Mónica Villares, Magaly Espinosa, Melissa Larner, Michelle Chase, Orlando Luis Pardo Lazo, Rafael Almanza, Ramón Hondal, Raúl Aguiar, Reina María Rodríguez, Reinaldo Funes, Rewell Altunaga, Robert Hullot-Kentor, Samuel Riera, Sarah Doty, Seth Price, Shambhavi Kaul, Sonya Posmetier, Sophia Lee, Tania Bruguera, Víctor Fowler.

A very special thanks to Jacqueline Loss, Julio Ramos, and Rachel Weiss, who read the whole manuscript at different points and offered invaluable suggestions.

A teaching leave enabled by Princeton University's Jonathan

Dickinson Bicentennial Preceptorship gave me the time needed to write up my research.

All conclusions and errors are my own.

A few paragraphs in the introduction and in Chapters 2 and 4 were first published as part of an article "Planet/Cuba: Jorge Enrique Lage's *Carbono 14* and *Vultureffect*," published in *La Habana Elegante* (Fall 2012). A few paragraphs from Chapter 5 were published in *Frieze* as "Games and Systems: Digital Art From Cuba" (no. 153, March/April 2013): 31–2. Portions of Chapter 3 were published as "Pozo inagotable, Autopista infinita" in *La Noria* (no. 7, November 2013). I am grateful to these journals for permission to publish the excerpts.

A Treasure Map for the Present

In the weeks leading up to the December 17, 2014 surprise announcement by Presidents Barack Obama and Raúl Castro of the normalization of diplomatic relations between the United States and Cuba, rumors circulated among scholars of Cuba about a coming lifting of the embargo, or the removal of Cuba from a list of state sponsors of terrorism. But such change was thought to be months away, if it was to come at all, and the rumors seemed as much wishful thinking as policy predictions. When, just days before the winter solstice, the two heads of state simultaneously confirmed renewed relations, many were incredulous that such a seismic event could arrive so unexpectedly. In Cuba, people pointed to the date of the announcement—the day of San Lázaro, who is melded with the Yoruban-derived deity Babalú Ayé—as proof of its miraculous nature. Soon thereafter we learned that the bilateral negotiations preceding the agreement had in fact taken some eighteen months.

Although most of the details of the new relationship remained to be worked out, a new era had undoubtedly begun. New laws, new agreements, new credit lines, new exchanges, the release of political prisoners—all were imminent. Profound changes felt palpable for Cuban politics, the economy, built and natural environments, and society.

In truth, however, Cuba has always been changing. Daily life as much as political and aesthetic imaginations long ago diverged from state rhetoric. The everyday, the planetary, and the digital increasingly replace national, regional, and analog narratives and counter-narratives. And if internet connections on the island remain famously scarce, controlled, and slow, since about 2013 Cubans have had realtime access to a wide

array of pirated global television programs, films, and "apps" through the *paquete*, or packet, a weekly curation of digital information circulated for a low price via flash drives and computers.

Freed from any obligation to verisimilitude, emerging writers and artists are forging a range of possible worlds. Take, for instance, the recent novel by the author Jorge Enrique Lage, *La Autopista: The Movie* (The Highway: The Movie, 2014). The title is a play on that of Julio Cortázar's short story "La autopista del sur" (Southern Highway, 1966). Cortázar's story and the film it inspired, Jean-Luc Godard's *Weekend*, told of motorists stuck on a highway in a giant traffic jam.[1] The original story was a short, existential meditation on an infernal state of waiting inside what, in the mid-twentieth century, remained an icon of modernity: the automobile. Lage's novel, by contrast, is a feverish satire of a dystopic future Cuba in the mid-twenty-first century. It is, in other words, a satire of outsized capitalism everywhere, but seen from the particular context of an island that for half a century was under a command economy, until modest market reforms were introduced, global climate change accelerated, and the future came to seem newly open-ended.

La autopista's titular highway, a never-ending road that extends beyond Cuba into the Atlantic Ocean, is quickly identified as a figure for conspiratorial flows of capital. And it is clear that we are all travelers on this nameless highway. Readers, too, suspect that the global economy, to whose petroleum-driven whims Cuba has also responded, is literally consuming the planet. And yet we remain waiting, stuck in a petroleum-centric world. Environmental activism notwithstanding, art and literature may offer the most promising visions of a different future, or of a dystopic one that is all but certain in the absence of urgent action.

The construction of the mysterious highway organizes the narrative of *La autopista*. The attentive reader soon grasps that mutterings about a grand "Unified Theory" actually describe the highway itself. The Unified Theory—that is, the highway—is

> hair-raising. Demented. Inconceivable. It had to do with flows of money, with displacements of capital, with market economies. It had to do with the map, if we imagine something like a treasure map, where the treasure moves all around, or where it remains unclear at the end what the treasure *is*. The flows of money are, on this map, like highways. There are

intersections, curves, detours; but also speed, sudden dips, leaps between dimensions. And something like an occult plot is behind it all, a plot that comes into focus like those two-dimensional and apparently chaotic stains, out of which suddenly emerges a figure in relief, when one shifts perspective. And of course, in the knots or nodes of that giant network beat the fetishes, the *idées fixes*, the trapped bodies of us all. They are carrying out upon us experiments that we will never even be able to imagine.[2]

Here we have it: late capitalism as a social experiment as nefarious as any communist social engineering was, but without the benefit of the latter's frankness. In *La autopista* we peer down upon a map of mutating capital—a moveable treasure—whose very aims are forgotten as it takes on its own *raison d'être*, chasing cheap labor and minimal environmental standards about the globe. Endless growth, astonishingly still the core of most economists' definition of a successful economy, is similarly an endless quest for a treasure that simply can't be had.[3]

But the treasure is not the only moving target. The reality indexed by the map also escapes us, since the *autopista* doesn't really go anywhere. And so we, readers and denizens of the planet, face a corollary problem of both geographic and temporal scale: that of studying a present that unfolds like an aimless *autopista*. This present seems as inscrutable, but also as meaningful, as a conspiracy. This may be why the novel's secondary plot (*The Movie*) is about a "making of" documentary detailing the construction of the highway, as if photography could help reveal what a casual glance misses: indeed, a character dreams of building a "secret bunker" to amplify and study, on a molecular level, photographs from the highway's construction.[4]

These passages confirm Fredric Jameson's claim that conspiracy yarns are, at heart, efforts to understand an incomprehensibly vast and detailed global economic system.[5] "Totality as Conspiracy" (1992) laid out Jameson's theory just a few years after the fall of the Soviet Union and against the backdrop of widespread privatization. The essay invoked a Flaubertian anecdote to illustrate the perils of seeking a too-literal map in lieu of the *cognitive* one that we need in order to understand complex moments. As it happens, the anecdote concerned a map of Havana. Conspiratorial allegories, Jameson wrote, demand an imperfect map. The map's flaws allow it to function as a *cognitive* chart, "which it would be disastrous to confuse with reality itself, as when Flaubert's Félicité,

shown a map of Havana where her sailor nephew has landed, asks to see the house he is staying in."[6] Félicité's naive error of scale was laughable in the nineteenth century, and perhaps even twenty years ago, when Jameson resurrected the example. Now her request is possible, thanks to satellite imagery and interactive maps. And yet the cognitive map is less visible than ever. How can one get a handle on the present?

Planet/Cuba offers one map of Cuban cultural production from the past decade. It focuses on an emerging body of work that reflects on a series of planetary crises: climate change, accelerating capitalism, pervasive surveillance. The works of art and literature that I examine in these pages are both typical of global trends, and singular. They warn of, or work against, a dark future, like much contemporary cultural production. But they do so in the context of a history marked by the fading and contested memories of collective constructions of society, art, and life itself—however fleeting, compromised and usurped, if they were ever a reality.

In a recent meditation on leftist pessimism and the potential for the arts to generate new thought, David Graeber observed that if the twentieth century was the century of projecting futures—and in few places was this more true than in post-1959 Cuba—in the twenty-first century we are increasingly bereft of visions of the future that are not frankly apocalyptic: rising oceans, an uninhabitably warm planet, nuclear disasters, mass migrations, and epidemics.[7] We therefore find ourselves flummoxed: "The revolutionary Future appears increasingly implausible to most of us, but neither can we simply get rid of it. As a result, it begins to collapse into the present," appearing here and there in "tiny imperfect flashes" under the surface of everyday life.[8] Like Lage's map that provides little orientation, these flashes don't add up to any coherent vision of the near future. Indeed, the future often seems unthinkable. Conjuring a future, and particularly a "revolutionary" one, may seem especially distasteful to many Cubans, cajoled for decades by the State to postpone present needs and desires for a golden future always just out of reach. For the Italian thinker Franco "Bifo" Berardi, the notion of the future is no longer useful for other reasons. In a present defined by oil's imminent "extinction," he argues, modernity's endless production is not only imperiled, but undesirable. For Berardi, we must cease to orient life towards the future's receding horizon and endless projects of dizzying accumulation.[9]

Yet art and literature can themselves be the imperfect flashes that illuminate corners of our present, proposing other ways of being, or diagnosing unsustainable patterns in the present. Cubans—like people everywhere—imaginatively extrapolate forward forces already at work in the present: ever more devastating hurricanes, deepwater drilling, Special Economic Zones, agricultural collapse, the final undoing of welfare states, authoritarian regimes. If, as Graeber argues, the future is collapsing into the present, science fiction, far from being mere fantasy, today provides something like a dark realism about the present.[10] At the same time, the art and literature that I examine in this book sometimes looks backwards, retrieving histories that exceed or elude the state's official political concerns and rhetoric. The environmental, the everyday, and the hermeneutical respond to pressures, conditions, and changes that transcend nation and state.

To better grasp the stakes of contemporary Cuban art and literature, we do well to situate them against the recent, rather different body of literature and art that emerged in the 1990s. Following the collapse of the Soviet Union and its massive support of the Cuban economy, Cuba entered a "Special Period in Peace Time" characterized by dire scarcity and drastic measures, easing somewhat around 2006.[11] Literature and art from the period were more explicitly concerned with the local conditions of a present that seemed rudderless. They described surreal responses to scarcity, the erosion of old beliefs and ideologies, the appearance of new social actors, and the vicissitudes of an emergent capitalism during Cuba's uneven and partial "opening" to a global market. Many works were characterized by a preoccupation with "marginal" urban types (transvestites, prostitutes, hustlers, pimps) and a capital city in ruins, haunted by widening class divisions. They favored microhistories over macronarratives, the minor over the epic.[12] For James Buckwalter-Arias, a subgenre of novels evinced exhaustion with socialist discourse and resurrected a putatively apolitical modernist rhetoric of literary autonomy.[13] According to Esther Whitfield, reading a slightly different canon, Special Period literature hawked images of a folkloric Havana and Cuba to a newly reestablished tourist industry, and to an international publishing market in search of both socialist exotica and pre-revolutionary Caribbean clichés.[14]

Those years, however, have given way to a new reality whose contours we are only beginning to discern. By 1992 the state had already partially

replaced some of the Constitution's Marxist-Leninist discourse—histor-ically internationalist—with a revived nationalist language. The internationalism associated with earlier tri-continental projects ceded to a focus on the folkloric insularity of the ways of life during the Special Period in the precise moment that the economy embraced tourism and became more mixed-market. No wonder that, as Jacqueline Loss has shown, art and literature from the early 2000s also revisited the cultural legacy of the Soviet Union, a prior globalization of a different kind, now viewed with nostalgia—if also with the resentment proper to former satellite states.[15] The 2006 succession in leadership from Fidel Castro to Raúl Castro (formalized in 2008) has been characterized in some respects by a still further move away from earlier internationalist politics to a more nationally oriented government.

Simultaneous globalization *and* abandonment of a former interna-tionalism has spurred in literature and art an embrace of the planetary, in contrast with both "the international" and an asphyxiating national-ism. At the same time, the hyper-local (neighborhoods, rural regions, subcultures) has returned as a space for artistic intervention. Contemporary literature and art, then, may evince less an exhaustion with the socialist principles touted or debated in earlier works, and more an exhaustion with *cubanía* or "Cubanness" itself, and with the middle-brow realisms of the 1990s, which nonetheless continue to flourish in world-literature markets.

Cuban literature is somewhat anemic today. Yet visual art is flourish-ing. Its success owes in part to a current boom in Latin American art more generally, in part to the strength of the Instituto Superior de Arte (ISA) and the San Alejandro National Academy of Fine Arts, the oldest of its kind in Latin America, and to the power of the feeder system that culls talent from throughout the island.[16] It also owes to a certain ubiquitous strain of contemporary art that fosters non-threatening (declawed) pack-ages of skill, materials, beauty, and innovation. More recently, the normalization of relations between Cuba and the US has spurred talk of still another art-market boom (if it happens, it may prove shortlived once the novelty wears off).[17] Like artists everywhere, Cubans have for some years now participated in global art markets, enjoying solo residencies in Europe, China and the United States. In curator Gerardo Mosquera's view, contemporary Cuban art generally displays a "post-minimalist synthesis" and cosmopolitanism along with the globalization of art

circuits. Even when much of it addresses local contexts, he observes, "the discourse has become more oblique, abstract and 'universal.'"[18]

Even this may already be changing. The artist and critic Antonio Eligio Fernández (known as Tonel), for instance, has recently suggested that the prior diffusion of such a "universal" discourse or aesthetic has itself, rather universally, now been displaced by a return to the particular.[19] A growing body of less high-profile art on the island has indeed trained its sights on local interventions: neighborhood centers, environmental projects in the interior, interventions into former factories.[20] Many projects are unfolding beyond the purview of the state's cultural institutions. Tonel even joins leading independent gallerists in deeming the past decade "one of the most intense chapters of private cultural and artistic activity in Cuban history."[21]

In the 1980s, the "New Cuban Art" abandoned earlier modernisms and moved away from preceding realisms.[22] Art collectives were formed—ABTV, Grupo Puré, Arte Calle—in what has sometimes been consecrated as a golden era in the history of the revolution, characterized by relative economic well-being, an engaged and immanently critical citizenry, and collective cultural projects. The moment was followed by an era of disillusion, beautifully chronicled by the art critic Rachel Weiss in her history of the New Cuban Art. After the emigration of many members of the 1980s generation, a number of art collectives dissolved. Then, in the latter part of the Special Period, several new ones were founded, including Enema and, less collective than workshop, Tania Bruguera's Cátedra de Arte de Conducta (School of the Art of Conduct). As Weiss has written, however, these new groups emerged in the "shadows" of a series of 1990s crises: "the expulsion from the Eden of unconflicted ethical protest, the wandering in the desert of savage capitalism, the casting of every single change as a darkening of an original brightness" of the 1980s.[23]

Yet beyond the pressures of the market and the banalizing analytic of globalization, a particular vision of the present, and future, is taking shape. In the chapters that follow I take a closer look at aspects of this vision in a variety of media, clustered around a series of concerns.[24] Many share a planetary perspective—both in the sense of planet-wide, and having to do with the planet itself—while still anchored in issues specific to Cuba (in many cases, still more specific to Havana). These include pressing environmental crises, extractivism, and a changing

political economy. They also include what labor, play, and "free time" look like today, in a political economy in which the state does not provide the means of survival for most people, but where the flexibility, pressures and temporality of a fully market economy also do not wholly obtain. It is an economy far from the industrial powerhouse imagined in the twentieth-century productivist dream. Instead, like many American nations, Cuba is deindustrializing: its leading export revenues now come from tourism, mining and petroleum processing, as well as professional services (primarily health-care workers' overseas missions, in exchange for petroleum) and remittances.[25]

The broad issues treated in the art and literature discussed in this book also date roughly to the period during which Raúl Castro has been president. While I am not asserting a clean break into a new era in 2006, Raúl's ascension to head of state did inaugurate a series of changes both internal to the nation and coincident with others external to it—proper to the entire planet. Continuities with earlier eras exist, of course. Yet these more recent concerns can be set somewhat apart from those that typified much of the art and writing of the mid-1990s, to say nothing of the 1980s. And the period following the normalization of relations with the United States promises different possibilities and realities.

Planet/Cuba is divided into six chapters whose themes are cross-cutting and inextricable from one another. Many of the same artists and writers appear in the different chapters, speaking now to questions of new media, now to questions of a militarized culture, now to questions of environmental crisis. Multiple concerns are often bundled into a single work. Thus a novel about a future Havana half-submerged under water imagines the city as run by a series of warring neighborhood sovereigns, propped up by deepwater petroleum platforms. A "mod"—or modification—of a video game wills back nature in the face of the genre's dominant narratives of destruction, conquest, and "Civilization"-building (to cite an eponymous game and genre from the past decade). A designer and visual poet creates an online journal to plan an ecologically self-sufficient community on land overrun with an invasive species.[26] An installation about ideology uses algorithms to process comparative quantities of North and South Korean propaganda; the propaganda is transformed into electric charges that stimulate excretion in earthworms, and the accumulated soil or humus literally forms new land.

This fusion of the technological and the ecological should not be surprising. Ursula Heise already perceived in novels from the 1970s the confluence of concerns about the Net and the environment.[27] And Manuel Castells—in an article reprinted in the leading Cuban ecological journal, *Ilé*—explicitly connected the emergence in the 1970s of the environmental movement to the rise of the network society.[28] Both, he argued, depend on fully "planetary" imaginations, on the conception of vast webs of connections (ecological, informational). In one such example, examined in Chapter 5, Cuban artist Harold Vázquez Ley's series of photographs entitled *Entropomorfía* document the ongoing circulation on the internet of outdated images of glaciers well after the massive ice chunks have themselves irrevocably melted. For Vázquez Ley, these photographic afterlives of glaciers offer a commentary on how representation—especially digital photography—and "nature" both increasingly refer to missing referents.

Entropomorfía points us towards the challenges facing any work that takes seriously both aesthetics and environmental crisis. Do we truly need another report quantifying the degree of certainty with which scientists are willing to attribute climate change to human doing? Is there any indication that presenting or consuming more information leads to activism and change? More specifically, is there any way in which aesthetics can contribute any new thought about, or solutions to, our contemporary crises (economic, environmental, and even of imagination)?

Lizabeth Paravisini-Gebert has highlighted these questions as among the "most urgent" for ecocritical work in the Caribbean. She wonders whether art and literature can be useful at all on their own terms, or only when artists and writers abandon aesthetics for activism.[29] Timothy Morton, on the other hand, has explicitly probed the ways in which central concepts in aesthetics, including ambience, environment, or subject and object, can offer meaningful new ways for thinking about humans' responsibilities and life on the planet.[30] Vázquez Ley's work aligns with Morton's analysis. It suggests to us that the very questions confronting digital photography—such as which "real" registers in a photograph when there is no longer an indexical and enduring relation to the reality represented—may help us think through what "nature" means today, when something as basic as, say, weather patterns, no longer bears close relation to historical trends or region.[31] Perhaps,

Vázquez Ley suggests, we can better assimilate an incomprehensible concept like extinction through the analogous, sensuous comprehension of that which disappears during an aesthetic experience.[32]

Of Place, Planet, and Negative Universal Histories

The nature of the problems facing the planet is beyond the framework of any one nation, or indeed of any geopolitical configuration. So why examine reflections on rising oceans, dwindling resources, eviscerated states, or petroleum pipedreams from the perspective of an island of 12 million in the Caribbean basin?[33] For one, global studies demand more time, more expertise, and more languages than most people can offer. Climate crises demand global responses realized in specific locales.[34] And Cuba's position as a historic node in global, imperial histories makes it a good site for examining the relay between local and planetary questions. For half a millennium, Cuba has almost always been simultaneously insular and global, of world-historical significance and at the same time simply a Caribbean or Latin American island.

Recently, in light of the human transformation of the planet's climate and ecologies, Dipesh Chakrabarty has suggested that we need a "new kind of global history that does not subsume particularities," or what he calls "a 'negative universal history.'"[35] A case can be made, I think, for reading Cuban history as such. Cuba has always been in the crosshairs of global empires, yet it has also confounded seamless histories of empire.[36] Today, "post-revolutionary" literature reimagines Cuba as transiting from a small island nation with delusions—however justified—of world-historical grandeur, to an archipelago on a shrinking planet.[37] It ends a century-long series of changing representations of the island: from Davidic protector of Latin America in the works of poet and revolutionary José Martí, to satellite of Cold War powers and site of futuristic fantasies, to a post-Soviet Planet Cuba of commodified experiences: *Buena Vista Social Club* meets Planet Hollywood.

A decade and a half into the twenty-first century, contemporary aesthetics now seem more interested in realizing a relation that might be articulated as something like planet/Cuba, reflecting both global environmental concerns and the specific challenges of one small nation among many others, with the slash embodying the negative universal

history that belongs to all places. Jorge Enrique Lage's 2010 novel *Carbono 14: una novela de culto* (Carbon 14: A Cult Novel) is one example of a work that registers these concerns.[38] A delirious mash-up of pulp genres such as fanfic, detective fiction, video games, and manga, the novel follows a teenage actress named Evelyn who has fallen from an exploding planet that was home to the Cubans into a post-communist city named La Habana (LH), located on Planet V. As Evelyn attempts to remember her past, the novel's protagonist uses a homemade carbon-14 radiometric dating kit to determine the age of many things, including that of the strange Havana he inhabits. This periodization—of both the science-fiction Havana of the novel, and the real Havana of 2010, when the book was published—constitutes a kind of archeology of a Cuban present burdened by its past.

A series of passages in the novel point to simultaneously planetary and local concerns. At one point Evelyn confesses, "I don't remember much about my planet":[39] perhaps an antidote to exilic nostalgia, perhaps an idea of a future in which Cuba's great aspirations, driven by Fidel Castro's messianic visions, would be but a distant memory. "Planet," a staple of science fiction and alternative worlds, invokes the scale of challenges today, while simultaneously suggesting the residual consumerist fantasy that ours is only one planet, disposable, among many more.[40] "What's bad is that when one gets tired of all the cities there is no other planet to go to," another character comments, reminding the reader of how great metropolises can become virtual planets, but also of the perils of conceiving of our planet as replaceable.[41]

Lage's use of planet deflates any airs the small island might harbor. "'Cuba.' 'What's that?' 'That was the name of my planet.' I told him I'd never heard of it."[42] Indicating the depth of contemporary weariness with Cuban exceptionalism, the joke is similar to another one featured, one year later, in Alejandro Brugués's 2011 zombie film *Juan de los Muertos* (Juan of the Dead).[43] In it the actor Andros Perugorría, exasperated, recounts how far he hopes to travel:

> I want to get the hell out of here and travel around the world. If they ask me where I'm from, I'll say from Cuba. If they ask me what Cuba is, I'll say a little socialist island in the Caribbean. If they ask me what socialism is, I'll tell them it's a system set up by Fidel Castro 50 years ago. And if they ask me who Fidel Castro is, I'll stay there forever![44]

Lage and Brugués thus imagine a comical and cosmic destruction of the island, or at least of Fidel Castro's centrality to it. A similar scene occurs in Erick Mota's novel *Habana underguater* (Havana Underwater, 2015), when a Russian—now, like the rest of his countrymen, living on the moon—asks some Cuban travelers: "'Do you come from Havana?' '*Da* (yes).' 'Ah, the patria of *Tscheguebara*!' 'Who? Oh, Che Guevara!'" The Russian finds such ignorance suspicious, but the Cubans specify: "'Cuba doesn't exist anymore and *El Che* is buried somewhere else.'"[45]

The island/planet returns once more in the last pages of *Carbono 14*, when, in a reprise of an earlier scene, the protagonist imagines a harsh and fantastical landscape, a cross between depictions of Mars and *Avatar*:

—Cuba

—What's that?

—That was the name of my planet.

—I've heard of it—I lied.—A mass of land with dark and salty oceans. Immense plains studded with holes, but not for playing golf. Mountain ranges rippled like intestines, throwing out sparks of mineral light to the horizon . . . Trees whose roots extend into the mist. Great beasts trapped in surprising food chains. And several distant moons.[46]

This is Cuba as some science-fiction film director might shoot it, or as an early modern conquistador might have drafted it on a map bordered by sea monsters and cannibals. But the planetary imagination also alludes to the real planet's challenges. Elsewhere in the novel a song by the band Gorillaz sounds in the background: "Every planet we reach is dead."[47] And Planet V's strange climate owes not only to the conventions of genre fiction but to global warming: in LH it has never snowed, or it hadn't anyway until that "that accursed morning when the climate went crazy."[48]

Despite attempts to isolate Cuba politically, the island has never been excepted from global trends, economic or climatic. Its environmental future hangs in the balance. On the one hand, tree-planting programs, a lack of growth and construction, and forced, post-Soviet deindustrialization led to reforestation, a reduction of fossil fuel use, and increased organic farming. In the 1990s the island responded impressively to the overnight disappearance of most of the petroleum it needed for agriculture, and was even seen to offer an ecological hope against the planet's generally dismal outlook. Many took up urban, hydroponic organic

farming. The 2006 World Wildlife Fund's Living Planet Report designated Cuba "the only country in the world to meet its sustainable development criteria."[49] In 2007 the island spearheaded a Caribbean Biological Corridor, conceived as a greenbelt between Cuba, Haiti, and the Dominican Republic, with the goals of reforesting to adapt to climate change, managing coastal areas, creating biosphere reserves, among other joint programs. Such plans are the background for comments such as that at the end of *Carbono 14*, when a character says of Evelyn's home that "her planet is, now, perhaps the only place where she will be safe."[50]

On the other hand, however, the legacy of twentieth-century industrial agriculture (and the government's efforts to "conquer nature") may have done more damage than has been accounted for.[51] Food insecurity is on the rise. Agricultural production has been steadily decreasing.[52] Organic farming emerged only out of necessity, and has not been able to adequately provide for the population. In an economy increasingly dependent on tourism, mining and oil exploration, and now a Special Economic Zone for foreign-owned companies, what further development is on the horizon? As Antonio Benítez-Rojo wrote some years ago, "a clean, green development is a possibility in Cuba's future, but is it probable?"[53] Benítez-Rojo may have been unduly pessimistic. Some environmental specialists have assessed Cuban environmental policies as solid.[54] But it is hard to back up claims either way with hard data. Ongoing reflection on these issues is crucial for determining what future does indeed take shape, and art and literature have a central role in such conversations.

Examining planetary changes as they unfold on a very small island nation can, again, illuminate "negative universal history." Cuba both is and is not exceptional. The economist Carmelo Mesa-Lago claims that in 1989 Cuba was probably the most economically egalitarian nation in Latin America.[55] This is no longer true. People remain poor. Inequality has returned since 1990, and to a greater degree with the reforms introduced by Raúl Castro. But neither has Cuba yet taken the path of broad privatization as in other formerly communist nations.

Modest market reforms have not yet yielded widespread, significant improvements in daily life. Moreover, by initiating minor changes and stepping back to evaluate its experiment, the state casts the island as a laboratory. This is not unusual. US environmentalist Bill McKibbin once described Cuba's post-1990 experiments with organic farming as a

template for planetary crises to come: "No one's predicting a collapse like the one Cuba endured . . . But if things got gradually harder? After all, our planet is an island, too. Its somehow useful to know that someone has already run the experiment."[56] It is an almost colonial view of Cuba: for centuries, European colonies served as laboratories for metropolitan innovation. And it persists, too, in the enduring obsession with "transition" in Cuban studies, where the specter of observing momentary historical change titillates more than any less spectacular investment in realizing genuine social justice or emancipation.[57] Jacqueline Loss has pointed out that not only does "transition" typically assume an inevitable shift to free-market capitalism, but its emphasis on the future prohibits recognition of real, ongoing change.[58] Cuba, moreover, is hardly alone in undergoing multiple transitions—but to what? Instead of reifying such catchphrases, we might today better examine contemporary aesthetics to discern what *is* taking place, without imposing teleologies.

Recent Reforms and Cultural Ramifications

In 2006, Raúl Castro informally took power from his brother Fidel; two years later, he formally assumed the presidency. The government has since introduced a number of reforms. These range from the seemingly quotidian, such as legalizing the use of cell phones, to the more sweeping: announcing the dismissal of 500,000 workers from state payrolls (a figure that was later revised),[59] opening a Special Economic Zone in the port of Mariel, removing the preexisting need for permission to leave the island, and permitting the sale of real estate and cars. These, of course, were followed by the normalization of diplomatic relations with the United States in December 2014, which brought additional accords. In these same years China has become Cuba's largest trading partner, although Cuban economists have suggested that Brazil, another of its larger trading partners, along with Venezuela and Spain, may be the more promising one.[60] Since the normalization of relations with the United States, a spate of new businesses have arrived and important exports from the US have been newly authorized, including building materials, goods for entrepreneurs, and agricultural equipment for small farmers.

The changes inaugurated in early 2015 have ushered in many expectations. They have even tempered, without necessarily obviating, some

of the darker prognoses essayed by long-time scholars of the Cuban economic and political system, several of whom have warned of a coming, unsparing neoliberal era. Gerardo Mosquera described the recent reforms as "firmly manacled to the centrally-managed economy as though this 'socialist' state were declaring: '*Le capitalisme, c'est moi*.'"[61] In 2011 Samuel Farber predicted either an "openly despotic Chinese form" or a "cosmetically disguised Russian style" of neoliberalism, with growing US influence and "International Monetary Fund-style structural adjustment," but in December 2014 argued that the new relations may "help to liberalize, although not necessarily democratize, the conditions of [Cubans'] political oppression and economic exploitation."[62] And already in 2006 Sergio Díaz-Briquets and Jorge Pérez-López claimed that "spontaneous privatization" was underway as state properties were transformed into "'private' corporations of which the *nomenklatura* members are owners or directors."[63] Ted Henken and Archibald Ritter, however, are more optimistic. They describe Cuba's economy as a "hybrid, 'post-socialist' one that combines capitalism, socialism, mercantilism, and patrimonialism, and celebrate what they see as a "grassroots privatization" from below of nonfuncional state enterprises.[64]

Since the mid-2000s, small businesses have, in fact, mushroomed and diversified. Artists have registered these changes: the conceptual art duo "Celia y Junior"—composed of the artists Celia González and Yunior Aguiar—responded to the expansion of private enterprise on the island by excavating the histories of their own grandparents' small businesses—a café and a cafeteria, respectively—in their 2013 video projection *Coffee Doesn't Grow That Way*. The piece included the projection of a video of their grandparents reminiscing about their businesses, screened in the kitchen of artist Sandra Ceballo's home/gallery *Espacio Aglutinador*, where Celia y Junior had also arranged the few objects (an ice cream scoop, an Italian coffee pot) salvaged from the small shops, both closed in the 1968 nationalization of small business.

At present the Cuban economy remains largely run by the military, however, which oversees the nation's biggest business conglomerates.[65] By many accounts, it is one of the island's best-organized institutions (led by Raúl Castro since 1959). Young artists reflect on this centrality of the military: Rewell Altunaga creates "machinima" of military video games, and Adonis Flores, a veteran of the Angolan war, makes performances

and photography that engage military tropes. Global gaming tastes, which often feature US soldiers, also contribute to the chosen imagery.

From the beginning the revolution was characterized by institutionalized militancy and military codes. The less visible importance of the army as a body running more market-friendly policies dates to the late 1970s, when, in part to work around the US economic embargo and in part to increase trade, the government incorporated numerous *sociedades anónimas*, or incorporated businesses, abroad. Additional *sociedades anónimas* were established in the 1980s to further international economic activity.[66] In this period too, Raúl introduced to the armed forces (FAR) the set of capitalist management techniques known as the *sistema de perfeccionamiento empresarial* (business improvement system).[67] Juan Carlos Espinosa dates the introduction of these techniques roughly to the 1986 Third Party Congress, and calls them "the guiding force and rationale for involving the military in almost every aspect of the economy. Decree-Law of 1998 officially declared [the business improvement system] to be the foundation of all reforms."[68]

After the dissolution of the Soviet Union, Cuba's military was overhauled; simultaneously downsized and increasingly involved in civilian enterprises, such as hotel management and tourism.[69] In the dark views of Farber, Díaz-Briquets and others, the officers currently running GAESA (a conglomerate of businesses), Gaviota (a tourism company), and similar corporations are "first in line" to become rich in a worst-case scenario of wholesale privatization. Farber in particular claims to discern the onset of an authoritarian capitalism in recent changes to land policy, such as the leasing of government land for up to ninety-nine years to build "golf courses surrounded by luxury housing, beachfront timeshares, and vacation homes for affluent tourists," and in the 2010 cuts to the government workforce.[70] He predicts a future state-controlled capitalism led by "the army and joint venture managers and technocrats, possibly in alliance with a small but growing petty bourgeoisie in Cuba and a wing of the Cuban capitalists in south Florida."[71]

Whether or not the changes that Farber fears comes to pass, Cuba already shares one fate with a diverse group of economies: it, too, is deindustrializing and becoming a service economy.[72] Contemporary writing and art from Cuba that grapples with questions of labor, play, and free time ought then to be read not only in light of underemployment in the ailing Cuban economy, but alongside those theories of temporality and

biopolitics in an era of "affective labor" typically ascribed to larger post-industrial economies.

But if not to resource extraction and ecologically questionable tourism, where might the Cuban economy turn for new sources of revenue? The government has long promoted biotechnology and, more recently, computational innovation: an encouraging strategy but perhaps not a realistic fix. Some leading economists have called for a move away from extractivism towards use of the nation's notable social capital and highly educated workforce.[73] A less glamorous option favored by others has been a reinvigorated agriculture.[74] Cuba has always been an agricultural nation, and two radical changes in farming call for new responses: first, its sugar industry, like the citrus industry, was the world leader in the late 1980s, but today is defunct; secondly, the island has entered a phase of significant food insecurity, now importing up to 84 percent of its basic foodstuffs (principally from the United States, thanks to loopholes in the embargo).[75]

To be sure, some such agricultural reforms are under way. In the Special Period the state aimed to increase national food production by authorizing a series of cooperatives. Since 2008 it has also permitted private farming via usufruct. (Since late 2012 and early 2013 the government has also encouraged a number of non-agricultural cooperatives.[76]) Three types of agricultural cooperatives prevail today. In the early 1990s the state created UBPCs (Basic Units of Cooperative Production), state farms turned cooperatives that commit to selling 70 percent of their basic production to Acopio (the state procurement and distribution agency). Together with Agricultural Production Cooperatives (CPAs), which date back to the 1970s, the UBPCs possess 50 percent of non-state cultivatable land. Credit and Service Cooperatives (CCSs), created in the 1960s, constitute the third type of cooperative. [77] These are joined by the private sector, which recently has produced more than half of all food grown, while operating on only a quarter of cultivated land.[78]

Complex, arcane, and technical as this agricultural map may seem, it is, nonetheless, common knowledge to any Cuban negotiating different produce markets. It has also been the subject of some brilliant video art by Yamil Garrote, whose animated shorts *Reforma Agraria* (Agrarian Reform, 2012) and *La vaca* (The Cow, 2009) are comedies about agricultural production today. The audio track in *Reforma Agraria* is a recording of Garrote's *campesino* grandfather reminiscing about how cooperatives functioned in the pre-revolutionary, revolutionary, and contemporary

eras. The grandfather's colorful, exaggeratedly "Cuban" forms of speech issue forth not, however, from a representation of the aged peasant, but from the mouth of an animated root vegetable leaning on its hoe in a dusty red field. As the animation progresses, the trajectory of national agriculture looks increasingly bleak. In the final scene the camera pans out to hover above what is now clearly an utterly barren field. It catches the tuber's form from a different angle. Suddenly, in the arrangement of its eyes, shoots and crevices, the root resolves into a skull, leaving little doubt about the consequences of earlier agrarian reform.

Following a devastating hurricane in 2008 the government urged citizens to plant vegetables wherever possible. Artist Glenda Salazar

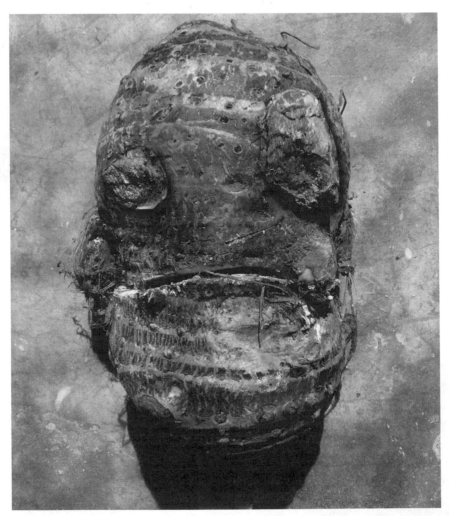

Figure I.1: Yamil Garrote, *Reforma Agraria*, 2012. Video still.

ironically took to heart the exhortation. Her 2009 installation *Producción* (Production) consisted of 700 small balls of earth, lettuce plants, and water. Salazar planted the lettuce seedlings in as little earth as possible, to question the lingering productivist mentality of agriculture conceived from above, rather than one that drew on farmers' knowledge about what plants need to flourish (all of the seedlings died).

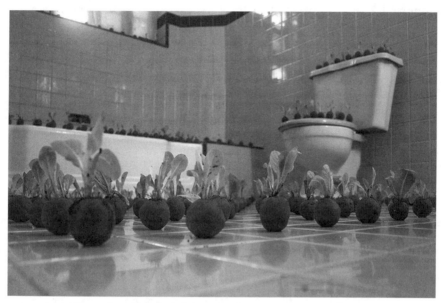

Figure I.2: Glenda Salazar, *Producción*, 2009. Installation:
700 balls of earth, American lettuces, water.

Meanwhile, the abiding centrality of sugar in Cuban culture since the times of slave labor through revolutionary *trabajo voluntario* (volunteer labor) was parodied in the 2013–14 production by Carlos Díaz's Public Theater of Rogelio Orizondo's *Antigonón: un contingente épico* (Antigone: An Epic Contingency).[79] One set piece in the production involved a performatively masculine *machatero* or cane cutter stripping off his field uniform to become a gay icon, singing "*Yo soy la machatera, cortando arrobas*" (I am the machete-wielding woman, cutting bushels).

But the iconic Caribbean commodity is in fact vanishing, and farmers have turned instead to cultivating *malanga* and other food crops.[80] In the 1980s, Cuba sold its sugar harvests at preferentially high prices to the Soviet Union in exchange for petroleum and other inputs necessary for typical "Green Revolution" farming (based on intensive chemical and

industrial aides to agriculture). After 1990 the island forcibly went organic in the absence of petroleum, petroleum-based products, and chemical fertilizers. In 2005, Fidel Castro declared that sugar was "a scourge belonging to the era of slavery," an observation with which few could argue, given sugarcane's nefarious history in the Caribbean.[81] Roughly half of all mills were closed, "60 percent of canefields were turned over to other crops, and 100,000 workers were dismissed, a quarter of those who had been employed."[82] Artists have taken up these issues, too: the photographer Ricardo Elías, for instance, made a series of photographs about former sugar-industry workers titled *Oro Seco* (Dry Gold, 2005–9).[83]

Castro couched the closure of the sugar industry in a language consistent with earlier goals of breaking with colonial monocultural patterns and neocolonial economic arrangements (sugar treaties with the USSR notwithstanding). Yet the decision, as the economist Mesa-Lago has pointed out, was a fiscally poor one, since the twenty-first century has seen a soaring demand for sugar in the expanding markets of China and India. According to Mesa-Lago's calculations, a steady uptick in sugar prices since 2005 means that Cuba has forfeited three billion dollars in potential revenues from sugar and ethanol.[84] Now the industry's rusted infrastructure is probably unsalvageable, although some Brazilian companies—the globe's leading sugar and ethanol producers—have spoken of reviving it.[85]

Surprisingly, over the past two years the government has also met on multiple occasions with prominent, Miami-based pre-1959 sugar barons. At the dawn of the revolution members of the Gómez Mena family were expropriated of their ten mills, 150,000 acres, and three distilleries. Today, their descendents in Miami, the Fanjuls, receive sizable US government subsidies towards their control of 40 per cent of all sugar grown in Florida (where they have been accused of severe environmental degradation); they are also one of the largest landowners in the Dominican Republic (where they have been accused of deplorable migrant-worker treatment).[86]

Even if possible, a revitalized sugar industry might not yield the self-sufficiency and environmental promise that it has for Brazil, which has pioneered the production of sugarcane ethanol as a sustainable source of energy since the energy crisis of the 1970s. And Monsanto has recently bought up two Brazilian sugarcane biotech companies; such agrochemical and biotechnology businesses now approach sugarcane ethanol as a "new world commodity" rather than a sustainable answer to dirtier energy.[87] Moreover, ethanol demands that large swaths of land be

devoted to a non-food crop, while yielding only a fraction of the current fuel requirement. In the meantime, the invasive bush *marabú*—the focus of the literature and art featured in Chapter 2—has invaded somewhere between 50 and 70 percent of all cultivable land in Cuba since the closure of the sugar industry. Here too, however, changes in the landscape remain ambiguous: *marabú* has been touted as a possible future fuel, and is currently being made into coal for export to Europe.

Biotechnology and agricultural possibilities, in any case, pale before one of the state's newest paths to economic development. The port of Mariel has recently been overhauled by the Brazilian firm Odebrecht and is now the largest in the Caribbean. It is equipped to receive the biggest container ships and tankers of the "New Panamax" or "Post-Panamax" size limit for the canal's third set of locks ("Chinamax" remains the largest bounding box). Mariel is managed by the Singaporean company PSA, and is the site of a new *Zona económica especial* (Special Economic Zone) where wholly foreign-owned companies may operate.

Discovery of easily extractable and high-quality petroleum would significantly alter the nation's prospects in terms of energy (and political) independence and solvency. To date, however, efforts to find such oil have yielded little. In 2001 the Brazilian national oil company Petrobras abandoned a dry wildcat well; in 2004 Spain's Repsol discovered that the oil yielded by one of its wells was of insufficient quality to justify further drilling; and in 2014 Cuba moved away from offshore oil exploration towards renewable sources after foreign firms halted further deepwater exploration, where most verified deposits are located.[88] But future deepwater extraction is not off the table.[89] In 2012 Repsol contracted a semi-submergible platform to explore the deep waters within Cuba's Exclusive Economic Zone.[90] Numerous firms have exploration contracts, including Petronas (Malaysia), Gazprom, Rosneft, and Zarubezhneft (Russia), CNPC (China), Sonangol (Angola), Petrovietnam (Vietnam), and PDVSA (Venezuela).[91] And petroleum has already determined foreign policy: some analysts have suggested that Cuba's openness to normalized relations with the United States owes to its dwindling petroleum subsidies from Venezuela, a plunge in oil prices, and the United States' regained status as an net oil producer.[92]

In sum, Cuba has inspired environmentalists for decades with its resiliency and innovation in the face of few resources, and its (albeit by-necessity) turn to green agriculture and reduction in petroleum use. Some scientists

and scholars are certainly undertaking innovative and important work reimagining agriculture, cities, and marine ecologies.[93] But nothing ensures that these environmental gains will continue under eased duress. Literature and art accordingly balance optimistic interventions with pessimistic speculations about more familiar, extractivist policies.

Chapter Summaries

The book's first two chapters examine questions associated with agriculture, environmental crisis, and ecological thought. Cuban art that engages with such questions often works with the archetypal binaries of rhizomes and trees. Chapter 1, "We Are Tired of Rhizomes," thus locates recent artworks' iconography of trees and environments in a longer history that opposes forestry to sugar's landscapes. I begin by analyzing several recent pieces that engage ecological concerns. I then turn to a reconsideration of the all-but-unknown writings of the pioneer of Cuban forestry, Alberto S. Fors (1885–1965), who published in the avant-garde literary, political, and ecological journal *Cúspide* (1937–9). Filling in missing links between the two periods, I then trace the legacy of Fors's ecological philosophy in the visual art of his grandson José Manuel Fors, a member of the groundbreaking *Volumen I* art show in 1980, and an active photographer today.

Chapter 2, "Marabusales," examines the explosion of the figure of the invasive, rhizomatic bush *marabú* in contemporary literature and art. I consider recent poems by Guantánamo-based poet José Ramón Sánchez, a video by the conceptual artists Celia y Junior, experiments with sustainable housing in fields overrun with *marabú*, and an extensive tract on the history and future of the plant both on the island and within the history of Cuban design, by Miami-based artists Ernesto Oroza and Gean Moreno. The varying connotations of this problematic rhizome—sometimes a metaphor for desperation, sometimes for failing agriculture, sometimes for the branching tentacles of capital—suggest the interwoven nature of ecological and other crises today.

Increasingly, global struggles for resources will concern water and oil. Chapter 3, "Havana Under Water," looks at a series of artworks and literature about disappearing glaciers, an imagined "post-carbon future," shipping containers, and, in Mota's novel *Habana underguater*, a dystopian future in

which Havana is submerged under the ocean. I explore how these works figure the sea as the last frontier in contemporary battles over the global commons. The sea also increasingly represents a unique threat to island nations, whose very existence may be at stake as icemelt raises ocean levels and radically increases "climate departure."[94] Chapter 4, "Post-Panamax Energies," focuses on the centrality of petroleum and of extractivism in projects such as the remodeling of the port of Mariel. I revisit the philosophical underpinnings of petroleum extraction in Cuba, then look at recent artworks and literature about oil spills and automobile culture.

In the book's final chapters I turn from more environmental themes to globally shared interests in the evolving nature of play, labor, and surveillance in the digital era. In Chapter 5, "Free Time," I examine what the ludic means today, and how it relates to both art production and a lack of industrial production. On the one hand, post-industrial work itself often involves play. Yet on the other, in Cuba a culture of informal economies, underemployment, and of what Loss calls socialist (or post-socialist) "ocio" lingers. At the same time, the games played in free time increasingly themselves often refer to militarized surveillance states, making "down time" potential fodder for systems of control.

Chapter 5 returns to the longstanding importance of "*el juego*" or gaming in Cuban history. In the early nineteenth century, members of the slaving elite were seen as given to corruption and gambling because they did not labor themselves. In the late nineteenth century, the Santiago-born Paul Lafargue penned his famous tract "The Right to be Lazy" (1889, reissued in Cuba in 2007), a comic redemption of non-work that, I argue, should be read alongside another essay by Lafargue on post-slavery wage labor in the Americas. Finally, in the 1950s, Cuba became the privileged site for casinos. These insular prehistories of play, plus devastating post-Soviet economic hardship, constitute the precedents for a poet's 2008 study of the ludic in Cuban poetry, a book that has itself become the subject of a recent video by the young artist Lester Álvarez. I tie these essayistic and literary attempts to wrest play and free time from industrial and post-industrial work regimes alike to similar questions raised by the artist Adrián Melis, whose oeuvre focuses on the causes and effects of *not* working, in both contemporary Cuba and Europe, and to queries posed by the video game art of Rewell Altunaga.

The book's final chapter, "Surveillance and Detail in the Era of Camouflage," takes these discussions into the field of surveillance art. I discuss a

growing body of art about paranoia, systems, and surveillance by Celia y Junior, Fidel García, Susana Delahante, and Rodolfo Peraza, all graduates of participatory artist Tania Bruguera's Cátedra de Arte de Conducta (School of the Art of Conduct). Recent artworks address both specifically Cuban contexts and a necessarily broader reality. The panopticon Presidio Modelo (Model Prison), built in the 1930s on the Isle of Pines, for instance, was first featured in a trilogy of pathbreaking 1960s documentaries by Sara Gómez, but is now the setting for a video game artwork by Peraza that highlights both the prison's local history and its more widespread architecture of control. The chapter concludes with a reading of Ahmel Echevarría's 2013 novel *La noria* (The Wheel) as a tale that connects the dots between a racialized history of surveillance, 1970s state vigilance and censorship, and contemporary Latin American literature's favoring of conspiracy as a privileged form for critiquing power. Focused on the relationship between the microscopic and the macro, these artworks and writings mirror relations between the local and the planetary in contemporary aesthetics.

CHAPTER 1

We Are Tired of Rhizomes

At first glance, recent Cuban literature seems to evince a renewed interest in the 1920s and 1930s. But the trend is primarily focused on European modernism or crisis, sometimes as it played out in Cuba, a sign perhaps of an eagerness to think beyond the nation. In *Djuna y Daniel* (Djuna and Daniel, 2008), for example, Ena Lucía Portela reconstructs the relationship between radical modernist figures Djuna Barnes and Daniel Mahoney, while in *Posar desnuda en la Habana* (Posing Nude in Havana, 2011), Wendy Guerra revisits the diaries of the Cuban-French Anaïs Nin.[1] Leonardo Padura's impressive reconstruction of Trotsky's time in Mexico in the 1930s and 1940s tracks his assassin Ramón Mercader back to Cuba, but in the 1970s (*El hombre que amaba a los perros*/The Man Who Loved Dogs, 2009), while Padura's exploration of the 1930s emigration of Eastern European Jews to Havana comes closer to examining the era with a focus on a little-known history of a Jewish quarter in Havana (*Herejes*/Heretics, 2013).[2]

Of course, Cuban authors have no obligation to write about Cuban history, which in any case is inextricably global. But it is notable that few writers seem interested in revisiting everyday life on the island during the same modernist period. The 1930s in Cuba were tumultuous. The decade saw both general and local strikes, a revolution in 1933, struggles against racism, the seizure of a sugar mill by workers, and the formation of anarchist circles with their own weekly publications—to dwell only on period politics, and to say nothing of the rich cultural production.[3] Many of the issues motivating Republican-era unrest remain relevant today. At a moment in which cooperatives have been embraced as an

experimental form for a new economy, it is striking that a collection of essays on cooperatives published in Cuba in 2009 addresses both historical, nineteenth-century examples from Europe and post-1959 cooperatives in Cuba, but passes over the history of early twentieth-century cooperatives on the island altogether.[4]

For the past half-century official discourse has denounced the first decades of the twentieth century as morally, politically, and economically corrupt. But political, aesthetic, and ecological experiments from the 1930s might productively be revisited in an uncertain present, and there are signs of fresh approaches to the period in both historiography and literature.[5] Padura, for instance, the preeminent Cuban novelist publishing today, claims he became interested in novelizing Trotsky's life precisely because the story was relatively unknown on the island and is important for rethinking the twentieth century.[6] Recent activist coalitions and independent forums such as *Observatorio Crítico* (Critical Observatory)—which offers a heterodox, left critique of current government policies—are recuperating histories of anarchism on the island. *Observatorio Crítico* member Isbel Díaz Torres is also the main figure behind *El Guardabosques* (Rangers), a small ecological activist group based in Havana.

A few legacies and archives of ecological thought from the early part of the twentieth century, however, *have* managed to remain alive and relevant, if insufficiently known. In particular, José Manuel Fors's photography and installations have, since the 1970s, engaged the figure of his grandfather Alberto S. Fors, the leading forester of the Republican period. José Manuel was a member of the New Cuban Art movement of the 1980s; today he continues to work on ecological themes, on the medium of photography itself, and on the relations between families and everyday objects. Connections between grandfather and grandson, scientist and artist have been revisited separately in articles by two of Havana's leading curators, Cristina Vives and Corina Matamoros.[7] Still, few studies of José Manuel Fors actually engage with his grandfather's thought. Indeed, the artist himself has worked more with his grandfather's iconography than with the engineer's pioneering ecological philosophy. Yet reading Alberto S. Fors's 1930s writing itself alongside contemporary philosophers suggests its renewed relevance for ecology and for a contemporary art already influenced by José Manuel Fors's generation of ecoaesthetics.

José Manuel grew up in his grandfather's house alongside the latter's xylotheque, a collection of Cuban woods. For decades he has appropriated

his grandfather's letters, writings, and photographs in his art, mining images and materials from his family history to meditate on nature and society. I will turn to an examination of these works at the end of this chapter, after considering in greater detail Alberto S. Fors's ecological thought itself. Revisiting these archives and debates is neither aesthetic nor antiquarian, but urgent, as some of the ecological pressures that had occasioned critique in the 1930s return.[8] Despite Fidel Castro's dismantling of the sugar industry, for instance, the crop may prove resilient. As noted in the introduction, the Miami-based Fanjul family—whose ancestors owned the very sugar mill whose associated cultural club published many of Alberto S. Fors's 1930s articles—have been in talks with leading economists for the Cuban government about reinvesting in the island, and in sugar. A review of the island's 500-year-old struggle between forest and sugar may be newly urgent for contemporary ecological and aesthetic thought.[9]

Figure 1.1: *Cúspide*, November 1937.

Figure 1.2: *Cúspide*, June 1939.

In what follows I first look at contemporary art's tropological interest in trees and environments. I then flesh out the backstory to these interests, tracing trees' abiding centrality to Cuban ecological thought. The second half of the chapter turns to the little-known writings of Alberto S. Fors and to the visual art of José Manuel Fors, connecting the ecological aesthetics of the 1930s to those of the '70s, '80s, and the present.

Art's New Arborism

What lies behind the current emphasis on trees, potentially so romantic and long the stuff of landscape painting? Early in *A Thousand Plateaus* (1980) the philosophers Gilles Deleuze and Félix Guattari announced "we're tired of trees."[10] Their proposal of the rhizome as an alternative, nonhierarchical model of association—underground, ramifying, horizontal—became, in the decades following the book's publication, one of the most adopted symbols or structures for imagining and describing democratic collectivities (manifest, for instance, in the digital art website *Rhizome*, now linked to The New Museum in New York). As

recently as 2013, the art journal *Third Text* cited Deleuze and Guattari as the inspiration for a special issue on ecoaesthetics.[11] But as the "society of control" that Deleuze also diagnosed deepens—a society based on coding, in which control is not hierarchical and spectacular but pervasive and insidious, rather like climate change itself—it seems time to announce, only partially in jest, that we are now tired of rhizomes: we want trees.[12]

Works by a new generation of Cuban artists summon a longer-standing attention to trees in Caribbean ecology and art, reactivated in the context of current concerns. The young artist Rafael Villares, for instance, frequently works with trees and "environments," blending aesthetic queries about the borders between subject and object with concerns about ecology. In *Retoño* (Shoot, 2009), Villares's arm is but one more branch of a tree trunk, making the artist's tool an extension of the nature in opposition to which *techne* was once imagined. Villares conceived of *Retoño* as an homage of sorts to the 1980s artists Juan Francisco Elso, José Bedia, and Ana Mendieta (discussed below); Mendieta had carried out a series of performances entitled *The Tree of Life* in 1976 and 1979, in which she camouflaged herself against the bark of a tree.[13] Adonis Flores, whose work is discussed in greater detail in Chapter 5, also made a piece named *Retoño* (2006), in which, dressed in camouflage, he shimmied up onto and hugged a high tree branch, becoming a growth along it.

In Villares's series *De la soledad humana* (Of Human Solitude, 2009), the roots of a severed tree trunk hung suspended over a dimly lit gallery floor, casting an intricate shadow of criss-crossing networks that faded into the surrounding darkness. From inside the trunk, some 3 meters in diameter, emanated the sounds of birds, people, and branches moving in the wind. In the artist's sketch for the piece, the ground appears as a globe. The shape suggests a planet no longer supportive of life, but inscribed with the shadows cast by the root system, severed and expelled from its surface. The structure of the piece inverts the order of things so that the roots of the earth's ecologies are above us, and we below, under spiny shadows cast by the floating system, reminiscent of an aerial view of rivers running black.

In a work made for the 2012 Havana Biennial, *Paisaje itinerante* (Itinerant Landscape), Villares constructed a giant planter to hold a full-sized laurel tree, with room enough to include a wooden bench beside the tree and stairs leading up inside it. The entire structure hung from a crane and was moved four times during the biennial, principally to locations otherwise bereft of trees. The idea, Villares asserted, was to give *habaneros* a new

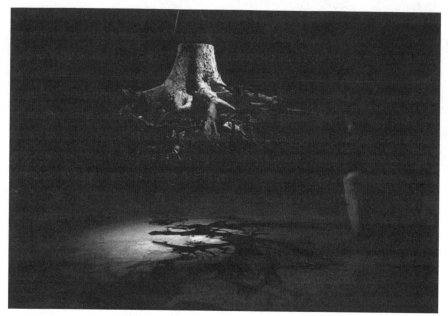

Figure 1.3: Rafael Villares, *De la soledad humana*, 2009. Sound installation.

perspective on their city: both from the tree's heights, and through the addition of trees to an otherwise concrete cityscape. The piece is also a striking example of convergence among contemporary artworks interested in the intersections of the natural and built environments: although Villares was not aware of any precedents for his work, in 2010 the Brazil-based artist Héctor Zamora made an installation, documented in digital prints, titled *Errante* (Errant, similar even in title to Villares's piece). Zamora suspended three separate trees rooted in giant clay-colored pots over São Paulo's Tamanduatei River, which is channeled through cement retaining walls and flanked by multi-lane avenues coursing through the giant metropolis. Zamora, too, framed his suspension of potted trees over a barren cityscape as adding to and changing the experience of public space.[14]

Paisaje itinerante is one of the most mature of Villares's works, its humor, scale, and transience through different cityscapes a sophisticated engagement with perspective and with urban ecologies. It is subtle in its understanding of what environment means. Earlier of Villares' works perhaps too easily presumed "nature" and "culture" to be stable categories, purveying common tropes about ecoart that Timothy Morton has recently attempted to pick apart. Morton writes that contemporary art that gestures beyond the gallery space (a stand of trees, the sound of water running) is

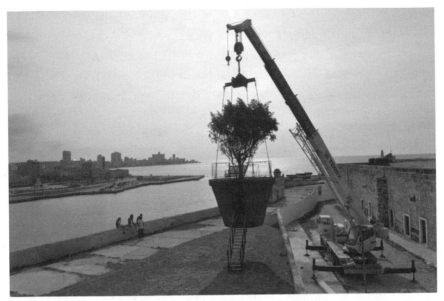

Figure 1.4: Rafael Villares, *Paisaje itinerante*, 2012. Installation.

"environmental" insofar as it attempts to erase the mediation between artist and nature, gallery and outside. Only taste, Morton notes, prevents us from seeing such installations as of a piece with more clearly kitschy "nature writing."[15] In both, artifice wishes to slink away and let nature step forth. For Morton, ecological art often pairs this "ecomimesis" (shunning mediation, imitating the environment) with a "poetics of ambience": a poetics, that is, that aspires to model the dissolution of the division between subject and object that haunts Western philosophical concepts, a division that purportedly enables degradation of the environment.[16]

Such a staging of ambience frames some of Villares's environments, which risk restaging parts of the natural world as pleasing sensory experiences. An installation in which Villares transported a stand of bamboo and played the sound of its movement (*Aliento*/Breath, 2008), for instance, recalls Morton's wry observation that the erasure between high and low "environmental" art is exemplified in minimalism's translation into modern kitchens, or in the fact that "Bamboo has become popular in British gardens for its sonic properties."[17] Another sound installation, *Respiro* (Breath, 2010) consisted of a false floor of cracked earth laid over a lightbox some six by four feet, creating the image of a barren topsoil lit from below. The installation was accompanied by the sound of breath and rhythmically swelling and dimming lights, to which viewers unconsciously aligned their

own breathing. (In 2015 Glenda León produced on commission a series of videos titled *Cada Respiro* [*Each Breath*], for the Matadero Madrid contemporary art space in the Spanish capital, in which scenes of "nature" were similarly correlated with the sound of breathing.) Some of Villares's environments furthermore bear the stamp of an abiding romantic position that Morton finds in Kant as much as in kitsch, in which nature is something "over there," available for observation, copy, and even for assimilating through a cancellation of this distance.

But Villares continues to work with environments with energy and imagination, stretching the nature of his site-specific works. At times he echoes the Cuban-American artist Félix González-Torres's interest in doubling and multiplicities. What in González-Torres was charged with affect and human absence, however—an empty double bed (*Untitled*, 1991), or two clocks falling out of sync with one another (*Untitled* [*Perfect Lovers*] 1991)—in Villares is a more abstract balancing of the concepts of nature and some sort of pair or opposite. Thus in *Polyphony* (2013) Villares placed in a sunny spot in the woods a speaker broadcasting the sounds of a Havana street corner, matched by an identical speaker placed at the same street corner at dusk and blaring the corresponding sounds of the forest environment. Villares photographed both spots, and when the large format digital prints were subsequently shown in a gallery, he provided viewers with headphones to listen to the sounds of the visually contrasting sites. By separating sound from its context, Villares sought not to produce a sensation of out-of-jointedness, but, perhaps counterintuitively, a sensorial totality that would include the aurally or visually excluded environs.

In *Absolutely Tropical* (2014) Villares installed a mini-beach environment on a circular stage within the ruins of the National Art School's Ballet Building (known as the Circus Ruins). The piece recreated a miniature, discrete environment to orchestrate new social experience, rather than to stage an encounter with nature as such. *Absolutely Tropical* was part of a commissioned group show entitled Pan y Circo (Bread and Circus), conceived as a platform to explore the ways in which "political" art has evolved since the 1970s, and, more generally, the ways in which politics means more than (or not at all) the relationship between citizen and state.

Pan y Circo sought to critique received understandings of *panem et circenses* as a strategy of distraction or of letting off steam fomented by domineering states: following the French historian Paul Veyne, the

curators instead held that ludic spaces allow for genuine experiences of being together, "small spaces of daily leisure (*ocio*), unreflexive and useless."[18] Such spaces of leisure, the curators suggested, constitute *true* moments of a life in common, and rupture a logic of means and ends by endorsing play.[19] Pan y Circo was indebted, too, to Jacques Rancière's notions of the political, in distinction to notions of state- or party-based politics or to willfully "political" art.

The exhibit unfolded across several ruined spaces: a plaza—"site for consensus and dissensus; political paradigm for democracy"; the unfinished Ballet School's eroded walkways that connect the ruined buildings, suggestive of dried-up water channels half-buried under leaves and earth; and a labyrinth, associated with games and the circus.[20] In the middle of a wide, circular stone stage, evocative of a prehistoric ceremonial site, Villares placed two plastic beach lounge chairs flanked and sheltered by a beach umbrella, and, beside them, a sound system, all anchored in an island of sand roughly 10 feet in diameter.

In exhibition documentation, participants sit on the chairs, sip beers to the recorded sounds of the ocean, and chat, as if at the beach. Villares created out of this simultaneously expanded and reduced field a stage for his generation, and he was unsurprised when they mainly acted like party-goers, as if proving that an earlier kind of critique was of little interest. Like a cartoon scenario set on a proverbial desert island, the piece set the stage for a punchline that lingers uneasily. The piece was intended to work in relation to other more explicitly critical ones in the exhibition: just as the overall exhibition argued against heavy-handed understandings of politics, and for the importance of the nonassimilable and the ludic, *Absolutely Tropical* instantiated a space of disengaged relaxation.

Villares, who was born in 1989, came of age in the new millennium. He draws as much or more on contemporary art as on a lesser-known tradition of environmental and arborist writing in Cuba. Still, he and peers such as Milton Raggi, who likewise make trees, environments, and forestation central concerns in their oeuvres, work within an insular genealogy of ecological aesthetics.[21] In addition to the avowed influence of Mendieta, Brey, and Elso, these artists gesture backwards towards a 1980s engagement with natural elements, and indeed to José Manuel Fors's art. To constellate various prior interventions with these more recent works, we need to widen our historical lens and trace in greater detail earlier reflections on Caribbean environments.

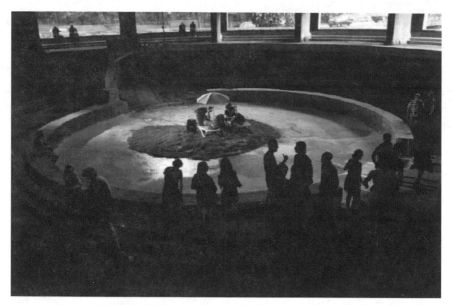

Figure 1.5: Rafael Villares, *Absolutely Tropical*, 2014. Installation.

Cúspide: An Early Ecopoetics

Histories of Caribbean ecological stewardship focus on the central battles between sugar and forest management. One study even locates the origins of global environmentalism in concerns over deforestation in the Caribbean: Richard Grove begins his sweeping history *Green Imperialism: Colonial Expansion, Tropical Island Edens and the Origins of Environmentalism, 1600–1860* with an account by Columbus's son Ferdinand, who knew "'from experience' that the removal of forests that had once covered the Canaries, Madeira and the Azores had severely reduced the incidence of mist and rain."[22] When Ferdinand left behind the experimental sugar plantations of the Canary Islands for the West Indies, he took this knowledge of sugar and deforestation with him, believing that Caribbean forests were responsible for producing rain showers, and that land clearing might reduce rainfall.[23] For Grove, this foundational episode makes modern environmentalism a "direct response to the destructive social and ecological conditions of colonial rule."[24]

Cuban historian Reinaldo Funes's similarly ambitious environmental history *From Rainforest to Cane Field in Cuba* also begins in 1492. It details five centuries of fluctuating but largely inexorable destruction of the island's original forests, which initially covered somewhere between 60 and 90 percent of the territory.[25] Cuban—and if one believes Grove, global—environmentalism

thus begins with the fate of trees and the risk posed to them by the sugarcane industry. The risible romanticism of the figure of the "tree-hugger" comes to seem oddly insightful. Trees turn out to be not merely a central trope in writing and art about Caribbean nature, but also a synecdoche for the forestry necessary to maintain rich ecologies in the face of sugar, as well as central agents in regulating CO_2 levels in the atmosphere.

In the mid-eighteenth century the Spanish Crown established the Royal Forest Reserves. The director of the Reserves in Cuba was responsible for overseeing woodlands' exploitation as well as conservation.[26] This vesting of both conservation and exploitation in the same official post led to predictable tensions. Throughout much of the nineteenth century any use of the colonial forests was constrained by "the defense of the 'sacred' right of property, definitively sanctioned by the royal edict of July 16, 1818."[27] The edict remained in place until 1876. At that point new Woodlands Ordinances for Cuba and Puerto Rico came into effect, marking the beginning of modern forest administration for both islands—but not an end to deforestation.[28] The assault on forests continued into the 1920s and 1930s, as the sugar industry intensified and lumbering for fuel also increased.[29]

The literary journal *Cúspide*, which ran from October 1937 until August 1939, was founded in this moment. Large and disproportionately US-owned companies consolidated smaller mills. The effects of the post-1929 economic depression dragged on. Like many periodicals of the time, *Cúspide* had a socialist bent, and it trained its critique on these and other challenges facing the island. But it reached beyond Cuba to include international political analysis, columns about the Americas, social commentary, and literature. The magazine combined these features common to many cultural journals at the time with the more singular emphasis on forestry and agricultural advice. *Cúspide* was unique not only for its focus on forestry and agricultural concerns, but also for its self-conception as a literary magazine for writers from "the interior" who sought to break the hegemony of Havana's literary elite.[30]

Cúspide was founded and edited by José (Pepe) Cabrera Díaz, an emigré to Cuba from the Canary Islands in 1909 and subsequently the manager of the sugar mill La Mercedita, located to the south of Havana in Melena del Sur, Mayabeque province.[31] As a young man Cabrera had founded the first workers' association in Tenerife, as well as the association's first journal, *El obrero* (The Worker).[32] These activities forced his emigration to Cuba for a first stint in 1900 and then, definitively, in 1909;

he eventually became the administrator of four of the Gómez Mena sugar mills.[33] Astonishingly, *Cúspide*'s essays, poems, and scientific articles about reforestation, husbandry, and rural poverty—all victims to varying degrees of sugar's monoculture—were published from *within* the mill itself. Along with editing the journal, Cabrera also built a library, schools for children and adults, and worked on reforestation projects.[34] Events were organized through the *Club Mercedita*, which oversaw a nursery that made free saplings and seeds available to the community: in one six-month stretch alone the Club planted 217,455 seedlings.[35] Alberto S. Fors, who had trained in forestry engineering at Cornell University, regularly published in *Cúspide*, on whose editorial board he also served.

Although it lasted only three years, *Cúspide* was important. It was published monthly and featured significant authors including Juan Ramón Jiménez, Octavio Paz, Gabriela Mistral, Emilio Ballagas, and José Lezama Lima.[36] It even brought well-known performers to the mill, including Afro-Cuban poetry reciter Eusebia Cosme and Mexican opera singer Alfonso Ortiz Tirado. *Cúspide* offered a surprising mix of genres. It indulged a typical 1930s *criollista* writing "*de la tierra*" (about the land). Yet it also sought to rival sophisticated Havana literary journals, even as—and in distinction with magazines published in the capital—it counted among its readers small farmers and even the *campesinos* who attended the night classes that Cabrera established at the mill.

Cúspide's multiple concerns were often fused in poems and articles about the landscape and rural life, or in protest pieces such as the short story "Se acabó la zafra" (The Sugar Harvest is Over). The story tells of a sugarcane worker hemmed in by the cycle of debt that accrues between the harvest (*zafra*) and the "*tiempo muerto*," or dead time, without work. The worker attempts suicide by throwing himself into the mill's machinery, only to be saved, against his will, shorn of his legs and now fully excluded from any kind of work.[37] *Cúspide*'s articles also provide insight into the debates and activities of the period's agricultural cooperatives, which, again, play a potentially important role in today's agrarian restructuring as well. In the 1930s, cooperatives were adopted as an alternative to the cycles of boom and bust so precarious for farmers of seasonally unpredictable commodities.[38] Today they constitute a promising corrective to decades of damaging collectivization, while warding off problems of top-down privatization.[39]

Ecumenical in its taste, the "books received" section of each issue included titles that span anarchist tracts and forestry pamphlets. One

such pamphlet written by Fors discussed forest cultivation in Cuba and exposed "how we are getting rid of our forest life."[40] Trees, indeed, were the heart of the journal. There were romantic poems about trees, articles about forestry (many influenced by arborist societies in the US), and industrial advice about woodlands care. Titles of poems and articles from just the April and May 1938 issues include: "The Boy Who Did Not Love Trees and Learned to Love Them," "Bamboo, Industrial Material," "What Trees Are," "At The Tree Festival," "Tree Festival" (poem), "Tree Festival" (article), "In Praise of Trees," and "The Tree."[41]

Mutualism in the Life of the *Monte*

Amidst saccharine eulogies to trees and pragmatic advice about the woodlands, Fors's writing stands out for its poetic descriptions of ecological systems. He alone argued that people must learn to read the systems that comprised the forest or wilderness, "el monte." An October 1937 article entitled "El grito de la jocuma" (The Jocuma's Cry) illustrates Fors's philosophy by describing the language of the jocuma tree. If the tree trunk is illegible to the non-initiate, he wrote, for the schooled reader of the forest it reveals all its history as if the bark were a papyrus inscribed with an ancient language: "The old jocuma tree of clean trunk and little garb is speaking, but few hear it and no one understands it, because only the initiated can interpret the language of the trees of the *monte*."[42] Fors then deciphers the trunk for the magazine's readers, noting a history of hurricanes and other events that have registered materially.

Fors's tale about the jocuma tree, however clumsy, was an attempt at inverting reigning anthropocentric relations to plants otherwise common in the journal. A more typical piece from *Cúspide*, for instance, depicted a tree as a stern schoolmaster lecturing Man on the proper use of the forest.[43] Of a piece with the hypostatization of nature that would make plants speak in human languages was a project in which the Club Mercedita planted a series of trees in the Bosque de La Habana, Havana's urban park laid out in the 1930s around the Almendares River. A brief write-up entitled "Vegetal Poetry" detailed the project: the trees selected to be planted created an acrostic that spelled the word "RECORDACIÓN," or REMINDER, assembled by selecting out the first letters of each kind planted: Roble, Eucalyptus, Caoba, Ocuje, Rama, Dileria, Alamo, Cedro, Inga, Oreja de Judío, Nogal.[44]

In contrast with these spectacular syntheses of the organic and the written, Fors published an article in 1939 entitled "Mutualism in the Life of the *Monte.*" "Mutualism" reflects the German biologist Ernst Haeckel's first definition of ecology as a science of the relations between organisms and their environment. The article demands that humans learn the language of the trees—which, Fors noted, was also the language of "humans," since we ourselves are a complex "mesh" of human and nonhuman, biological and nonbiological agents (to borrow Timothy Morton's recent formulation).[45]

Consonant with *Cúspide*'s socialist, syndicalist, and cooperatist orientations, Fors conceived of the environment as a network of individuals mutually dependent on one another:

> from the diminutive crustacean . . . to the proud dove, all are important members of the great forest society, united by natural connections of mutual dependence, each one necessary, in a specific way, to the life of the others. True socialism reflected in each leaf, in each inch of crust, and each square meter of soil! Such is life in the natural forest; the dense, high forest, somber and humid, without excavations or barren terrain, free of violations and cultural abuses. One need only isolate the trees, separate them from the rest of the vegetation, to see them begin their withdrawal, to slowly disappear, lacking relations and kin.[46]

The *monte* is a network of interdependence whose forms express themselves without need of speech. Implicitly writing against the anthropocentric focus common among *Cúspide*'s "tree" articles, Fors affirms:

> We don't need the trees to speak in order to uncover the natural history of the *monte.* Its physiognomy, the modalities of its inflorescence; the forms of its seeds and its habits, express the multiple and delicate relations of mutual dependence that unite it with the other trees, with the wind, with the insects, with the birds, with the river and with the microorganisms in the soil, in the various processes of fertilization, dissemination and growth.[47]

The *monte* provides its own legend. But if it does not require translation, it does require the proper spirit: an openness to the nonhuman and collective. "To describe all these relations; to understand the life of the monte, it is not enough to penetrate it," Fors argues. Instead, one must bring a heart "predisposed" to comprehend a totality beyond this or that detail.[48] One

must be familiar with the *monte*. Going in with "some preformed images," one can then see "something more than the form of things, their colors and movements; one sees also the reason for their existence, their relations."[49]

"Nature" is often imagined as a "real" opposed to, but also the raw material for, artifice and aesthetics.[50] Fors says something different. We need prior study to grasp the *monte*'s reality. We need to apprehend totality at work. Moving *beyond* the aesthetic—color, or movement—we can grasp the ontological and the relational. "Mutualism in the Life of the *Monte*" argues, then, for an understanding of the forest as a set of necessary relations. This epistemological approach imitates the ecological network of the forest itself. Only by abandoning an individualist or even phenomenological vision, and perceiving the forest as a being larger than any single tree or species, can we understand and "read" its significance, its system and its functioning.[51]

Today, philosophy, anthropology, and aesthetics are again turning to parallels between human and nonhuman environments. Eduardo Kohn has written a book entitled *How Forests Think: Toward an Anthropology Beyond the Human*, and bio-artist Eduardo Kac has drawn on the Czech/Brazilian philosopher Vilem Flusser to propose a "dialogical aesthetics" for the twenty-first century that highlights the interpenetration, rather than separation, of subjects and objects.[52] Flusser and Kac turned to Husserl's phenomenology to move beyond the subject/object divide. Fors took a more neo-Kantian position. He believed a proper understanding of the *monte* must go beyond aesthetics—that is, perception and sensations—to get at the essence of things. The expanded, even microscopic vision that Fors imagines is a "broader" but also a "deeper" scientific comprehension of first causes: if ordinary vision is "superficial and imperfect," he writes, what might we see with "additional eyes"?

> Surely we would not see the scent of the flowers nor the germs that float suspended in the air that we breathe, *but we would see something more than the outer shell of things: their meaning and their causes.* To he who knows the form, the size, the coloring and the habits of the cicada, for instance, how easy it would be to find one when it sings mimetically on the thick branch of the ilex, after twelve years of subterranean life! But how difficult it is to see for he who only brings with him normal eyes! [*my emphasis*][53]

Fors articulates an epistemology of the *monte*. Those who bring with them the additional eyes of science and observation can penetrate the surface of the world. Those who move out from their own subjectivity can get at the thing itself, its first causes. Such secrets are expressed in a language that is not human. Yet they are accessible to those humans who are open to our species' embeddedness in shared ecosystems.

Fors was singular among *Cúspide*'s contributors for his unique dialogue between literary-philosophical and ecological concerns.[54] Often kitschy, some of the journal's positions could even be astoundingly aristocratic: in "¿Ama a los árboles el guajiro cubano?"(Does the Cuban Peasant Love Trees?), for instance, Nicolás García Vurbelo answered negatively, citing an "absolute lack of artistic sense," "mal gusto" (poor taste), and indifference to an aesthetically pleasing environment. In an insult to both peasants and modern art, García Vurbelo complained that this inaesthetic relation to the environment was turning the Cuban landscape, pleasantly "popularized in almanacs and food tins,"[55] into "avant garde painting," "unrealistic," and "abstract."[56] What the author wished to behold as the commodified, pastoral image of the Cuban countryside appeared closer to some experimental, abstract sketch, thanks to the peasants' *use* of the land.

Cúspide's romantic and post-romantic investments in the Cuban forest or *monte*, including its importance as a site of refuge for runaway slaves, were alternately recovered and revised during the early years of the revolution. On the one hand, the revolutionary state, singular among Caribbean nations, reversed deforestation.[57] The state planted 2.5 billion trees in the three decades after 1959.[58] Today almost 30 percent percent of the island is forested, up from a nadir of some 15 percent in the 1950s.[59] The government also passed a number of laws legislating environmental protection. The 1976 Constitution, updated after the 1992 "Earth Summit" in Rio de Janeiro, underscored citizen involvement in the environment and added concepts of sustainable development.[60]

Yet the early years of the revolution also saw campaigns to implement powerful industrial agriculture along Soviet models. The so-called "Green Revolution"—the term was coined by then-USAID Director William Gaud in distinction to a "red revolution" by the Soviets—relied upon a plethora of industrial fertilizers, pesticides, and other innovations to produce high-yield crops in the "Third World," where a Cold War United States feared that food scarcity might make populations more susceptible to communism.[61] But communist nations embraced

industrial agriculture, too, indeed with arguably greater enthusiasm. With Soviet guidance, Cuba adopted the widespread use of pesticides, massive seedings, the attempted drainage of the rich wetlands La Ciénaga de Zapata, and the diverting of the island's major rivers, in accordance with Fidel Castro's mantra "no drop wasted."[62] The island would eventually use proportionally more nitrogen fertilizers per hectare than other American nations, including the United States.[63] Ernesto "Che" Guevara undertook a campaign to clear wide swaths of forest for cane planting (a project that ended in the *zafra* of 1970, famously distorting the nation's economy). In a project named "Plan Ceiba"—incidentally invoking the national tree, which several Cuban religions hold dear—bulldozers and dynamite literally laid waste to the forest to make way for fruit trees.[64]

These campaigns were aestheticized as epic, massive, sublime endeavors in the pages of the magazine *Cuba Internacional*, modeled after journals such as *LIFE*. Yet the projects were simultaneously humanized in lavish photo essays and interviews with the workers involved, depicted as "everymen" joyfully engaged in the labor of the revolution. In a signature series *No hay otro modo de hacer la zafra* (There Is No Other Way to Harvest Sugar), the photographer Enrique de la Uz documented the swings and blows of the machete against sugarcane, as if the graceful gestures of the *machetero* were the practiced poses of a studied martial art, rather than the

Figure 1.6: Enrique de la Uz, *Untitled*, "No hay otro modo de hacer la zafra" series, 1970.

grueling work that sugar harvesting had implied for centuries. De la Uz later exhibited *No hay otro modo de hacer la zafra* alongside work by Luc Chessex and Iván Cañas at Cuba's Salón 70 at the Palacio de Bellas Artes.[65]

Other period photo spreads zoomed out to an aerial, even intergalactic perspective. In the October 1969 issue of *Cuba Internacional*, for instance, one finds a frank range of interviewees' reactions to the first moon landing alongside a generous photo essay shot by Mario Ferrer entitled "Rice: A Colossal Effort." Photographs of rice paddies shot from an airplane reveal their abstract designs to be strikingly similar to that of the era's nascent Land art or Earthworks. Aerial views of the land undergird Green Revolution agricultural aesthetics as much as they do, say, Robert Smithson's *Spiral Jetty* (1969–70), undertaken in the US that same year.[66] The ecological sensibility of the 1930s everywhere ceded to the industrialist, massive scale imagined both in agriculture and, unsurprisingly, in art as well. Cuba's epic agriculture was not a singular example of its programs but part of industrial form more broadly.

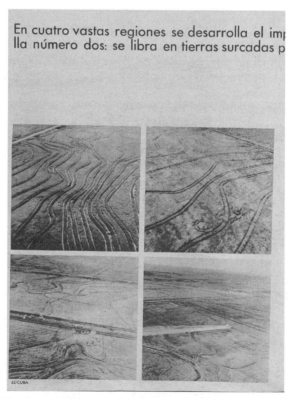

Figure 1.7: Marco Ferrer, "Arroz: un esfuerzo colosal," *Cuba Internacional*, October 1969, 32.

Volumen I

As the 1970s gave way to the 1980s, massive mobilizations and agricultural campaigns were abandoned for other engagements with the environment and with everyday life. The New Cuban Art of the 1980s took up ecological questions on a local scale, though it was also informed by Land art from the United States and Europe. In 1981 the Cuban-American artist Ana Mendieta, well versed in US and European performance and Land art, returned to the island to realize a series of works entitled *Esculturas Rupestres* (Rupestrian Sculptures, 1981). The sculptures, carved out of soft stone in the caves of Jaruco, looked like neo-prehistoric figures tucked within a chalky womb. They were visible only to those in the know, and difficult to find even for people who lived nearby.[67] The hidden, concave figures inverted the epic and geometric contours of Green Revolution transformations of the earth, as well as Land art's giant constructions visible from the stratosphere. Claiming that dominating nature was part of an imperial drive that she contrasted with a "female force" in the earth, Mendieta called her art "earth-body work" in explicit distinction to Smithson's "Earthworks."[68]

The precise relation between Mendieta's art and Smithson's is complicated. Olga Viso claims that the earth-body works were "deliberately contrary to the monumental gestures" of Smithson and Michael Heizer.[69] Charles Merewether, however, has argued for Smithson's influence on Mendieta, whose cave pieces, he claims, may be an homage to Smithson's prior work in caverns.[70] And like Smithson, Mendieta eventually became interested in earth art that might be visible from above. She meant such work to allude to prehistoric monoliths and artworks along the lines of those of Newgrange, Ireland, and the Nazca lines in Peru.[71]

Moreover, we might align Mendieta's emphasis on the inner fold or on the seemingly earthy and organic less with some 1970s earth-goddess notion of feminized nature—however much Mendieta herself encouraged such readings—than with a language shared with Cuba's 1980s generation of artists, virtually all of them men. Mendieta famously introduced Cuban artists to her colleagues in New York: José Bedia, Flavio Garciandía, and Ricardo Rodríguez Brey all visited Luis Camnitzer in New York.[72] Mendieta also introduced the American artists and critics Lucy Lippard, Carl Andre,

and others to peers in Cuba. It was a moment in which Rodríguez Brey took up the legacy of Alexander von Humboldt's studies of American nature and Juan Francisco Elso narrated the pre-Columbian origins of the Americas.[73] Tomás Sánchez's landscape paintings from the period, meanwhile, include what Rachel Weiss has described as "exquisitely rendered landscapes of garbage and puddles," terrains that yielded "minor insights."[74] Sánchez's series of paintings of landfills also provides a cogent reflection on the continuities between manmade and natural landscapes.

In a 1981 interview Sánchez discussed his paintings of landfills as elements in a practice exactly opposed to notions of nature as an external, reified thing. Such reifications, he argued, facilitate nature's apprehension as something to be collected, consumed or ignored:

> Humans sometimes treat nature like something without value, inert. They study it, analyze it, divide it, classify it, like some inanimate object, but also, they contaminate it, destroy it . . . [In a landfill] you can find whatever you want . . . whatever thing that man has valued at a given moment, and when it breaks it goes to the trash heap, which becomes a portrait of those who made it. Jesus Christ said: by your work you shall be known, and one could add: by your landfill you shall be known.[75]

If Sánchez's lush, tropical landscapes seem at first to celebrate typical beauty, his similarly smooth paintings of landfills suggest at once a sameness with which nature and objects are apprehended, captured, represented, and analyzed, and a kind of unknowability of nature that is opposed, in the expansive greens and blues of his paintings, to the intricate semiotics in which the objects in his trash heaps seem to participate. Crucially, Sánchez perceived the inventory-like, historicized nature of trash; how our contemporary landfills are the modern equivalent of classical archeology's heaps of amphoras. His landfill paintings themselves now constitute canny portraits of twentieth-century practices. Sánchez's prescient insight is today confirmed by the striking detail that his landfills contain almost exclusively "natural" materials. Scraps of wood and metal sprawl across the ground. There is not a plastic bag or bottle in sight, as anecdotal histories of the period confirm: there was hardly any plastic packaging circulating in Cuba at The time.

Cristina Vives describes late 1970s Cuban art as more generally concerned with remainders and trash. Sánchez shared his preoccupations

with other artists included in what would eventually be the historic *Volumen I* exhibition, such as José Bedia and Gustavo Pérez Monzón, both of whom were also interested in organic materials, for instance.[76] And one year after *Volumen I*, the collective *Grupo Hexágono* (Hexagon Group) carried out a series of interventions into different landscapes and ecologies. Meanwhile, trees were becoming a recurrent referent in José Manuel Fors's work by the late 1970s.[77]

If, as Vives has argued, Fors's early art seemed "intuitively" to emulate that of his grandfather, by the 1980s the reference was deliberate. Vives perceives in the twin collections that Alberto S. left behind—collections of tree samples and photographs of family members—a reaffirmation of the forester's interest in the affinities between human and nonhuman ecosystems laid out in his articles in *Cúspide*. For Vives, José Manuel's "ecological interest" was part of a long process of research that carried the artist from land, to humans, to families, in a reprisal of his grandfather's steps. Corina Matamoros, for her part, adds that José Manuel Fors's agronomist father—Alberto S.'s son—was yet another intermediary in a genealogy in which scientific experiments were taken up as artistic ones: José Bedia's series *Crónicas americanas* (American Chronicles, 1982–86) used photographs of the Amazon taken by Fors's father from a plane flying over Guyana.[78]

In 1981, Fors produced *Hojarasca* (Fallen Leaves), 12 clear cubes with a wash of dried leaves trapped inside, set upon the earth. The boxes both do and do not impose *techne*'s order on nature: the organic matter is neatly swept into the clearly demarcated, geometric boxes, yet the boxes are transparent, eroding the barrier they delineate. The cubes echo works such as Hans Haacke's *Condensation Cube* (1965) or Sol LeWitt's open cube sculptures (1973), which similarly emphasize multiplicity or seriality. But while *Condensation* displayed water's cycling through phases, *Hojarasca* translated photography's containment of a moment in time into sculpture. Since the leaves were already dried, they underwent little change once contained by the clear frame.

In 1981 Fors also created a second installation that placed cross-sections of tree trunks in drawers taken from furniture in his family's house.[79] The piece alludes both to the time recorded by tree-rings and to the concept of "family trees," while linking wooden furniture to its source. If nature is, as Sánchez argued, too often set apart and

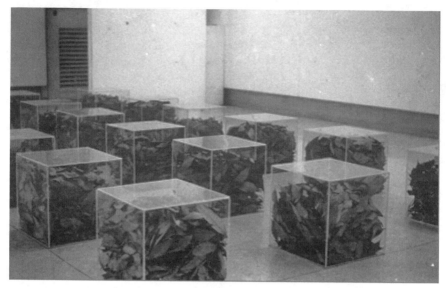

Figure 1.8: José Manuel Fors, *Hojarasca*, 1983.
Installation: leaves, 12 Plexiglass boxes.

dissected—like a wood sample from Alberto's xylotheque—art borrows from a tradition of scientific experimentation while assuaging the break between object and subject, nature and artifice.

In 1985, having perceived numerous anthropological and ecological allusions in the works of Fors, Bedia, Brey, Pérez Monzón, and Rolando Paciel, the curator Corina Matamoros invited the artists to think of a scientific referent for their work for a group exhibition.[80] Fors had turned increasingly to photography, and for his contribution to the exhibition he and Matamoros made a trip to visit Alberto S.'s collection of native woods, with which José Manuel had lived as a child in his grandfather's house, and which had since been donated to the Centro de Investigación Forestal in Siboney, a wealthy Havana suburb.[81] They documented José Manuel's photographs beside some fifty specimens from the xylotheque, yielding the new works *Eucaliptos* (Eucalpytuses) and *Homenaje a un silvicultor* (Homage to a Forester).[82] *Homenaje* consisted of a square of three columns and four rows of a selection of photographs: images of the sky, old photographs of Alberto S., tree trunks, and grass. Vives describes these works as epitomizing José Manuel's converging concerns with family and actual trees:

In a closed space within one of the rooms in the museum Fors laid out a collection of objects: photocopied photographs of his grandfather, his

books on botanical treatises, wood samples—part of the scientist's collection—and three sizable photographic mosaics: "Pine Forest," "Shadow Beneath 5 Billion Trees," and "Homage to a Forester." To build the installation he delved into family memories and the family photography collection, he studied trees and wood more scientifically, he read letters and documents; in short, he managed to tie up the loose threads of his own earlier work and structured the history of a family whose legacy he inherited and within which he was formed. With this work Fors managed to articulate the basic discourse of his later work: man, his memory, and his personal history, like a foundational axis of life.[83]

After these seminal pieces Fors went on to work in a number of media, though principally photography and installation. His contemporary work continues to mine family trees, but they are now decidedly genealogical and intimate, and references to the landscape or nonhuman materials are fewer. A preference for sepia-toned images of families has taken over, as has a practice of multiplying such images until they become color, texture, pattern, often splintered through cuttings. This multiplication and fragmentation suggests the rifts in families—especially, perhaps, those divisions suffered during the early years of the revolution (in Fors's family as well). But it may indicate too a choice to take the history of photographic portraiture in a more minimal direction, to make portraits the raw material for abstraction, design, and sculpture.

Fors recuperates a silvicultural past. But he moves away from working with natural materials themselves to turn 1930s forestry into design. Again, he does not engage substantially with his grandfather's writings, but uses Alberto S.'s figure and work in forestry to initiate a parallel practice of artistic experimentation. José Manuel's art—particularly his photographic techniques—carries out its experiments proximate to, but not derived from, Alberto S.'s botanical research.

If José Manuel's practice has grown away from environments and towards a refraction of family portraiture, however, a new rethinking of the environment in Cuba has emerged in recent years. It engages the consequences of both the end of the sugar industry—less positive than one might expect—and the opposing specter of a possible return to the extractive relation to the land by the sugar industry that reforestation has partially reversed. Forgotten histories and debates are necessary today as the fate of the island's rich ecologies is shaped by a changing economy.

CHAPTER 2

Marabusales

The paradigmatic rhizome gripping the Cuban imaginary today—Raúl Castro himself mentioned it in a national speech in 2007—is undoubtedly the non-native bush *marabú* (marabou).[1] *Marabú* was scarce a hundred years ago, but by the mid-twentieth century it had become a scourge for farmers. Now, following the state's decision in 2002 to drastically shrink the sugar industry, *marabú* occupies somewhere between 50 percent and 70 percent of cultivable land. As the sugar industry disappears, *marabú* rushes in to kill off what remains: the official reason given for failed sugar harvests between 2007 and 2011 was that the invasive plant had overrun half of the crop's land.[2]

The recent closure of almost half the island's sugar mills, and the dedication of 60 percent of these lands to other crops, has inspired a variety of artworks and films exploring post-mill communities. Some indulge nostalgia for prior, more vibrant eras, from the humming mill towns of the 1980s to more remote, pre-revolutionary pasts. Alejandro Ramírez Anderson's *deMoler* (2004), an elegiac documentary about the closing of the *Paraguay* mill in Guantánamo, was followed by Laimir Fano's *Model Town* (2007), about the town of Hershey, Cuba, built in the 1920s by the eponymous chocolate industrialist.[3] The feature film *Melaza* (Molasses, 2012) by Carlos Lechuga, came next, and focused on a young couple struggling in a former sugar town.[4] The female lead is the sole employee of a former mill, and spends her mornings assessing the remaining equipment, awaiting a future in which it might run again. Her boyfriend, a schoolteacher desperate to find additional work, considers cutting *marabú* for cash.

As *marabú* spreads across the landscape it becomes an easy but poly-semic metaphor in contemporary poetry and art. The Santiago-based poet Oscar Cruz has suggested that *marabú* is lodged "in people's mentality" as a "thorny kind of thinking," as if the rhizomatic weed had found its way inside people's skulls, making thought as impassible as the notoriously tenacious plant.[5] In the recent work of some half-dozen artists and poets based on the island, *marabú* figures in allegorical terms. It is often both material evidence for, and a symbol of, state power—and its failure.[6] *Marabú* became a problem of greater magnitude during the Special Period, when the petroleum sometimes used to kill its roots grew scarce.[7] The timing of its resurgence turned it into a kind of natural history or visual manifestation of the difficulties of post-Soviet life and the state's response to it. As the plant takes over fields that could be producing needed crops for national consumption, it is seized upon as proof of poorly functioning agrarian policies.

Sometimes a symbolism is imputed to *marabú* that barely connects to the real conditions spurring its growth. One artist recalls cutting back *marabú* at an "*escuela a campo*" (a two-week sojourn at a rural school during which urban teenagers perform agricultural labor) as a trial filled with scratches and machete grazes *designed* to allegorize or even prepare students for difficult, painful sacrifices ahead.[8] At other times the woody stalks are simply an inexpensive, readily available material for an *arte povera*: in *Línea marabú colección otoño* (Marabú Line Fall Collection, 2005), Guillermo López forged portable suits of marabou branches, for an emigration- and flight-themed dance performance staged by his wife, choreographer Tania Vergara, director of Camagüey's Endedans Contemporary Ballet Company.[9] Finally, a number of artworks that use or thematize *marabú* build on a tradition that takes the city to be an urban ecology producing its own ecoaesthetics. The savage, hardy plant shares space with art about writing and letters, as if language itself were the leaves and shoots (*el monte*) of urban spaces.

One significant artwork stands in contrast to these works produced on the island. *Modelo de expansión: marabú* (Model of Expansión: Marabou, 2013) is a work by the Miami-based Cuban artist Ernesto Oroza and the Cuban-American artist Gean Moreno. It is both text-based (in the form of a tabloid printed with information and plastered like wallpaper on the wall) and object-based (in the form of small strings of *marabú* seeds). *Modelo de expansión* harnesses the plant as a symbol

not only for failed agricultural or environmental policies, but for a global capitalism and environmental crisis that cannot, at this point, be fixed or eradicated via older forms of husbandry.

Marabusal, the First Independent Intellectual Community, and Poetry's Urban Ecologies

On a small street in a nondescript, residential section of Havana's Cerro neighborhood, graphic designer-turned visual artist Samuel Riera has, for several years, run a quirky and compelling independent gallery, Riera Studio. Today, Riera Studio is dedicated to promoting lesser-known Cuban artists and Cuban *art brut*: the work of psychiatric patients, autistic children, and those who have never recovered from electric shock therapy. But Riera's own design, video, art, and poetry is striking, and his personal trajectory is also significant.

After years as a graphic designer, Riera turned to ecological art. He dates this shift to Raúl Castro's assumption of power. For Riera, the political change meant a move away from Fidel's epic scale to the more pragmatic and humble contours of national problems. It was into this newly local scale that Riera sought to intervene, creating an art that engaged insular environmental problems.

Such a scalar move is complex. Territory, like related concepts such as *terruño*, or homeland, is always paradoxically the least national of spaces, the geological bedrock or substrate onto which borders and ideologies are mapped. The Raúl-era embrace of the national, however, meant a reprieve from the positioning of Cuba as a state with primarily internationalist obligations and orientation, whether as Latin American, communist, or "Third World." Raúl's attention to more minor, local problems, in Riera's reading, facilitated artists' considerations of local communities, audiences, and ecologies.

In 2006 Riera, Lisbet Flores, and Jacinto Muñiz founded a short-lived digital magazine titled *Marabusal* (a bush or thicket of *marabú*).[10] The magazine was the visual component of a conceptual art project for which the group requested, and received from the state, some hectares of land covered with *marabú* in the province of Cienfuegos. Designed to be sustainable, the community was entitled "Primera comunidad intelectual independiente" (First Independent Intellectual Community), a

parodic riff on 1960s proclamations of Cuba as the "primer territorio libre de las Américas," or first liberated territory in the Americas. The three artists imagined a land cleared of *marabú* and occupied by solar-powered buildings and communal baths. They blueprinted the project in dialogue with engineers, historians, and scholars.

Marabusal fleshed out the details of the settlement in graphic design. The magazine's articles and images were laid out in a rough checkerboard to suggest an eagle's-eye perspective on farmland. Riera and his peers thus conjured the aerial perspectives and scale favored by 1970s Land art and the 1970s Green Revolution photo essays in *Cuba Internacional* that had documented rice, fruit-orchard and other planting projects. But *Marabusal* also registered newer, post-industrial, more sustainable aspirations.[11] According to Riera, the magazine was, moreover, an early response to reflections about the then-imminent, but mysterious, *Zona económica exclusiva* (ZEE, Exclusive Economic Zone). The authors didn't yet know, however, where the Zone might be established, or that it would make use of the port of Mariel. So on the eagle's-eye maps they playfully marked out potential, speculative zones and labeled them "ZEE." Riera claims that one of the magazine's aims was, in fact, to inform readers about the potential development. But when Riera's computer was stolen in Venezuela, where he was teaching for two years, with it disappeared the existing digital run of *Marabusal* and almost all of the community's plans. The artists abandoned both the magazine and the proposed intervention. Only a few images remain.

Now working alone, Riera next made a piece titled *Ecosol*, exhibited at the cultural center *Casa de las Américas*. *Ecosol* (also the name of an Argentine brand of solar panels) was essentially a self-sufficient system of solar energy, a response to the island's pursuit of energy independence. But to Riera's disappointment, the piece was illegible to the larger public as either art or intervention. Parts were stolen, elements destroyed, the artwork sabotaged. Riera's rueful conclusion was that Cubans, weary from years of scarcity and basic lack, were "not prepared for such environmental philosophy."[12] (The opposite might well also be affirmed: Cubans have recycled machine parts and other manufactured objects for decades.) In any case, frustrated with work on environmental systems, Riera abandoned the field for interactive digital poems and for what he named *Galería Postal* (Postal Gallery), a series of actions via the postal system that echo, apparently unwittingly, 1970s mail art, in which artists

Figure 2.1: Samuel Riera, *Primera comunidad independiente, Marabusal* magazine, 2006.

including the Brazilian Paulo Bruscky and the Chilean Eugenio Dittborn circulated paper art through the postal system.

Riera's frustration with environmental aesthetics and interventions led directly to his decision to make electronic poetry. He began creating a series of electronic visual and aural poems, moving from design into work with language, often as an antidote to mystifying official discourse.[13] He explored video art as well: *En el más verde de los campos* (In the Greenest of Fields, 2011) is a one-minute clip, transferred to digital video, from a 1980s Cuban cartoon (possibly of Eastern Bloc origin).[14] Three swollen pigs graze on a faded, pinkish background above the sentence "In the greenest of fields grazed the most rotund of pigs."[15] The piece is not only an homage to the Soviet products defining the 1980s (Riera's mother had given him this and other films when he was a child) but also a laconic commentary on the scene. Recalling the notion of an era of "las vacas gordas," or fat cows—typically used to refer to the sugar boom of the 1920s, but also to the Soviet-subsidized 1980s—the poem also invokes the more sinister figures for which fat pigs usually stand in, from caricatured capitalists to the protagonists of George Orwell's *Animal Farm*. Finally, the dissonance between the faded pink color and the description of the "greenest fields," a dissonance underscored by a

constant high-pitched harsh sound, suggests the discrepancy between official rhetoric and the immobilized reality depicted. "The grass is always greener on the other side," the video announces enigmatically.[16]

Riera merged his interests in agriculture, language, and urban circulation in a performance that he organized parallel to the 2012 Havana Biennial. He hired a few men who sell sundries from carts throughout the city to hawk the artist's own "boniato poems," tubers inked with messages, still perfectly edible when cooked. One of the sweet potatoes reads simply "*Yo estoy vivo*" (I am alive). Surprisingly, Riera was unaware of conceptual artist On Kowara's series of telegrams sent to friends and curators from around the world that had similarly announced "I am still alive," and which likewise established mere existence as poetry—in Riera's case, a living, consumable poetry.

Riera is but one of a number of artists who have moved from more hermetic visual poetry and language art into electronic forums or into the urban built environment. Yornel Martínez has also developed a delicate and intriguing body of work in this vein. *Revista P-350* (Journal P-350, 2009–10) is a series of artisanal artist-magazines, some made by Martínez, some by other artists, many produced collectively. All reuse materials and are drawn, written, painted, or composed of collages on repurposed bags that once contained P 350 Portland cement, the grade used by the military (it carries a fine if used by civilians, who are restricted to grade 250). Repurposing the bags thus puts them back into everyday circulation by artists and readers, while also raising the question of their origins. The magazines linked directly to the built environment: they comprise a writing that emerges from the city itself. Almost every "issue" mixed images, collages, and texts, but the works are more artists' books or image-based—or at least a kind of visual poetry—than they are narrative. Several feature ecological critiques, or collages made of local and imported products' advertisements, reminiscent of, say, 1970s light-hearted German parodies of "capitalist realism."

Martínez's interest in how texts are woven into everyday life was realized more publicly in a series of pieces in which he installed excerpts of poetry or philosophy on the marquees of Havana's five most famous and iconic movie theaters. The Payret Theater marquee, which faces westward towards the often blazing sun, displayed choice words from the mid-century poet Virgilio Piñera: "TODAY: The light begins to birth light." Nuevo Vedado's Acapulco Theater announced a line from Antonin

Figure 2.2: Yornel Martínez, *Cine Payret*, 2012–14. Intervention realized on the marquees of Havana cinemas.

Figure 2.3: Yornel Martínez, *Revista P-350*, 2009–10.

Artaud: "TODAY: In an eternal flight the horizons flee." And the Vedado's Yara Theater announced simply: "TODAY: Fixity [José Lezama] Lima."[17]

One of the island's most lauded artists, Carlos Garaicoa, has also been interested in translating the language visible in everyday transit through the city into art. His series *Fin del silencio* (End of Silence, 2010), exhibited at the 2012 Havana Biennial, borrowed fonts from the terrazzo lettering on Havana sidewalks, hurried over or passed by on the way to the bus, to form philosophical phrases. The series began as an idea around 2005, when Garaicoa took photographs of the pre-revolutionary signage of former private businesses that remain embedded in Havana sidewalks. Some five years later, he transmogrified the signs—simulated granite chips and all—into finely wrought, densely piled carpets produced in Belgium.[18] The tapestries, which weave in the shadows of absent passersby, telephone poles, and the letters themselves, translate the signs of the transformed urban environment into more intimate (and more rarified) phrases: "El Pensamiento" ("Thought," as if it were a department store like the mid-twentieth-century icon El Encanto); "Reina Destroys or Redeems" (Reina is the name of a central shopping street, but also "queen" and "reign"); "The Volcano Will Explode, Illuminated, We Wait," and "General Sadness Will Deny Pleasures," among other cryptic expressions.[19] Here, tessellation encrusted in the sidewalks, like the repurposed spaces of post-revolutionary architecture, sheds its commercial purpose, becoming art. The pieces also translate the public space of the street into a hallmark of the bourgeois interior. That they were produced by a blue-chip artist calls attention to the divide between everyday life and urban signs, and to their literal translation into the currency of an elite art market. In a recent interview with the art magazine *Arte Cubano*, Garaicoa asserted that the works emerged from a conviction that "the city is the ecosystem of the human being."[20]

The works of Martínez and Garaicoa suggest the close links between (urban) ecologies and text-based visual art today. Riera's more specific trajectory from design through ecology and eventually into electronic and urban poetics interweaves concerns that, as we shall see below, Oroza and Moreno also fuse. These cross-pollinating interests are frequently yoked in work on *marabú*, which has particularly lent itself to poetics.

In 2012 the Guantanamero poet José Ramón Sánchez published a poetry collection entitled *Marabú*, bookended with two thematic poems:

Figure 2.4: Carlos Garaicoa, *Fin del silencio*, 2010. Carpet: wool, mercerized cotton, trevira CS, cotton and acrylic, 286 cm x 478 cm.

"Marabú" and "El árbol nacional" (The National Tree).[21] The book that unfolds in between these two poems documents the harshness of life in the poorest part of the island. "Marabú" declares:

> I write like one who sets
> *marabú* bonfires
> Every letter a thorn
> Since innocence
> Is of little good to me now.
> (The cows who eat it
> give good milk.)[22]

For Sánchez, *marabú* is the natural landscape for his work: invasive, prickly, a terrain of abandonment—although not so for the cattle who happily chew it and spread its seeds through their excretions.

Sánchez is withering in his treatment of more metaphorical sacred cows too. In *El derrumbe* (The Collapse, or Ruination), a collection Sánchez also published in 2012, the poet rewrites a romantic couplet by the island's most famous poet, José Martí: "Two patrias have I: Cuba and the night/ or are the two one?" Sánchez turns this into a harsh line about prostitutes: "The blond and the mulatta/ or are the two one?"[23] If Martí once scribbled in his notebook the haunting, almost Adornian adage, "for a shattered life, a poetry of shards," Sánchez's motto might better be

"for a landscape of *marabú*, a poetry of *marabú*."[24] Thickets of *marabú* hide base crimes in his poem "La montaña (The Mountain)," in which a raped and murdered woman is abandoned in a cave; "The perpetrator hid/ in the marabuzales/ to the south of the city/ and they pulled him out of there with dogs."[25] No justice emerges when the culprit is pulled from the bushes, as if the *marabusal* extended beyond the hillside, beyond the cave: "Although he was a prisoner/ and bits of his skin/ were under the dead woman's nails/ he denied the crime./ Another schematic history."[26] The environs of both *Marabú* and *El derrumbe* are harsh lands, grim interiors, ugly relations, and dangerous mines (several copper and nickel mines are located near Santiago and Guantánamo). In *Marabú*'s "La roldana" (Sheave) Sánchez writes of a miner blown sky-high.[27]

For Sánchez both a devouring nature and a bankrupt social order are images of contemporary disaster. A section from the title poem from *El derrumbe* reads:

> And the Island?
> We already know:
> The Island doesn't exist.
> The corpse is an island.
> The Cosmos is dead and we
> cry at its funeral.
> A very long funeral.
> Filled with interruptions
> because they say that the funeral
> expands infinitely.
> Like a carnivorous flower
> that opens to catch its prey . . .
> That flower will not stop
> it will follow the ruination.[28]

The poem begins by scaling in and out between island and Island, from the geographic formation to the state, between a dead body, a dying island and a dying or dead cosmos. The funeral "expands infinitely." But we know it is actually the universe, or cosmos, that expands infinitely. Is the universe, then, an infinite cycle of death? If so, perhaps the funeral is not so dire after all, and is instead something like the condition of life itself.

What we might recast as an expanding *funeralverse* is likened to a carnivorous flower that swallows and outlives the *derrumbe* or ruin that, like *marabú*, is both a material reality and an allegory for decrepit infrastructure, hopes, homes. The ravenous flower is like the infinite funeral, which is, in turn, like the island. The two poetry books complement one another: ravenous plants will outlive the built environment's ruin. As the series of metaphors brings us to an image of infinitely expansive vegetation (death/island; funeral/universe; carnivorous flower/*marabú*?), we are close to the title and concept of Oroza and Moreno's *Modelo de expansión: marabú*.

Literally enclosing Sánchez's book, *marabú* both opens and closes the collection. *Marabú*'s sardonic final poem "The National Tree" (which is actually the Ceiba) addresses the questionable origins of the invasive plant in Cuba:[29]

> *Marabú, Aroma, Aroma francesa,*
> White aroma, Devil's thorn, Weyler. Dichrostachys cinerea.
> Family: lugimonsas.
> Subfamily: mimosaceas.
> From the French marabout and this
> From an Arabic dialect marbut.
> Bush or small tree
> native to Africa
>
> . . .
>
> It was introduced in the nineteenth century
> and there are various versions the lady
> Monserrate Canalejo, as an ornament
> On her farm *La Borla*, on the outskirts
> of the city of Camaguey; José Blain, in Taco-Taco,
> Pinar del Río, to study plants;
> foreign cattle (Colombia)
> brought after the Great War
> ejected the seeds after having
> ingested the fruits in their places of origin.[30]

The narrative continues on like this, less lyric poem than appropriated scientific information, with increasingly dire observations:

Once established it expands and proves
difficult to eradicate because its deep roots
sprout shoots wherever they emerge
on the surface. It destroys the natural vegetation.
Cutting or burning it augments the number of shoots.
It reproduces easily and forms impenetrable forests.
Its roots, numerous and profound, penetrate
the soil and facilitate its ventilation and their own propagation[31]

Sánchez emphasizes the rhizomatic nature of the plant (which also spreads through seeds). It is voracious, made more hardy by any attempts at rooting it out.

And yet the poem admits what some people, interested in turning the scourge into a boon, also proclaim: "It protects great areas against erosion . . . / It is used as firewood/ and is good for making coal. It fixes nitrogen in the soil."[32] With this sheer recitation of facts, both established and speculative, worrisome and optimistic, the poem sheds most indices of "lyric" poetry and approximates conceptual works of appropriation.

But what then of the title, "The National Tree," a quotidian, humorous term for *marabú*? The poem ends with the dry but oddly resonant lines: "It came to occupy more than 1,000,000 hectares:/ Ten percent of the national territory."[33] Narrated in the preterite, the poem seems to look back from a vantage of post-disaster upon the history of a deadly invasion. Ten percent of the nation has been occupied by an "alien" species. *Marabú* represents something much bigger than a mere ecological vexation.

In what way, then, does this otherwise scrupulously metaphor-free, flatly enumerative poem contribute to the widespread allegorizing of the plant? The invasion of this "alienígena" or alien species is not a metaphor for immigrants (of which there are few in Cuba), of unwelcome foreign occupations, or even for the new market practices introduced by the recent reforms: Sánchez's Guantánamo is defined more by generalized hardship than by the growing inequalities visible in Havana. Instead, the vision of the nation ceding to a scrappy, thorny bush seems to point to a kind of abandonment: of agriculture, of biological diversity, of a healthy ecology.

This specter of a rapacious plant that leaves in its wake an impoverished variety of crops recurs in the art duo Celia y Junior's video art

Efemérides Detalle #5 (Ephemerides Detail #5, 2008). A handheld video shot from a car window records the vegetation flanking the island's central artery, which runs like a spine throughout the island. The only blur of green foliage visible in the video is *marabú*; no other plants appear. The video visually echoes Raúl Castro's reproving and ironic comment in his speech of July 26, 2007 that, on a trip through Cuba's provinces, "what was most beautiful, what most stood out to my eyes, was how beautiful the *marabú* was alongside the highway."[34] Scrolling along the bottom of the screen beneath the blurred strip of unending *marabusales* runs an eighteenth-century poem lauding the biological riches of the island, in ironic contrast to the reduction of the present to *marabú*.

Celia y Junior's artworks often deal with systems: the national blood-donation system, the issuing of marriage and divorce licenses and identification cards, a map of networks of health professionals who offer specialized services in their off-hours, the digitization of all sociology dissertations produced at the University of Havana since 2001.[35] If we take *Efemérides Detalle #5* to be consistent with the artists' abiding interest in systems, their vision of *marabú* suggests something like a biological and epiphenomenal index of bureaucratic policies: specifically, an index of a poorly functioning agricultural sector. Symbolic import again prevails: the video comments on the deformation of the island's *agricultural* ecologies and economies, even if Cuba has among the richest ecologies in the Caribbean.[36]

Modelos de expansión

No work has so clearly considered *marabú* as both ecological development and metaphor as Ernesto Oroza and Gean Moreno's *Modelo de expansión: marabú*, exhibited at Factoría La Habana and again, in a slightly different form, at the Cristo Salvador gallery in September 2013. The Factoría La Habana installation consisted of an entire wall papered with Oroza and Moreno's *Tabloid #26*, subtitled *Navidad en el Kalahari (el continuo molecular)* (Christmas in the Kalahari [the molecular continuum]). The broadsheet was printed with a dense, eight-page article on *marabú*. Its cover and back page bore a repeating pattern of

Figure 2.5: Ernesto Oroza and Gean Moreno, *Modelo de expansión: marabú*, 2013. Ink on paper, marabou seeds.

exploding airplanes, cars, and palm trees from a comic drawn by Tonel for the 1980s project TelArte, a massive undertaking sponsored by the Ministry of Culture in which some 150 artists designed patterns for millions of meters of textiles.[37]

Seen from a distance, the gallery appeared to sport a wallpaper printed with nested sets of repeating disasters. The burning planes, cars, pyramids, and palm trees, viewed in light of the work's title, became forms of expansion (explosions, replications) that illustrated the artwork's subtitle: they became a kind of *marabú*, a rhizomatic multiplication in which 1980s Cuban design ran riot in the digital age. Indeed, the recuperation of a movement from the 1980s—Cuban art's most canonized moment— is explicitly avowed in the tabloid's closing lines, and asserted as an attempt to imagine design's response to the new biological paradigm of the invasive rhizome.

Oroza began as a designer, and he has long been interested in alternative histories of Cuban design. He has curated a material history of homespun inventions, many of which have powered Cuban daily life for decades. These have often been concocted as a result of periodic and seemingly overnight disappearances of necessary parts when the island's trading partners suddenly withdraw from the scene, as when pre-1961 US consumer goods were marooned by the embargo, or replacement

Figure 2.6: Ernesto Oroza and Gean Moreno, *Tabloid #26, Navidad en el Kalahari (el continuo molecular)*, 2013. Ink on paper.

parts for Soviet and Eastern European consumer goods disappeared with the dissolution of the Soviet Bloc. Oroza has collected a series of such objects that demonstrate what he calls "technological disobedience":[38] a kind of non-computational, artisanal hacking; inventions that depart from their original components to become something else in an ongoing process of "*resolviendo*" (making do), already a topic in 1980s art.[39]

Oroza is particularly interested in past moments that have resisted both free-market capitalist and state capitalist strictures. In *Modelo de expansión: marabú* he and Moreno bring a new perspective on repeating ecological disasters through their interest in a secret history of design. Such disasters begin with Columbus's arrival in Cuba and continue through slavery, neocolonialism, and the revolutionary reorganization of farmland. Research into "technological disobedience" opens up a more expansive history of how design responds to environment, moving beyond the world of manufactured objects to include the natural world.

Tabloid #26, like Sánchez's poem "The National Tree," begins with the dubious origin myths of *marabú* on the island. The French Monserrate Canalejo de Betancourt was accused of importing the plant for "decorative reasons," an important note given that *Modelo de expansión: marabú* was shown in an exhibition of contemporary Cuban design, and is interested in how the *form* of *marabú* may itself may be shaping interior design and other arts. In Oroza and Moreno's history, *marabú*'s forms of replication are born in the colonial period, yet morph into the forms of the present and future, dragging along a past that won't die.

The tabloid's origin tale begins with a scatological rewriting of the nativity scene alluded to in its title: Christmas in the Kalahari. The time is the mid-nineteenth century. A seed bounces around a camel's digestive tract, then shoots out in an explosive release. Humanity's proximity to animal life as described in the manger scene has been displaced, and the cycle of transplantation and rooting of *marabú* transpires between a camel and the Cuban soil, mediated by feces (today cattle that have eaten *marabú* are quarantined, since the plant propagates through the spread of seeds in their excrement). In a phrase that both mocks and honors the gravity of biological change on an island, the authors write that the "enormous patty of excrement . . . will change the biological course of the island forever. And it hardly needs be added that to change the biological course of an island implies the deviation of all possible courses."[40] The seed's inexorable expression seems to belie the pure contingency of the process of shit, migration, and species exchange, with seismic repercussions, since all experiments carried out on an island are both self-contained and amplified in ways not otherwise possible.

The artists then introduce the names of two related species typically grouped with *marabú*: *Aroma francesa* and *Weyler*. We already know, from the foregrounding of a quasi-nativity scene, that we are looking at a kind of fable about Cuban history, beyond mere natural history. *Aroma francesa* and *Weyler* are therefore significant. As the possible sources for the plant's transport to Cuba unfold, *marabú*—native to Africa—is described now as French (*francesa*), now as Spanish (in the form of the name of the most hated general from the 1895 war and engineer of Cuban reconcentration camps, Valeriano Weyler), and finally as an African specimen escaped from the Pinar del Río Botanical Garden. Then, on a more speculative note, Oroza and Moreno trace the seed to cattle used to feed slaves on transatlantic voyages. The authors even

suggest that the "cursed spine" or *espina maldita*, as Arabs call the plant, is a punishment for the island's nearly 400 years of slavery.

Oroza and Moreno are at pains to decode the plant as the sign of eminently political challenges, "From the concentration camps of . . . Weyler, the miseries that the War of Independence left on Cuban fields, or later the persistence of monoculture and poor land distributions, up through the more than fifty years of lands without *campesinos*."[41] Finally, they suggest that *marabú* is "the tempest. A concentrated and homogeneous force that, indifferent, erases both Caliban and Ariel."[42] Caliban, of course, is a key figure in Caribbean studies, a crude figure endlessly marshaled as a symbol of resistance to enslavement and imperialism.[43] But Oroza and Moreno suggest that we are now in a *post*-postcolonial moment, in which inequality has survived like a steadfast root, while once-cherished identitarian binaries are rendered irrelevant in an era of wholesale climatic and biological change.

Tabloid #26 imagines *marabú* as possessing a preternatural intelligence that allows it to sniff out the most propitious routes forward, apprehending totality on a molecular level, able to rush into spaces and fill them: "We are dealing with an intelligence of totality, taken in on a molecular level," the authors write, as the plant moves into new ecosystems.[44] This is a powerful metaphor for globalization and climate change, since these mutations take place on a molecular, distributed, and inescapable level throughout the planet, yet are riddled with locally specific expressions and differences. The plant also serves as an ideal image for global capital's commodification of nature: it arrives "as an index of other patterns of consumption of energy, which the invaded ecosystem cannot permit itself the luxury of emulating."[45] These, of course, are contemporary patterns of consumption expanding (like the title's *expansión*) throughout the globe, and making inroads into Cuba, without yet alleviating the island's seemingly unending deprivations. The metaphor is reinforced when the authors write that the plant understands "the new territory as a source of nourishment, as a space for extracting energy."[46]

There is something triffid-like in the artists' description of the willful plant, which attaches itself to animals, to *campesinos*' daily routes, quietly plotting its appropriation of increasing tracks of Cuban soil, where it forms new images and designs on the earth itself. The plant's unstoppable growth draws or traces (*dibuja*) the unwitting and ancient paths of the *campesino* tilling his earth—despite the previous claim that there

have been no *campesinos* in Cuba for fifty years. The artists' very language (*dibujar, dejar grabado*) points to a new aesthetics of *marabú*: the plant is changing the look of the Cuban countryside and with it, Cuban aesthetics. The new look, they propose, is something like an aerial map of the plant's migrations, aided by countless other species:

> Spirals, perfect and broken circles, crossed and tangential lines are the forms that the consolidation of a terrifying biological invasion takes on the island. Such magnitude can only return us to a historic precedent: the Spanish conquest. But the new colonization seems to come from the future, or at least anticipate it.[47]

The designs of *marabú* trace not only the invasion of the plant but also anticipate the invasion of a new colonization—"climate catastrophe"—which is at once impending but already here, already probably too late to remedy.

In their prediction that *marabú* will somehow survive us, Moreno and Oroza give the post-human a sinister twist. Their vision suggests a future anterior, a post-human planet that will survive when we have abandoned a non-productive earth to less discriminating plants. At the same time, as the tabloid's origin story suggests, this future is one that repeats prior colonizations, reminding us of the economic paradigms behind *marabú's* spread, as Cuba has turned away from sugar—itself the destructive monoculture mentioned as part of the island's dark past—towards new markets of tourism, health-care export, and mining. The liberation from a crop associated with slavery has brought new industries whose toll on the land remains to be seen. For the artists, *marabú* is both intensely local and planetary, elucidating "colonialism and class stratification, an incipient capitalism, the first globalization that develops via the 'triangle trade' (also known as the Middle Passage)," but also demanding "another modality of thought, a horizontality of multiplicities," the very Deleuzian, rhizomatic logic that the actual rhizome proves may be ambiguous at best.[48]

The recent growth of *marabú*, however, is more complex even than the weighty topics of slavery, monoculture, collectivization, lost knowledges of husbandry, and contemporary capitalism suggest. *Marabú* invades abandoned sugar fields, returning nitrogen to soil destroyed by monocultivation. It does not, for instance, take over existing forests, since the plant does not like shade. It might as easily, then, be seen as a metaphor for digging in one's heels (roots) against a "return" to

industrial agriculture, just at the moment when inputs are sufficiently in place to abandon organic farming. Or, as in Riera's piece, *marabú* may designate a land freed from both sugar and a poorly managed state agriculture, ready to be reclaimed by whoever is up to the task. Indeed, some urban youth are today "*recampesinando*," or repeasanting, moving to the countryside to work the land.[49] *Marabú* might be an index of the island's increasing insertion into international markets, of its need to revamp its agricultural sector, or of the end of the reign of sugar, which for hundreds of years radically shaped the island's landscape, as *marabú* is doing now.

Oroza and Moreno broach the inevitable comparison with the Deleuzian rhizome, casting the root system in an almost jubilant light: "*Marabú* produces an enzyme of the future, it presages the organizational codes of the future: it obliges us to speak of it in terms of vectors, of continuities, of multiplicities, of networks and infinities."[50] Present on the island since colonial times, *marabú* is also, for the two artists, the plant of the information age: "To visualize its expansion," they write, one must turn to "languages of synthesis such as cinema, architecture of infrastructures and networks, the massive production of generic objects, informational space and time."[51]

As Oroza and Moreno recognize in their claim that *marabú* refuses to remain "subsymbolic," the invasive species arrives today as a code imbued with a surplus of meaning. For the Miami-based artists, *marabú* forces its way out of metaphor into not only the ecosystem that it alters, but also the visual arts and literature, distorting or forging new patterns. Strikingly, *Modelo de expansión: marabú* theorizes, in a metacritical move, the growing concern with *marabú* in contemporary Cuban cultural production.

The authors track, for instance, the plant's increasing prominence throughout forty years of the career of the landscape artist, folklore editor, and author Samuel Feijóo, whose books, they claim, the insatiable plant began to "metabolize." Like Celia y Junior's *Efemerides Detalle #5*, Feijoo's extensive corpus reveals a more gradual but undeniable pushing out of native flora by *marabú*. The plant edges out, *even on a textual level*, earlier references in Feijóo's works to other foliage, such as:

The Barrigona palm, the white jaguey; the wild avocado, Black Witch. The genetics of the Invader, evolving in continental lands, does not find competition even in the purest literature . . . The swamp of *marabú* closes

down the visuals for the "sensitive courlis" . . . a few places remain where [Feijóo] doesn't mention it, but in others it's evident that the cursed weed stalks wells, looms over cities, strangles paths, Feijóo's narratives come apart; the endemic plants absorb, at every line, less ink than the alien species that already pierces entire paragraphs with its thorns.[52]

M arabú is now a recurring pattern in the arts. It is a vision of the "potentially infinite" beyond twentieth-century design's dreams of mechanical reproduction: a deindustrializing and futuristic expansion.[53] Hence Modelo de expansión: marabú's repeating imagery of exploding tanks and burning palms, which are borrowed from TelArte textiles but now suggest a self-replicating plant.

Art and design's renewed interest in rhizomatic forms of repetition in the environment goes beyond the singular case of marabú, certainly. Contemporary art is peppered with parallel explorations of expansion and replication, sometimes anchored in more urban environments. The young painter Luis Enrique López-Chávez's canvases based on classical Spanish floor tiles, for instance, rescue quotidian forms of repetition from a crumbling environment and freeze them in painting. The tiles themselves, like marabú, are both ancient and futuristic, derived from medieval Arabic patterns, which, it has recently been discovered, antici- pate the long-hidden structures of subatomic particles.[54]

López-Chávez photographs tiles from colonial apartments in disre- pair, in the process of being razed, or under construction, then creates paintings of their intricate, interlocking patterns. He has stated that his painting tends towards abstraction, despite its figurative ambitions, confirming "a certain rhizomatic metaphor that Gilles Deleuze proposes about abstraction. It is, without doubt, the kind of plant that cannot reproduce by seeds, but instead through parts of itself that extend continually into new lands."[55] As built patterns such as traditional azule- jos fall into ruin (derrumbe)—and are preserved in the paintings of López-Chavez—new organic patterns multiply. For Oroza and Moreno, however, this may ultimately be a sign of resignation. They see marabú as an agent that reverses an image of a picturesque countryside into a savage wild—the brutal nature of, say, José Ramón Sánchez's Marabú.

CHAPTER 3

Havana Under Water

For the 2012 Havana Biennial, Roberto Fabelo Hung erected a translucent screen alongside Havana's Malecón seawall, superimposing ghostly, digital reproductions of icebergs in a polar ocean onto the gauzy view of the sea behind it (*Aire Fresco*/Fresh Air, 2011). Through the semitransparent screen the real Caribbean ocean could be seen: contemporary Cuba as merged with the globe's polar regions, or perhaps better, the former polar regions being eaten away by tropical waters in a period of frighteningly rapid climate change.

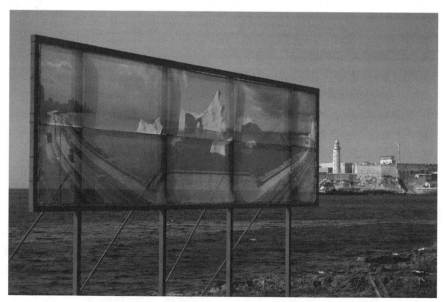

Figure 3.1: Roberto Fabelo Hung, *Aire Fresco*, 2012.
Steel billboard and digital print on mesh.

A half year later, Rafael Villares exhibited a "sound photograph" entitled *La imagen que descansa* (The Image at Rest, 2013). The viewer stares at a large photograph of a calm sea, while sounds of a storm recorded in the same spot play through headphones. The sense of a tempest lurking behind apparently tranquil waters opens up in the disjuncture between the visual and the aural. The dissonance is accentuated by the singular nature of the viewing experience, rather than the collective unease and action necessary to combat climate change. This tension between the singular and collective encounter with a changing nature is indicated by the work's original title, since scrapped: *Your Serenity Bothers Me*. Shortly thereafter, in a series of watercolors exhibited in November 2013, painter Luis Enrique Camejo rendered images of Havana as if after an extreme flood, with cars and buildings half-submerged in surprisingly still waters.

The sea has long been a defining feature, indeed an inevitability in Cuban art, literature, and life. Now it turns ominous. The placating distance of the Kantian sublime has telescoped. The ocean, that most given of givens on an island, has become an unknown entity at the heart of climate change. As environmental scientist James Hansen has underscored, "the most important climate feedbacks all involve water, in either its solid, liquid, or gas form."[1] Only two decades after Chile transported an iceberg to the Universal Exposition in Seville (1992), a gesture that art critic Nelly Richard critiqued for its patent aspirations towards whiteness (versus indigeneity), purity (versus the recent, dirty past of the

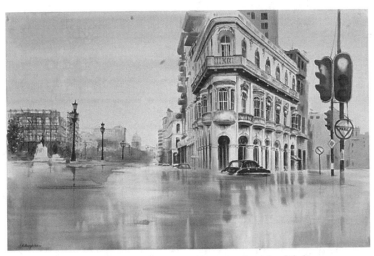

Figure 3.2: Luis Enrique Camejo, *La isla del día después acuarela #4*, 2013. Watercolor.

Pinochet dictatorship), and a neoliberal sheen that seemed to recapitulate the globalism of the 1492 celebrated at the Exposition, Fabelo Hung's icebergs in 2012 suggest quite other referents.[2]

Aire Fresco exceeds the simple pleasures afforded by art's ability to summon the impossible (icebergs in the Caribbean) since the floating chunks of ice seem increasingly implausible anywhere, reminding us of the rapid disintegration of polar caps in warming oceans. Whiteness is here less a symbol of naturalized hierarchies than a secretly essential color for the survival of the planet. For, as it happens, one of the most basic elements of art—color, or its absence—turns out also to be a basic element determining the science of our endangered future. A warming earth melts ice and snow, both of which possess reflectivity, or "albedo" (whiteness), allowing them to reflect "back to space most of the sunlight that hits them. Land and ocean, on the other hand, are dark, absorbing most of the sunlight that strikes them. If ice and snow melt, Earth absorbs more sunlight, which is a 'positive' (amplifying) feedback."[3] Vanishing whiteness from the polar caps means warmer waters, which, as they melt ice shelves, release currents of water that sunder still more ice.[4] Scientists have predicted "ice-free" summers in the Arctic by 2018, or even as early as 2016.[5]

These changes, catastrophic as they will surely be for nonhuman "nature," will reconfigure human life too. Hansen speculates that "global chaos" will be difficult to avoid as ice melt continues, and wonders where people from low-lying areas such as Bangladesh will move on to, as their lands disappear.[6] But Bangladesh at least enjoys the relative advantage of contiguous land. Cuba, on the other hand, is part of the Association of Small Island States (AOSIS), a group of some fifty small islands rapidly imperiled by climate change. As a recent study suggests, "climate departure"—the moment when temperatures in a given region will always be warmer, the coldest years hotter than the hottest years during the mid-to-late twentieth century—is likely to hit the Caribbean as early as 2023 (and the rest of the planet by 2047).[7] Some reports are predicting a global climate that will be several degrees warmer as soon as the next two years.[8]

In light of such news, another work exhibited in the 2012 biennial, Liudmila y Nelson's *Absolute Revolución: La isla* (Absolute Revolution: The Island, 2003–9), takes on a different cast. *Absolute Revolution* is a video that transposes the Martí monument from Havana's Plaza de la Revolución onto a background of waves, as if the obelisk were an Atlantis

emerging from, or descending into, the open sea. Complementing the two artists' vision of islands disappearing into the ocean is author Nuria Ordas's science-fiction novella *Entremundos* (Betweenworlds, 2010), which imagines a Caribbean future under ozoneless skies:

> Many cities had been lost forever. Of the small islands, once dispersed throughout the oceans, not half remained, and in those that did it became almost impossible to live, because the tsunamis, floods and storms made them uninhabitable. The sun had grown lethal; it caused serious and painful burns. The long-frozen icecaps had, moreover, melted in only a few years. Many territories took precautions. Building the *Frontón* [a stronger version of Havana's seaside Malecón wall] was one of them.[9]

Of course, the omnipresence of water in Cuba's cultural imagination is nothing new. The best-known Cuban poem of the twentieth century, Virgilio Piñera's 1943 "*La isla en peso*" (The Whole Island), famously begins: "The curse of being completely surrounded by water/ condemns me to this café table."[10] The obsession with the sea and with insularity persists in Cuban art.

But like the shifting connotations of icebergs, the import of these old themes is changing. A certain aesthetic crudeness or literalness seems to

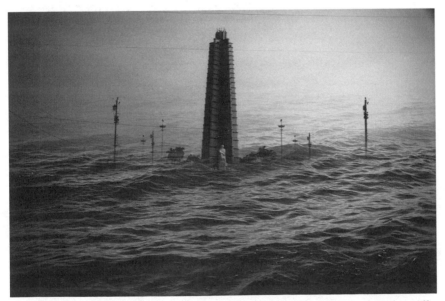

Figure 3.3: Liudmila y Nelson, *Absolute Revolución: La isla*, 2003–9. Video still.

accompany the urgency of communicating climate change (and, on a more minor scale, to accompany the rapid proliferation of biennials): the photographic series by Rogelio López Marín (Gory) *Es sólo agua en la lágrima de un extraño* (It is Just Water in the Tear of a Stranger, 1986) also pictured the ever-present ocean and pools of the wealthy neighborhoods fusing with parks, roads, buildings, in a more subtle, uncanny and effective way than some of the more recent works.

In 2013 the Cuban state removed the longstanding *"permiso de salida"* or permission needed to leave the island. Now insularity has less to do with actually being trapped on the island, or even with the Piñeraean sense of New World parochialism. It has instead increasingly to do with the fragility of coastal life in an era of rising sea levels, endangered watersheds, and development clustered around Cuba's extensive coasts: "sea and sand" tourism, with its development of formerly pristine keys, and, hovering on the horizon, deepwater petroleum exploration and processing.

Of course, many of these challenges are neither new, nor unique to Cuba. Indeed, the island has a strong history of conservation legislation, the best-conserved environment in the Caribbean and, as the region's largest island, its most important ecosystems, including the healthiest coral reefs in the Caribbean.[11] But water has been a concern, at least since the Ministry of Science, Technology and Environment, CITMA, outlined a national environmental strategy in 1997 and identified the principal problems affecting the environment, both inherited and emerging.[12] The report listed soil erosion, deforestation, and polluted inland and coastal waters as the major concerns.[13] Waters run with agricultural effluents, oil, the byproducts of mining activities, and sewage. The report adds to these more minor concerns the more worrisome "loss of coastal and marine biodiversity . . . from habitat destruction, poor fishing practices, mangrove destruction, minerals extraction."[14] Benítez-Rojo, in an article on Cuban environmental ills, painted the findings of the CITMA report darkly:

> watersheds were deforested, and their waters—contaminated by human, animal, and industrial waste—were spilling out into the bays and the coastal areas; the soils had been compressed, desertified, and salinated; garbage dumps proliferated, septic tanks overflowed permanently for lack of cleanup teams . . . water treatment plants were lacking or ill-functioning, and the industrial use of beach sand and deforestation of the coastal mangrove swamps were eroding the littoral.[15]

Benítez-Rojo sets a grim tone, though these are not catastrophic prob-
lems. More pressing now may be the effects of remodeling the Port of
Mariel. Mariel promises a new era of development with petroleum
processing, a free-trade zone, and closer linking to China and Brazil's
giant economies, but also potential problems for the littoral. Petrobras is
rumored to be planning a refinery and connections out past Cuban
waters, allowing arriving tankers and ships to avoid US embargo compli-
cations (the embargo itself may well finally be thrown over for new
business opportunities). On paper, anyway, the state appears determined
to curb the severe ecological problems posed by the port. It demands
Environmental Impact Assessments for all development projects, and
mandates adoption of the most environmentally "benign" alternatives.[16]
But it remains to be seen how stringent such oversight will be.

Afterimages of Nature

Contemporary art has been less concerned with these local chal-
lenges and more preoccupied with urgent and spectacular problems,
both far-flung and regional. Humberto Díaz, for instance, who works in
multiple media, made the striking piece *Tsunami* (2009), a giant sculp-
ture built of terracotta roof tiles that appear at once Japanese and
Mediterranean. The tiles heave and dip, emulating giant waves, after
Katsushika Hokusai's famous print *The Great Wave Off Kanugawa* (c.
1830). The rippled and uneven tiles also suggest the debris of roofs
carried away by a tsunami, like the devastating wave that hit Indonesia
in 2008, or anticipating the disaster of Hokushima in 2012. Díaz has said
that he sought to render in art the "cause-effect" relation between
humans and the environment, in order to suggest an "apocalyptic" vision
of the world resulting from industry's effects on the environment.[17]

Tsunami's variegated and undulating surface is created by the struc-
tures supporting the waves: cardboard boxes and shapes of varying
heights, designed to reproduce the miniature gullies and rises within the
larger wave. The imperfect composition of terracotta roof tiles suggests
an artisanal craftiness, rather than a computer-generated simulation. It
also suggests that the tiles are like the epiphenomenon of the underlying
structures, invisible to the human eye except in their effects: rising
temperatures, rising sea levels. The overlapping or disjunctive tiles figure

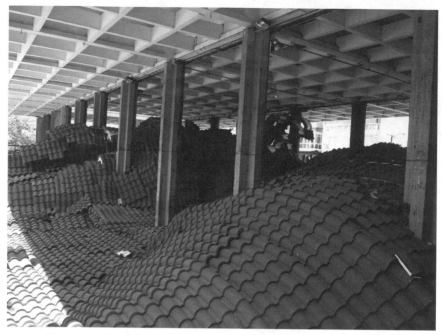

Figure 3.4: Humberto Díaz, *Tsunami*, 2009. Installation: expanded
polyurethane, paint, wood, 250 cm x 340 cm x 750 cm.

overwhelming, imminent or arrived change like a wave crashing
unevenly over us. Human-wrought "seachange" takes on local, specific
versions: the piece was assembled differently in Havana and Saint
Petersburg, for instance. In a nice, although probably accidental symme-
try, scholars believe that the wave Hokusai rendered was not actually a
tsunami but an "extreme wave" built of many small crests of waves, like
Díaz's own piece.[18]

This apocalyptic vision has been echoed in the work of the more
blithely commercial painter Camejo, whose series of watercolors *La isla
del día después* (The Island the Day After) was exhibited in December
2013. While Cuban kitsch, done right, once signaled an embrace of
popular culture and rejection of grand narratives, a tourist-oriented
version has become one option available for artists forced to turn to
markets, minor and elite. (Other options include the kind of "global
contemporary" aesthetic of which Díaz is perhaps an example, overtly
"political" art, and a recent boom in painting.[19])

Camejo's work, with its images of old cars and vistas of the city's
waterfront, flirts unironically with the aesthetic of the kind of paintings
sold in tourist souvenir shops or outdoor fairs. But it also appeals to

many Cubans interested in a legible and cinematic painting. Camejo is best known for dichromatic oil paintings of cosmopolitan cities (Havana, Panama City, Amsterdam), where he lingers on surfaces and reflections: bus windows, shop vitrines, revolving doors, railroad tracks, rainy sidewalks. In *La isla del día después #4* he widens these reflective surfaces into an ever-present watery medium swallowing up the city.

La isla del día después #4 offers a view into the heart of the city, looking upwards from Havana's majestic Prado pedestrian walk. The foreground is flooded by what must be a swollen sea and torrential rain. Yet the scene is serene, not particularly disaster-stricken: reflections on the water's surface from the buildings and streetlight poles are smooth and unbroken by any current or wind. Indeed, the scaffolding around a building in ruins—a faithful rendering of a currently existing structure—suggests the precariousness of current infrastructure *before* any natural disaster has struck. Rather than constituting evidence of a churning force of nature, the pooled water seems only one more stultifying element in a rather uneventful Caribbean capital. Still, no people are visible: only an empty car suggests human traffic. The image suggests the sinking of the city into a watery future.

The most interesting detail of *La isla del día después #4* is the spectator's implied position, either in the ocean or just beside it at the Malecón (which would presumably be submerged as well). Yet even this curious positioning seems less the painting's point than a casualty of the need to render the cinematic image that Camejo wants to push: the city's most beautiful promenade; the distant, august Capitol in the background; a colonial building opening onto the ornate warren of streets of Centro Habana; the requisite old car. The vantage is thus less about an uncanny positioning or even a sublime contemplation of nature's power than it is a filmic gaze upon post-crisis cities as we have seen them before, in countless movies (which the painting series' title also invokes), reminding us that "apocalypse" originally meant a visual revelation.

Working in this same vein, Harold Vázquez Ley's *Avistamiento #7* (Sighting #7, 2010), an oil painting from the series *Tutorial*, in the palette and style of Dirk Skreber's 2001 *Untitled* series of post-flood paintings, exploits positioning to a more canny degree. Vázquez Ley's series' title alludes to the paintings' source in an internet tutorial on how to create digital evidence of UFO "sightings." Vázquez Ley grafts images of such imaginary crafts onto other scenes that he downloads from the internet.

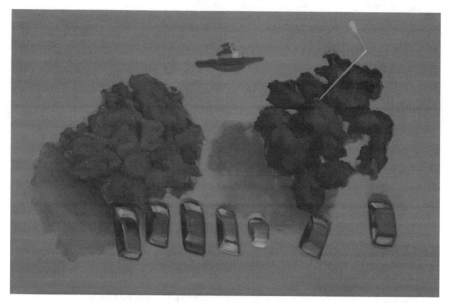

Figure 3.5: Harold Vázquez Ley, *Avistamiento #7*,
2010, "Tutorial" series. Oil on canvas.

Avistamiento #7 locates its UFO amidst what, thanks to innumerable television reports from post-flood disaster areas from around the world, is today a familiar scene of submerged cars and trees seen from above. The paintings introduce an absurd, "extraterrestrial" element into a scene whose disaster, we suspect, owes to all-too-earthly causes. Doctoring the images with the ships of fantastical beings suggests the disavowal, and externalization, of the root causes of environmental crisis—here attributed to forces outside even our universe.

Tutorial is an example of Vázquez Ley's sustained interest in the relation between art and putative referentiality. He is particularly interested in how painting and photography have responded to the internet, and in the lifespan of images caught up in its accelerated rhythms of accumulation, dispossession and circulation. Images multiply and referents disappear.

Dèmodé, for instance, is a series of oil paintings that explore obsolescence in aging icons of commercial design: clocks and furniture, rollerblades and coffee pots. To the collection of small, quotidian durables Váquez Ley suddenly adds the image of a military airplane or drone. The untitled painting, reminiscent of the work of the American artist David Deutsch, suggests how many of our most fetishized technologies

were born of military innovations or fashions. In the end, however, Váquez Ley is interested less in cycles of consumer excess and forced disappearance than in the dematerialized, representational abundance of digital images that follows material scarcity or disappearance.

Váquez Ley focuses on the changes suffered by photography, a medium whose documentary quality supplants any need for a real referent. Digital images are consumed and multiplied on a scale not previously possible. In the series *Límites de salinación* (Salination's Limits, 2010) he has thus staged geographies that do not exist, in photographs that are not photographs: Nordic landscapes of snowy pine trees; textured, aging colonial stones; hand-pixilated, newspaper-like images of baseball plays, all made of salt crystals on a black background. The collection of salt "photographs" entitled *Entropomorfía* (Entropomorphy, 2010) further explores the resonance between photography's questionable indexicality

Figure 3.6: Harold Váquez Ley, *Untitled*, "Dèmodé" series, 2010. Oil on canvas.

and its newly dubious fidelity to a world in which familiar landscape scenes no longer exist.

Photography has always captured temporal "nows" that have passed. It has often staged worlds that do not exist. Vázquez Ley's salt "photographs," however, do something different. They present a real world that no longer exists.[20]

Entropomorfía is based on older photographs that still circulate on the internet, of glaciers that have melted away. Again Vázquez Ley creates the images by arranging salt crystals. He works with salt because it approximates pixels, and because its properties connect it to entropy's principle of equilibrium. Here, however, the equilibrium he wishes to invoke is not that of some organic process of elements balancing each other out. Rather, he is interested in the balance between information and disinformation, reality and irreality, that is created by the "relative death" enabled by the persistence of aging images on the internet.[21]

Entropomorfía is important because it suggests one of the ways that aesthetics can—quite uniquely—help us comprehend a changing relation to both the material world and its digital renderings. Ecological aesthetics need not merely provide content about environmental crisis. Form and aesthetics themselves have something to teach us about our relation to "the outside world," to the "ecology without nature" that Timothy

Figure 3.7: Harold Vázquez Ley, *Cook*, "Entropomorfía" series, 2010. Lightjet print on archival paper.

Morton has called for. Vázquez Ley suggests that how we think about history and the present, material reality and images, and information and disinformation, informs how we interact with "ecology" and how we construe nature as one element of another antagonic pair, against culture.

Before examining *Entropomorfía* more closely, I want to turn to some recent theories from literary studies that help us grasp the import of Vazquez Ley's series. Recently, the critic Jacques Khalip has attempted to grapple with how poetry can help us think about environmental crisis. His work in part responds to the implicit question of why one should even worry about poetics or art when faced with species-wide extinctions, including our own. Khalip proposes that the very concepts that seem most concrete and irrefutable, most beyond language and aesthetics—concepts such as extinction—can be productively opened up through art. He finds, for instance, that the seemingly catastrophic charge of extinction still harbors within it a secret hope for redemption. The idea of extinction thus exists in part, Khalip argues, to warn us about how we may yet avert it.

But what would happen if extinction were a concept that resisted being marshaled for intervention into crisis? Can we consider ideas about time, nature, and change that would be beyond humanism altogether? In an era of radical breaks such as climate "departure"—which, according to contemporary science at least, is irreversible—we need, Khalip writes somewhat perversely, to "stop thinking of extinction itself as answerable to a before/after logic—to question how we distribute, apportion, and designate what counts as brimming with 'life.'"[22] Our most basic notions of life themselves are tied to a romantic humanism. Aesthetics that reflect on the anthropocene ought not reinstall humans at their center, Khalip argues, even if we have created the current geological epoch. Hard as it is to conceive of, our concepts of change and time must address the nonhuman environment.

Vázquez Ley's saline images of the eroded glaciers *Quilka*, *Cook* and *Del Ruiz* assume a related stance about what extinction might mean today. They offer a commentary on how representation and "ecology" (or "nature") today *both* increasingly refer to missing referents. The series is concerned with vanishing or death, both informational and material. It makes human and nonhuman death in some ways equivalent. This is a singular insight: while photography has perhaps more than with any other medium been associated with subjectivity and human death, its affinity with other kinds of disappearances has typically

received less attention. Vázquez Ley translates natural extinction of both species and their habitats into the vocabulary of photography. He uses aesthetics to process climatological events.

Subhankar Banerjee, one of the preeminent photographers of climate change today, has pointed out that while we have vast archives of human portrait photography, there have been virtually no exhibitions of portraits of animals.[23] Vanishing landscapes have fared better, but even they have not pressed photography's urgent relation to death to the degree that human portraiture has.[24]

Vázquez Ley uses photography's intimate relation to death to tie referential loss in the natural world to replication in the digital. In his work, photography not only registers something that is no longer with us, but registers the fact that absence itself produces immaterial excess. The loss of the real glacier spurs the circulation of digital records of its former state.

In the nineteenth century the deathbed photograph was meant to counteract a person's slipping away. Today the loss of species, places, and ways of life produces a retrospective archive of the recently departed. For Vázquez Ley, the temporality according to which things and beings are used up and pass into extinction extends from the rapid, artificially cycling of industrial fashion ("Dèmodé") into glacial time. The production of the former may even occasion the demise of the latter.[25]

Manuel Castells borrowed the term "glacial time" from Scott Lash and John Urry to describe an *enduring* time that links humans and nature, and stretches several generations into the future (the relation between a person and her great-grandchildren, for instance). Castells placed glacial time in distinction to clock time (that of the state, industrialism) and "atemporal time" (that of the information society, of "instant wars" and financial transactions).[26] Now the term seems poignantly dated to a recent past of less spectacular global warming, in which "glacial" connoted permanence beyond observable change.

Habana Underguater

A recent novel brings together, in synthetic fashion, visual art's images of melting icebergs, floods, tsunamis, and post-apocalyptic scenes, viewed from the depths of a rising ocean or from the vantage of extra-terrestrial aircraft. Erick Mota's *Habana underguater* (Havana Underwater)

confirms the importance of science fiction for understanding the present and near future. It meditates on the new temporality of the anthropocene, on the enduring legacy of the Cold War in Cuban imaginaries, and on the critical importance of both water and petroleum today. These ecological concerns are, moreover, processed by the strangely parallel logics of digital gaming and the Afro-diasporic religions sometimes referred to as Santería, and which, like computers, are dependent on binary decisions.

Habana underguater takes place in a futuristic, post-apocalyptic Havana. Half of it is now under water (*underguater*) in the wake of a massive hurricane. A group of hackers and internauts of the "Red Global," or Global Net, are on the hunt for a missing peer and traitor whose avatar is Rama, known in real life as Juan. Rama has stolen an *ebbó*, an *ofrenda* or offering, from the virtual altars of the Orishas, incarnations of the ancient West African gods still worshipped in the Caribbean and Brazil. In Mota's novel the Orishas dwell within and govern the netherspace of the Global Web.

Like contemporary video games that trace their roots back to postwar role-playing games such as Dungeons and Dragons (in turn influenced by J. R. R. Tolkien), *Habana underguater*'s plot derives from a simple quest structure. A clan of *santeros,* or Santería priests, has hired the novel's protagonist, a hitman named Pablo, to kill the thief.[27] To recover the offering, Pablo teams up with Pedro, a soldier for an Abakuá society, the secret society founded in Cuba in the 1830s as an heir to the Ekpé or Leopard secret societies from Nigeria's Cross River region.[28] They are joined by Miguel, a magician ("el Mago") and his three daughters, as well as Ravana (online avatar of a character named Carlos), onetime friend and now a rival of Juan/Rama.

The object of the book's quest is in some ways what Alfred Hitchcock called a "McGuffin"—a stolen jewel or some other such relatively dispensable excuse for a plot. McGuffins can also serve as objects knitting together histories. Similarly, Fredric Jameson has argued that capturing historicity in narrative requires a trick for rendering a time frame beyond the biological limits of any individual human—a kind of species-time, perhaps even an inhuman time.[29] Such a *longue durée* forces narrative to invent means to translate vast spans into smaller human scales. This, Jameson argues, is why stories use "lost objects" as Lacanian "quilting points" for History: "A birthmark, a tell-tale word," and other convenient

signs become palpable evidence of the invisible time that exceeds the briefer, individual, human story.[30]

Eventually the protagonist of *Habana underguater* finds the *ebbó*. Rama—in Hindu tradition the perfect human, making Rama both an ancient but also *future* New Man—examines the offering and concludes that it is "just a map of a route, a hidden destination in the Net."[31] The "stolen object" becomes a map of the networks, a single object quilting together a web of relations. The stolen *ebbó* serves as a lost object that holds together the trans-temporal, fantastical narrative, and restores the realism of a terrifying future that may await Cuba and the planet.

Like many science-fiction novels, *Habana underguater* must flesh out its locale. After a period of "anarchy" following a massive hurricane that sunk the capital and spawned a "15 Day War," Havana has been divided. To the north lie autonomous neighborhoods where private armed forces settle matters of state. To the south lie peripheral zones where "the true Autonomous Havana" has been established, ruled by its own urban codes.[32] These halves, in turn, have been divided into five semi-autonomous, warring zones, several of which are under water and referred to as *puebloshundidos*, "sunkentowns."

Mota's city both is and is not contemporary Havana. Like the real Havana it is in post-Soviet ruins, although in the novel some neighborhoods have fully sunk into the ocean. Existing neighborhoods such as Centro Habana are complemented by invented ones such as *Ciudad Reggae*. A "Corporate Miramar Zone" mirrors the actual 2014 opening of the Zona Económica Especial in Mariel, while also nodding to Miramar's status as the center of Cuban and foreign-own businesses.[33] (In the novel Mariel is the site of a nuclear-energy reactor.) Apartments are holdovers from the Soviet style, their doors and windows eroded by saline air. Many of the inhabitants of this Havana choose to live far above the waterline in the shells of abandoned buildings, while gangs maraud through empty halls, looting and sacking abandoned furniture and consumer goods.

Sovereignty is distributed across a number of wealthy churches that control petroleum platforms in the Caribbean; a recent set of Holy Wars has seen Spanish marines attack Protestant Corporations. In an inversion of *balsero* or rafter crises, a character escapes Miami on a raft headed to Havana, evading sharks until she is saved by a patrol that protects the Jehova Witnesses' petroleum platforms. The "Malayocoreano-japonesa"

(Malaykorean-Japanese) platform, meanwhile, supports a pan-Asian and Brazilian manufacturer of military paraphernalia. Mota's vision extrapolates forward Brazil's growing economic importance, and builds on speculations that its remodeling of Mariel was designed to facilitate trade with the Pacific rim.[34]

The "ex-capitalist" United States has, meanwhile, disintegrated into warring militias sprinkled across places such as "Old Texas" and "Mexicocalifornia," and, in a comic compounding of prefixes, "Little Old Washington"; its lands are now radioactive.[35] The tattered remnants of the United States evince its ugly self-destruction through violence. And since climate change is the direct result of industry-led economic growth— both state and market-driven—changing weather becomes a natural history of developmentalism: indeed, "North America is extinct."[36]

The novel probes the nature of sovereignty. Mota's Havana amalgamates several contemporary authoritarian institutions: hierarchical and strictly masculine secret societies, as well as market, state, and carceral regimes. It creates a pastiche of all four forms, borrowing from US, Soviet, and Cuban versions. Viejo Alamar (presumably on the site of the existing housing complex Alamar) enjoys a peace otherwise associated with the "Russian" times (the KGB are still—or again—operative). Now, however, the peace is assured by the protection offered by the Abakuá Foundation, with its own laws of "zero tolerance" established by the *ñáñigos*, out of sight of the mercenary FULHA, or Fuerza Unida de la Habana Autónoma (United Forces of Autonomous Havana), and hidden too from the private police of the Marianao ghetto. (FULHA is a homonym of "*fula*," Cuban slang for dollars. The term *fula* allegedly dates back to slavery, when traders gave problematic slaves this name—perhaps a reference to the Fula or Fulani people. The word came to mean something illegal, and was attached to cash in the early 1990s when the US dollar was criminalized.) The novel's air of pananoia is comic, and rather than allegorize contemporary forms of repression, it paints a dystopic future as pulp fiction.

Habana underguater riffs on an isomorphism between religious regimes and the control of resources, property, and money. The Catholics have their own private army and constitute a "Corporación Unión Católica," the Catholic Union Corporation, or CUC—also the acronym for one of Cuba's two forms of currency, equivalent to the dollar, in distinction to the Cuban peso (the two are currently being melded into

a single currency). There exists, naturally enough, an "Archbishop of the CUC"—the Vatican, too, has been privatized.[37]

These sketches of alternative forms of sovereignty are for laughs. But they also suggest serious and subtler forms of rule. For instance, the digital logic of the now virtual Regla de Palo (which, along with Regla de Ocha, is one of two dominant forms of Afro-Cuban religion), is a different kind of "rule" (*regla*) from that which organizes corporations in a post-state landscape. The Orishas comment at one point: "The problems of the corporations are not the problems of the Regla de Ocha."[38]

Beyond these speculative political economies, *Habana underguater* takes pains to provide the reader with the more quotidian details of the future city. It imagines precarious and ad hoc information networks that seem still more futuristic in contrast with contemporary Havana's minimal digital infrastructure. Instead of only seeing these as futuristic fantasies spun from "underdevelopment" or simply the lack of internet connectivity, though, we might read the novel's descriptions of technological resourcefulness as prescient. The imagined inventions anticipate a shared future that will rely on simultaneously technological and rudimentary means in a climatically and politically chaotic reality. A character named Santiago who "had to invent to survive" adapts Japanese connectors to Russian circuits, sets crowns for teeth, recovers information from burned disk drives, carries out organ transplants, and so on, at one point agreeing to forensically identify a corpse for a promise that he can repossess its fillings for future dentistry.[39] Like Mota's characters, we may all, in the future, have to attend to broken bodies and technologies alike, wetware as much as hardware or software. While parodying difficulties of the Cuban present, the novel's fusing of the futuristic and the archaic in the novel also predicts a future that only exaggerates a present that, as Bruno Latour claimed, has never been as modern as it imagines itself to be.[40]

Habana underguater does not always aspire to diagnostic verisimilitude, however. The fact that much of the action takes place in an internet designed as if it were a video game yields an aesthetic in which buildings thrust skywards "like a drawing by Frank Miller," the well-known, politically reactionary comic-book illustrator now infamous for impugning the Occupy Wall Street movement. Clouds appear as if painted by the French academic artist William Bouguereau, and a simulated sky recalls the Sargent-like Spanish painter Joaquín Sorolla Bastida.[41] Describing a Global Web run by Orishas, Mota notes that "the rest of the cubo-web had been programmed

Figure 3.8: Rewell Altunaga and Yusnier Mentado,
Havana Strike, 2007. Modified video game.

with the intention of reproducing a fragment of the Hamel Alley in the Havana of the late twentieth century."[42] A traditionally Afro-Cuban neighborhood (Callejón de Hamel, in Cayo Hueso, Centro Habana), which is often marketed as "folklore" to tourists, has been accurately understood as a staging, here captured and reproduced as a setting for a game.

Picturing Havana as the post-apocalyptic setting for a video game is not entirely new. In 2007 the artists Rewell Altunaga and Yusnier Mentado modified the video game *Counter Strike* for a performance they named *Havana Strike*, basing their intervention on one of the original game's settings in Havana. The performance consisted in creating an impromptu trailer for the imaginary film *Havana Strike* out of a *Counter Strike* game between the two artists/players. The art game/trailer unfolded in real time and was projected onto the screen of a provincial cinema. These pieces return the animation of live players and unpredictable outcomes to a setting that threatens to ossify as a mere curio for players elsewhere.

An Afro-Cuban Futurism?

As his treatment of Hamel Alley glancingly suggests, Mota's novel reintroduces African and African-descended histories into a largely white genre. The novel also adapts current Abakuá practices to a virtual environment, but eschews turning the Orishas into some emancipatory

pantheon. Abakuá deities, from their home in the Net, protect those humans that do their bidding on earth. As in existing African-derived Caribbean religions, these spirits sometimes "mount" the minds of humans to realize actions in everyday life.

Mota's Orishas are shadowy figures that occasionally descend from the Net into material life, donning "mimetic suits" to impersonate humans.[43] The notion of immaterial gods impersonating humans is part and parcel of science fiction's staple musings on a future in which humanity's robotic creations eventually control us. Rejecting servitude to a god, or anyone, one character announces "I won't be the 'horse' for anyone here or outside [the Net]. What do you think, that for so little I would let myself be possessed through the wireless network like an automaton?"[44]

The specter of a new enslavement in *Habana underguater* takes the still more specific form of a mutinous branch of AI (Artificial Intelligence). These rebelling AIs are the second-generation progeny not of humans but of a now-extinct Artificial Intelligence. Its descendents seek an independence that "almost ends in revolution." Another character reflects that robots "programmed by the KGB" seem to serve a kind of slavery.[45] The quotation suggests continuity between the island's past of racialized slavery and a post-human future of robotics. We've already been there, Mota suggests: we've already seen humans turned into servile robots under racialized, neofeudal regimes. The past of Atlantic bondage threatens to return in a networked, information-age enslavement.

Mota's novel also brings back the longstanding association between colonialism and fantasy and science fiction. If science fiction has been read as a genre with roots in colonial exploration narratives, *Habana underguater* reminds us that Cuba is a place indelibly marked by a colonial past.[46] Although Mota's protagonists are African-descended Cubans from Centro Habana, the author abstains from folkloric caricatures of black urban culture of the kind that is regularly pitched to tourists. The novel does not explicitly name the ongoing economic inequality that unduly affects black Cubans. Yet it alludes to a biopolitical control of populations and creation of "undesirable" groups: entrance into the autonomous neighborhoods, for instance, requires that retinas be scanned, a security measure that is applied to all those who come from Centro Habana.[47]

The novel's soldering of Afro-Cuban religions to a digital future—an Afro-Cuban futurism of sorts—passes through the binary logic of

Santería.[48] In *palo* religions, priests produce information by adding up the results of a series of binary choices, recorded as 0s and 1s. These procedures facilitate Mota's depiction of the Orishas as digital coders, in lines such as "Every Orisha codifies his offerings following differently encrypted algorithms. And no one decodes an Orisha."[49] Here West African religions update "ancient" knowledge in a near future, again suggesting how cultural forms considered ancient or archaic might well be the keys to surviving an increasingly apocalyptic future (or present). Elegbara, historic deity of the crossroads, becomes "he who opens and closes the paths in the Net."[50]

Private armies like the FULHA contend with guerrillas, "*babalawos, hackers o abakuás*," making computer hackers equivalent to the high-ranking members of Ekpé or Abakuá-derived codes (Abakuá or Santería priests). In *Habana underguater*, "if you infringe on an Abakuá code, you'll be killed."[51] The openly political theology (or openly theological politics) of this near future, in which warring religious sects are simultaneously giant, petroleum-supported corporations, furthermore reminds us that religion, too, is a form of coding information.

After the *Ciclón*

The backstory to *Habana underguater* emerges only in fractured pieces. A giant hurricane (*el Ciclón*) has spawned massive migration and overcrowded neighborhoods. Hurricanes are a resonant figure in Caribbean history and literature, where powerful storms have long shaped cities and landscapes.[52] One of the most visible and experiential effects of global warming is indeed the increasing strength and frequency of hurricanes.[53] In this, too, the region's past becomes oddly fresh again: Cuban science fiction began in 1920 with a novel about manmade climate change produced by redirecting the Gulf Stream; today a weakened Gulf Stream has been detected.[54]

It is, then, entirely significant that the minor apocalypse preceding the novel's present was "the Hurricane of '16." The figure of the cyclone taps into both atavistic, biblical flood narratives and intensifying, contemporary weather disasters. After the Cyclone the Russians departed for the moon, leaving the Cubans to "eat the cyclone" ("jamarnos el Ciclón"): an allegory for the evaporation of Soviet economic support. If

Habana underguater takes place in a post-Soviet period, it is also a post-industrial present. The *Ciclón* was named "Florinda," vaguely suggesting some massive invasion from Florida—like the novel's reverse wave of *balseros* seeking refuge from Miami. The wealthy neighborhood of Miramar, currently home to many businesses, sports "industrial ruins" that surge up like "the old bones of a giant."[55]

The *Ciclón* has brought about a new everyday. The sound of waves is a permanent soundtrack in the narrative, again as if the novel were a multi-media game. In the first few pages "waves beat against the half-submerged buildings. An infinity of algae, urchins and crabs occupied the interior floors awaiting high tide."[56] As the story proceeds, the sea assumes the myriad and opposing connotations variously ascribed it: freedom and fence, life source and grave, horizon and depth, site of electrifying hurricanes and of numbing boredom. But it now takes on the "law of the jungle" mentality that accompanies the wildcatting of the earth's last nationless space. The waters are both overfished and overregulated: "when Underguater belonged to Centro-Habana, and the Regla de Ocha was in control, things were better. The santeros didn't care about our fishing."[57]

Today, rising ocean temperatures threaten Cuba's fishing industry. In the novel, the sea is privatized and fought over.[58] Mota paints a sea studded with embattled fishermen:

> Small polymer and rubber rafts floated in the blue of the deep waters. The fishermen drifted beyond the security limits. Almost at the horizon, the extractive platforms flew the logos of the Catholic Union Corporation and the Jehova Witnesses. Some *FULHA* helicopters criss-crossed the sky, like great black birds, in the direction of the cosmoport of Old Havana.[59]

In the context of battles for the sea's riches, the sound of lapping waves passes from connoting a peaceful if elegiac swallowing of industrial ruins, to the insistent tune of new battles over possession and extraction:

> The sound of the waves breaking against the coast arrived from the north. The waves flowed between the buildings of the *sunkentown* to die at the Camilo Cienfuegos pedestrian jetty ... The fishermen's boats blinked their Chinese lanterns in Morse code, in the eternal exchange with the Jehova Witness platforms about the price of fish in *Underguater*.[60]

Underguater is ground zero for the embattled private armies, a "war zone" to which *santeros* have blocked all access.

The question of what "possession" may look like in the future—real, virtual, or somewhere in between, as in the case of the *ebbó*—is suggested by Mota's figuring of the seas as the terrain for such disputes. The battles in the background of *Habana underguater* between fishermen and those regulating fishing rights and prices are located offshore in disputed waters, as they were in the early modern age of expanding European empires. Hugo Grotius's seminal *Mare Liberum* (Freedom of the Seas, 1609) argued, in its self-interested quibbling with the Portuguese Empire over "discoveries" in Asia, that to *discover* meant more than merely *seeing* something. The latter might be a theoretical possession, perhaps, inasmuch as 'theory' comes from the Greek θεωρία, looking at or beholding. Instead, Grotius believed that discovery meant "to take real possession thereof . . . [F]or that reason the Grammarians give the same signification to the expressions 'to find' and 'to occupy'" in situations otherwise deemed *res nullius*, to belong to no one.[61] Mota anticipates the reactivation of these debates as overfishing and petroleum extraction exhaust existing resources.

The ocean thus becomes, at the novel's end, more than the mere site of resource squabbles. It becomes a cipher inscribed with the ontological changes facing the planet. It is also the key to unlocking the inner truths of the Orishas, the open sesame to a sphinx-like query from a god to a young female combatant intent on surviving her encounter with the spirit. The question asked the young warrior is precisely *what the sea is like*. For the sea, apparently, is a medium that the Orishas cannot experience or describe accurately. It is a figure for the earthly real beyond the reach of the Orishas, who are "not of this world. Neither the real nor virtual one."[62] If the girl cannot answer correctly, the Orisha posing the question will be able to possess her like a zombie, mounting her at will for the rest of her life as a conduit to the human world.

But the disquieting truth behind this narrative climax, which otherwise feels somewhat contrived, is that what we once took to be fixed truths about the climate and the ocean no longer hold. *What the sea is like* is no longer just a fairy-tale interrogation, but an actual unknown. The girl's answer is a lyrical description of the lapping waves in *Underguater*. It might also be a realistic description of "normal" hurricane season in present-day Havana, when the water often flows many

blocks into the city, and well up to Fifth Avenue in the Vedado neighborhood:

> When the horizon is black and the rain's mist falls in the distance, the waves reach up to the remains of houses and slap at the facades like a clutch of crumbling saltpeter. The waves course through the streets, over-spill the old sewer system and make waterspouts in the middle of avenues. You who have travelled through the net, tell me whether, from consoles everywhere, one can hear the roar of the sea like a hungry animal, feel its warmth as a lover in heat . . . You are a prisoner in your ocean of binary pulses, just as are we, outside it.[63]

In this nostalgia for the real against the digital, an "oceanic feeling"—which Romain Rolland, in a letter to Freud, said described religion's sense of the eternal—is both a test of humanity and, sadly, circum-scribed.[64] The ocean threatens to spill over banks, to swallow cities, to devour like a hungry animal. But it is also overfished, privatized, and inaccessible to those cordoned off in a virtual existence. In *Civilization and its Discontents* Freud borrowed Rolland's oceanic feeling but likened it to a line from a play, "we cannot fall out of this world": in other words, we are all a part of this world, for good.[65] In Mota's novel, an oceanic feeling is grasped at as the last tie to this world, even as global warming changes it.

Post-Panamax Energies

Located about an hour's drive outside of Havana, Hershey is a model town built by Milton Hershey in 1920. Its sugar mill, renamed Camilo Cienfuegos after the revolution, closed in 2002. If you ask the town's inhabitants what they now do for a living, most will answer that they have turned to agriculture, to low-budget tourism, or to work in the oil fields of Boca de Jaruco. As the island abandons sugar, it turns to the coast and sea for its new economy: tourism, oil processing, and the port of Mariel.

Oil is central to this oceanic turn. The bulk of the world's richest deposits border seas.[1] The Caribbean claims just under half of the hemisphere's crude oil production, and possesses more than half of its refining infrastructure.[2] As readily available oil reserves dwindle worldwide, companies turn to those under the ocean floor, previously prohibitively difficult to access. In a rush to access remaining resources, the oceans, as we saw in the previous chapter, are a last frontier, with deepwater drilling the latest stage in extraction.[3]

Energy independence has become a central concern in Cuba, as elsewhere. For environmental activist Vandana Shiva, "energy," in a mechanistic vision of nature, means "the capacity to do work." But machines requiring fossil fuels increasingly do our work.[4] We tend to think of energy, and especially fossil fuels, as sheer potential; concentrated power. But these forms of energy, intended to free up "life" from grueling "work," have subsumed life through their climate-changing effects.[5] Today, Matthew Huber has argued, "the real subsumption of life to capital is actively powered not through muscles though but fossil-fuel

combustion."[6] Cognizant of energy's central role in organizing life itself, art and literature comprehend and represent this almost Spinozan power circulating through and powering the world.

The Cuban artist Edgar Hechavarría has repeatedly worked with questions of energy: both the kind animating art and the kind that is harnessed for production. Investigations into chromatic power underlie his series *La causa de muchas cosas ocultas. Espectro* (The Cause of Many Hidden Things. Spectrum, 2007), sets of red, blue and yellow overlapping squares, circles and triangles painted on grey cloth backgrounds. Drawing on the nineteenth-century discovery of primary and complementary colors, and updating Piet Mondrian's *Composition with Red, Yellow, Blue, and Black* (1921), Hechavarría's series of colors highlights the building blocks out of which color complexity emerges. Hechavarría is after the productive power of color, something like what Deleuze termed "color-force": how color makes visible different forces.[7]

When the cloths were hung in Havana's Galería Servando they formed passageways that guided viewers between the elemental colors and shapes. Secondary colors emerged in luminous form—red and yellow light bouncing to create orange. Hechavarría's interest in directing traffic resurfaced in *Nube* (Cloud, 2003), an immense black cloth hung from the roof of the Centro Hispano Americano, sited along the Malecón, as well as in *Rompiendo barreras* (Breaking Barriers, 2003), lines of yellow dividers like overturned yellow bowls that directed spectators though a winding line, like the kind that divide lanes of traffic.

Hechavarría combined his interests in flows of energy, both optic and productive, in a series of works on wind energy and shipping containers. *Energía* (Energy, 2006), exhibited at the 9th Havana Biennial, directed participants through a series of turnstiles. Behind them Hechavarría projected an image of windmills generating power. The artwork moved people through the show in parceled-out numbers, reminding spectators that we are all moved and controlled by the generation or absence of energy. The spokes of the turnstiles and, on the screen above them, the eolic (wind) mills mirroring them, were militaristic, suggesting airplane propellers. On the one hand, the piece alluded to new forms of harnessing energy. On the other, it cast the apparently cleanest and most pacific source for energy-capture or generation as a vaguely bellicose act. But against whom?

When the piece was made, the migratory reforms that would eventually allow all Cubans to leave the island without receiving an exit permit

Figure 4.1: Edgar Hechavarría, *La causa de muchas cosas ocultas. Espectro*, 2007.

were still seven years off. The spokes could thus be seen to mete out exits and entries into the island, as sketches towards an unbuilt project, *Memorias* (Memories), part of a realized series entitled *Apuntalando* (Shoring Up, 2008), confirm more explicitly: in manipulated photographs, giant turnstiles are stationed in the ocean just past the Malecón, as if they were oil derricks, container cranes—or, indeed, giant turnstiles, determining circulation. In the space of the biennial occupied by *Energía*, participants passed cheerfully through Hechavarría's turnstiles. A logotype in the top-left corner of a poster for *Energía*, enclosing the initials of the artist (who had previously belonged to the collective Enema), aped marketing design, suggesting a subconscious guiding of the masses. The swirling blades/spokes seemed not only a source of control, but also an image of the powers that move the contemporary world: energy and markets, including art markets, circulating capital.

If windmills are built to attain energy independence—the piece seemed implicitly to ask—is the goal of the Havana Biennial still that of producing the artistic independence from art markets and habitual curatorial axes that was its goal when, in a pioneering move, it was first established in 1984? Or is the biennial now better characterized by its

Figure 4.2: Edgar Hechavarría, *Energía*, 2006. Installation.

insertion into such markets?[8] Marianela Orozco updated some of these questions for the 2012 Havana Biennial with her piece *Playtime* (2011), which planted a field of windmills—or better, human-sized pinwheels— in the concrete by the Malecón, where the pinwheels spun for pure, childish, useless fun, as opposed to serious, eolic production.

The sociologist Alberto Toscano has recently argued that while in the nineteenth and twentieth centuries production and consumption drove global markets, today the global economy is propelled by circulation.[9] For Toscano, the sea, and containerization, have therefore also become privileged spaces for *redirecting* the power that courses through them.[10] Hechavarría's interest in circulation and the sea derives from a similar hunch. His hypostatization of circulation in *Energía* and *Memorias*—a circulation that, again, was limited for Cubans circa 2006—stands in contrast to unremitting, fixed, basic needs, energy among them.

Hechavarría built on his interest in flows into and out of ports in a second version of *Espectro* (2007) and in *Elemento contenedor* (Container Element, 2009). *Espectro*'s earlier version, as we saw, featured cloths painted with primary colors. The same red, blue, yellow, and black pigments were then brilliantly lacquered on four large shipping containers

Figure 4.3: Edgar Hechavarría, *Memorias*, "Apuntalando" series, 2008.

exhibited at the *Fin del Mundo* Biennial in Patagonia, Argentina. Hechavarría also planned a project called *Contenhenge* (Containerhenge), a circle of containers in the style of Stonehenge, to be erected in a Havana park, as well as a sketch of a *Spiral Jetty* made of containers in the bay.

Containers are a crude reminder of the material basis for the speculative capital associated with the post-1970s global economy. Even as finance capital drives markets, today's economy arguably continues to circulate more things about the world than ever, in an intensification of the earliest mercantile era of encircling the globe. These unassuming vessels for goods are also used as humble, protean spaces for everyday living. One needn't revisit the long list of artists and architects who have

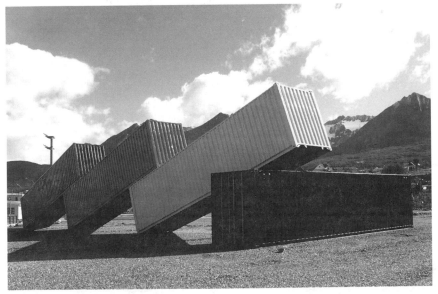

Figure 4.4: Edgar Hechavarría, *Espectro*, 2007. Installation.

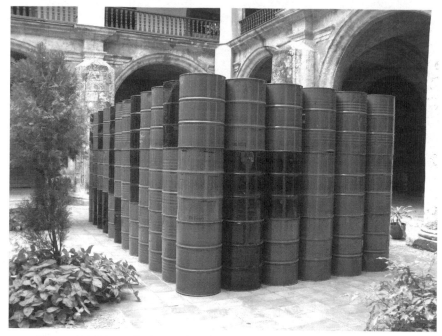

Figure 4.5: Edgar Hechavarría, *Elemento contenedor*, 2009. Installation.

worked with containers as symbols or repurposed living spaces, but merely, as Hechavarría has noted, look around the neighborhoods of Havana to find slightly damaged containers, purchased on the cheap, serving as construction-site storage and any number of other ends.[11]

At Argentina's *Fin del Mundo* Biennial, Hechavarría's containers blocked out, in simple lines, a set of colorful geometric "mountains" positioned before the backdrop of the dry peaks of Patagonia. Patagonia was once truly the end of the world for sailors familiar with more northern Atlantic routes. But recent Argentine fiction has seized on the polar region as a symbol of the same conquering impulse that, since the early modern period, has enabled environmental destruction.[12] Containers— and biennials—at the *fin del mundo* suggest that commerce not only now arrives at the end of the world, but also hastens it.

Post-Panamax Mariel

In 1980, over a period spanning roughly six months, an estimated 125,000 Cubans left the island via the port of Mariel in a boat lift. Emigrés were picked up by family members and others living in the

United States. Cruelly depicted in the US and Cuba alike as "escoria" or scum, the emigrants were stigmatized by organized repudiation acts in Cuba, while US media produced a new, unsavory depiction of Cuban exiles. A language of "counter-revolutionaries," homophobia, and hatred on one side, and of freedom, political persecution, and rescue on the other, dissolved into a mutual disdain for what was portrayed as a more lumpen, poor, gay, brown, and criminal emigration processed in detention centers, then scattered throughout the United States.[13] The first wave of departures of Cubans in the early 1960s produced images of a nattily dressed white bourgeoisie departing for Miami that open Tomás Gutiérrez Alea's 1968 film *Memories of Underdevelopment*. "Mariel," on the other hand, yielded the bitter, baroque, nightmarish visions of writer Reinaldo Arenas, for whom, if Cuba was one kind of hell, Miami was simply another, and New York City a fleeting space of freedom, until AIDS arrived.

For Rachel Weiss, the 1980s New Cuban Art unfolded in the wake of the "national trauma" that was the boat lift.[14] The artist and critic Tonel has argued the opposite: that a renewed art scene was well underway in the 1970s, hence "not a direct result of the traumatic spectacle of the Mariel boatlift."[15] In any case, if Mariel entered history as a spectacular (inter)national trauma, and either set the tone for, or colored, a new generation of artists, it shaped a lesser-known aesthetic moment too. The short-lived, New York-based magazine *Mariel* (1983–5) was formed by "marielitos," writers who had left Cuba during the boat lift. Its editors included Reinaldo Arenas, Juan Abreu, Reinaldo García Ramos, and René Cifuentes. *Mariel* published eight issues over two years. The magazine often fully engaged the shrill rhetoric of the Cold War. Yet it also attempted to stake out a space beyond such discourse.

Evincing both tendencies, *Mariel*'s inaugural issue essayed a new relation between aesthetics and politics: the magazine advocated for an art that would be neither state propaganda nor capitalist product. The editors argued that whereas in perfect totalitarian societies art was doctrinaire, in capitalist societies it was mere commodity.[16] Under capitalism, the editors claimed, artists cease to be "creators" and pass into the realm of "producers." Yet they also wrote "there is no such thing as a mercantile art, as there is no such thing as a doctrinaire art": "Every artwork is a challenge, and as such, implicitly or explicitly, a manifestation—and a song—to freedom."[17] Genuine art for the editors meant a

space of freedom beyond ideologies. (The charged concept "freedom" was naturalized.)

Most of the first issue's articles meditate on the condition of being a *marielito*, and on connections between Mariel and Key West. But the issue also includes the poem "Aguas" (Waters), by the poet Delfín Prats, who spent time in a labor camp (the notorious UMAPs, or *Unidades Militares de Ayuda a la Producción*, Military Units for Assisting Production) for being gay. "Aguas" is principally about a love affair. Yet it also reflects on water as a flow of various forms of energy: "Not happiness itself/ But the pleasure of contemplating the circulating waters," the poem begins: a diminished or deferred happiness reduced to the modest pleasure of movement, circulation.[18] The flowing waters are "much more valuable" than the beautiful and absent (*marielito*?) youth to whom the poem is addressed. A gloss on value follows, flowing like a rivulet to the ocean, or a wave sinking after its crest. A list of other equivalents into which water translates follows: figure, coin, energy, cash, shadow, darkness. The waters are

> Incalculably more valuable:
> figure
> money
> energy
> cash
> shadow
> darkness
> The waters escaping towards Leonero,
> Escaping towards the sea.[19]

Here and in other pages from *Mariel*, water is alternately freedom, sexual explosion and a liquid bathing the wound rent by separations suffered between Mariel and Key West, between exiled authors and friends and family on the island. But it is also power, energy, value, money. The pleasure of movement, of change, and of becoming, named as "circulation," and indeed of water as life-giving element, opposes capture.

If Toscano finds capital's dominant mode today to be that of circulation, he also argues that this contemporary privileging of logistics was anticipated more than a century ago in *Capital*'s second volume.[20] There Marx observed that the circulation of commodities turns into an entire

industry—that of transportation—which forms its own kinds of production, even as its "distinguishing feature is that it appears as a continuation of a process of production within the process of circulation and for the process of circulation."[21] Indeed, producing and shipping forms of energy in order to continue producing and shipping has, at times, made up the bulk of what container ships move: Timothy Mitchell documents that in 1970, oil alone "accounted for 60 percent of seaborne cargo worldwide."[22]

This is probably not the circulation that Prats had in mind in 1980, though he certainly perceived that the lifeblood of island economies (and of sexual exchange) is fluid. Still, he saw the power of water, and the cover of darkness, as a significant force, simultaneously a means of transportation and a good. What, during the boat lift, was still linked in the US to a Cold War logic of "containment" of an expansionist USSR, has today given way to what the logistics industry calls "containerization." The drive is now to extract, process, and ship, in order to build economies that can further extract, process, and ship.[23] Cold War "containment" sought to limit the expansion of communism. Today all states seem to seek increasing containerization, to ship the greatest amount of goods at once.[24]

How will poets write of the new Mariel? Will they write about the Special Economic Zone? Will they update Prat's libidinal flows? Will they, like Hechavarría, thematize containerization? The economic promise of the new export-processing zone may overwrite the pain associated with the boat lift, as well as the anti-"containment" ethos in the work of Arenas and other *Mariel* authors. It overwrites too the seedy, seductive port culture registered in Sabá Cabrera and Orlando Jiménez's famously banned documentary *PM* (1961), partially shot in Regla, across the bay from Havana, and the occasion for Fidel Castro's notorious formulation of an aesthetic policy: within the revolution everything, against it, nothing.

Ports have historically represented a singularly dynamic space of exchange, beyond reigning mores and laws. In Havana, longshoremen's unions traditionally influenced economics and politics, and were a connection to Atlantic circuits of knowledge and exchange. In the late nineteenth century, Abakuá societies controlled the hiring of stevedores, and in the early twentieth century the port was the site for significant labor struggles. Memories of such historic sites of contact and confrontation stand in contrast to the transformation of ports everywhere into more segregated, self-contained, free trade zones, often, as is the case of

the new Port of Mariel, set somewhat apart from the towns that once grew up around them.

Between 2012 and 2014 the Brazilian oil, gas, and infrastructure firm Odebrecht overhauled and expanded the port of Mariel; it has also newly been charged with renovating the airports.[25] Odebrecht is one of a group of businesses known in Brazil as "national champions."[26] The Odebrecht Group also controls Braskem, the largest petrochemical company in Latin America. It leads the continent in ethanol and bioenergy, oil and gas, plastics and logistics, and "sustainable technologies."[27] It also oversees petroleum drilling, as well as infrastructure projects (hydroelectric plants, airports, housing, ports) from Miami to the North Sea, from Angola to Portugal and to the United Arab Emirates.

The Cuban press has billed the new Mariel as facilitating exports, import substitutions, high-tech projects, technology transfer, and foreign investment.[28] The port's Special Economic Zone trades on its geography, reprising the philosophies of history that defined the Caribbean itself: the port, the website for *Radio Rebelde* claimed, is ideally located "in the path of super ships crossing the Panama Canal, now in the process of expansion, and the future transoceanic canal projected in Nicaragua."[29] Other observers have suggested that the port was designed to facilitate deepwater oil exploration and extraction, and, at a minimum, to further its current services of container storage and distribution of petroleum.[30]

Mariel is central to Cuba's economic reforms. According to Emilio Morales, a GAESA subsidiary will build *maquiladoras* at Mariel "to produce high-value added goods such as appliances, computers, construction materials, exportable biotechnology products, and even automobile assembly."[31] The principal nations poised to take advantage of the port are, he believes, China, Brazil, and Venezuela; if the US embargo is lifted, it, too, may benefit. The Brazilian government has already hailed Mariel, over whose inauguration in January 2014 president Dilma Rouseff jointly presided with Raúl Castro, as an "export platform for Brazilian companies."[32]

Designs for further economic power and influence in the region, are, however, perhaps less important than what Maristella Svampa and others have termed Brazil's neo-developmentalism. Like other progressive Latin American states that have in many respects rejected neoliberal policies, Brazil continues to rely on resource extraction, often by private

companies aligned with the state, to generate wealth.[33] What underlying philosophies of possession and energy influence contemporary petroleum extraction and approaches to green or fossil energies in Brazil, Cuba, and beyond?

National context can shape notions of who "owns" oil, and where the proceeds from its processing and sale might be directed. Yet resource extraction depends upon widely shared ideas about our relation to the natural environment, to the global market, and to a common future— one that eventually will be without fossil fuels. Longer histories of thinking about petroleum extraction as a modern primitive accumulation—a privatization of the commons—and philosophies of possession can illuminate how unspoken but influential philosophies of energy are being reflected and reconceived in art and literature.

In Pursuit of a Wild Animal

Used selectively for millennia, oil was discovered as a potentially important fuel in the nineteenth century. As new uses for petroleum-based products were found in the early twentieth century, European and American legal theorists turned to medieval common law and civil law, respectively, for legislating oil's possession.[34] Both codes were themselves based on a distinction in Roman property law between the appropriation of mobile versus immobile things.

Medieval hunting law dealt with questions related to the ownership of wild animals, known as *res ferae naturae* (he who captures the wild beast owns it). It dictated to whom, for instance, a dashing rabbit belonged. Fundamentally addressing a practice related to basic food procuration, the law was not concerned with the question of *why* or *if* a human being could truly possess an animal, deciding its life or death. Instead it parsed the question of which human may possess a *moving* target that traverses terrain. When property is sundered from a fixed territory, to whom does the unfixed thing belong? Hunting law thus inadvertently recognized the arbitrariness of "possession" as such, since an animal belongs only to itself when it is in the no-place of movement, of passing across the earth. But the law also suppressed this admission by reasserting property rights at the moment in which movement stops, in which the animal is fixed in place with a weapon, spearing it to the earth (US case law about

petroleum actually invoked a whaler's spear).[35] Appropriation, in this law, becomes making the animal *proper* to a place and, so, to an owner.

To decide who has the right to appropriate oil, which, like the hare, runs "fugitive" throughout expanses of lands, both North American and Spanish jurists turned in the late nineteenth and early twentieth centuries to *res ferae naturae*.[36] Roman property law had been revisited in the early modern period when rights to the seas were disputed. Grotius, in his treatise claiming and establishing the "freedom of the seas," turned to Roman civil code to distinguish between the possessive fates of those things considered to be *res nullius*, or belonging to no one, and things that belonged to all, *res communis* (air, light, the sea), which "by the consensus of opinion of all mankind are forever exempt from such private ownership on account of their susceptibility to universal use."[37] Giant bodies of water, and small rivulets of running water, were deemed to belong to no one (and hence available for general use). But things that could be captured *in* these waters entered into the space and time of possession. Such things belonged to the category of that which has "not been marked out for common use, such for example as wild animals, fish, and birds," and which therefore could *become* the possessions of a private individual.[38] Animals, as opposed to the seas or common lands, could be possessed by humans. Although oil could have entered European (and Latin American) law as a *res communis*, it entered as a wild animal.[39]

Harvey O'Connor's history of the petroleum industry in the United States, *Empire of Oil* (1955), was translated into Spanish by the publishing house *América Nueva* in Mexico in 1956 and published by the Imprenta Nacional de Cuba in 1961, allowing for its quick circulation. According to O'Connor, the United States' legal choice to apply *res ferae naturae* to oil, which theoretically allows anyone to possess it, "caused astonishment in non-Anglo-Saxon lands," where "the sovereign—first the king and later the nation—owned the underground minerals."[40] By non-Anglo-Saxon lands, Harvey was likely referring here to the Middle East, not Iberia or Latin America. Spanish civil code, after all, had also decided that petroleum would belong to he who extracted it.

It was true, however, that in some Latin American cases oil was seen as a national resource. In Mexico, for instance, subsoil deposits belonged until 1884 "first to the crown and then to the nation."[41] In Cuba, oil was first refined in 1870, for kerosene.[42] By the 1880s the nascent industry was private, not of the state; an associate of John D. Rockefeller

established a refinery in Havana in 1882.[43] In 1889, Spain updated its *codigo civil*, which also applied to its colonies, including Cuba. Article 465, "On Possession," of an 1889 Royal Decree, still valid today in Spain, invoked *res ferae naturae*, but did not yet apply it to petroleum, for which two concessions were granted in Cuba between 1873 and 1898, in the areas around Cárdenas and in Motembo.[44]

In 1927, twenty-five years after independence from Spain, the Cuban government handed over to US and European petroleum companies rights to the national subsoil *gratis* and "in perpetuity."[45] A decade later this surprising grant was corrected. Lázaro Cárdenas's nationalization of the Mexican oil industry in March 1938 created Petróleos mexicanos (Pemex; itself denationalized in 2013) and inspired Cuba's Ley Cubana de Minerales Combustibles (Law of Fossil Fuels) in May 1938. The Law of Fossil Fuels limited concessions to thirty years, denied concessions to foreign states and restored exploratory rights to the nation.[46] A *New York Times* newspaper article from June, 1938 reported that "Juan Marinello, leader of the Communist Party in Cuba, Dr. Rodolfo Mendez [*sic*] Penate, vice president of the Cuban Revolutionary party, Carlos Prio Socarras [sic], student leader, and Lazaro Pena [sic], labor leader" spoke to a crowd of some 15,000 in Havana, praising Mexico's nationalization of petroleum. The leaders also "urged Cuba to follow the same program and achieve 'economic liberty.' 'Mexico at present is the Cuba of tomorrow,' Señor Marinello declared."[47] In these same years, Cuban anarchist newspapers advocated an alternative internationalism of the commons. They sought to resist the logic of what the economic historian of Latin America Victor Bulmer called "the resource lottery" that determines nations' economic insertion in global markets according to the natural resources that happen to be located within their borders.[48]

US and British oil companies retaliated against Mexico for its nationalization, beginning an embargo. Often forgotten today is that it was again over petroleum that the US initiated its embargo against Cuba in 1960. On June 28, 1960, the Cuban Government demanded that the Texas Oil Company of Cuba refine Soviet crude, as it was obligated to do by the 1938 laws. One week later, 70,000 barrels of Soviet crude were delivered and processed in the refineries. The US State Department, however, refused to let the companies proceed.[49] Cuba eventually nationalized US oil companies; by the fall the US had initiated a partial economic embargo, made complete in 1961.

To return to 1939 and 1940: Cuban and international companies perforated wells throughout the island and studied their yields. Allegedly they then covered up the drillings and informed no one of their findings.[50] Such rumors led the pioneering environmentalist Antonio Núñez Jiménez, a decade after the Second World War, to claim that "the interest of such foreign companies is to make there appear to be a lack of petroleum in Cuba, with the idea of maintaining our presumed high-quality deposits as a reserve in case of war."[51] Such suspicions concord with petroleum corporations' behavior in the Middle East in the early twentieth century. According to Timothy Mitchell, the early oil industry sought not simply to discover oil but, seemingly paradoxically, to delay its extraction, the better to control prices.[52]

Cuba's "second stage" of petroleum began after the island restored ownership of oil to national companies and gave "full security to domestic and foreign capital aspiring to licit and considerable earnings in Cuban petroleum exploration," which, combined with the discovery of the Jatibonico field, generated a boom in the 1950s.[53] The second phase was characterized by a markedly different time frame. The subsoil that in the 1920s had been given away in perpetuity to foreign companies was now allotted only for a "constructive temporality."[54]

Notions of possession thus varied over the early years of the Cuban oil industry. Yet the heroic, virile iconography associated with oil everywhere was a constant. The Cuban petroleum industry received a boost in the late 1960s and early 1970s from Soviet scientists, ushering in the next round of extractivist hopes. A sample two-page spread in *Cuba Internacional* from April 1971 celebrates these explorations under the title "Encountering Hidden Petroleum."[55] The article follows a Soviet engineer overseeing sea explorations.[56] The bold accompanying photograph is a neoconstructivist image of a giant white plume or geyser exploding out of the sea, evidence of engineers sounding for oil. The shape is reminiscent of both a mushroom cloud and a fist. Words are printed vertically in red up the white plume of water, as if also blasted by the explosion: "Above, the water shot over/ all the heads. Below, the artificial/ quake sounded the possibilities/ that here, tomorrow, petroleum might surge forth."[57]

The text is penned in an ebullient, masculine, epic tenor: "In that small fragment of the world called Cuba, a group of men want to seize hold of the future by looking towards the the subsoil"; "young and old

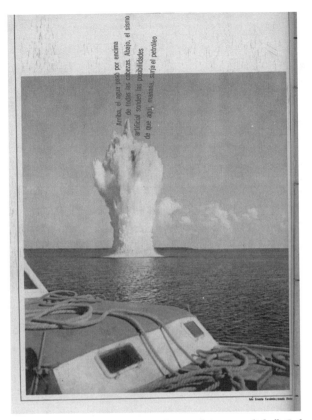

Figure 4.6: "Al encuentro con el petroleo escondido," *Cuba Internacional*, April 3, 1971. Photograph by Carlos Piñeiro Loredo.

men, Soviets and Cubans, hurry to wrest from the depths of the Earth the definitive answer."[58] But much of the oil extracted during the Soviet period was not of high quality, and the petroleum never quite surged forth as hoped, though it increased throughout the 1980s and 1990s.[59]

Today, Cuban petroleum law is no longer that of the wild animal. The civil code ignores any difference between commons and state (commons are typically defined as beyond both private property/market and the state). Cuban state property includes those lands that do not belong to small farmers or their cooperatives, plus "the subsoil, mines, natural and living maritime resources within the Republic's economic zone, forests, waters and ways; sugar mills, factories, fundamental means of transportation."[60] Oil is currently processed and distributed by a national company, Cupet. Certainly, it is the state that stands to benefit from any future oil discoveries. Yet the existence of contracts with many international firms muddies the question, should any sizable discovery be made.

The Black Lines of Contemporary Art

No discovery of oil has yet changed Cuba's economic or energy landscape. Yet oil's centrality to the world has made it the theme of a series of interventions by young Cuban artists. Humberto Díaz's *Afluente No. 1* (Effluent, 2009), exhibited at the Centro Cultural San Pancho, in Jalisco, Mexico, is a sculpture of the roof and trunk of a Ford Maverick '74, the front part of the car having sunk into the earth in a pool of apparent effluent. (Oil makes up 13 percent of Mexico's exports, and accounts for a third of the nation's tax revenue.[61]) A simulation of petrol extends in a shiny, rubbery black pool around the car and across the brick plaza. From several vantages the view of the sunken car ends at a parking lot beside the sculpture; the lot's rows of newish pickups and jeeps suddenly, if inadvertently, become part of the artwork as well.

Díaz has stated that his goal in *Afluente No. 1* was to work with an overvalued object, a modern fetish. (Originally he had hoped for a Mustang, rather than a Maverick, given the former's iconic status, but its owner didn't want to see it destroyed.) The notion of the distorted

Figure 4.7: Humberto Díaz, *Afluente No. 1*, 2009.
Installation: Ford Maverick '74, concrete, paint.

value attributed to a collectible car and the dearness of petroleum today find their parallel in a ballooning art market. The Mexican artist Gabriel Orozco embraced this fetish-status of certain cars when he severed a Citroën in 1993, removing the center and soldering back into existence a slimmer, sleeker, weirder, object of desire. Díaz plays on more sinister images, while simultaneously infusing his sculpture with the sunny Pop of a Jeff Koons. The oil slick has the fake sheen of plastic fried eggs, melting ice cream—or blood. The plunging car and the expansiveness of the spill suggest both the chilly bodies of water that are the inevitable endpoint of ill-fated cinematic car chases, and the almost biblical dissolution of the car's hard body back into its source of energy, which the automobile both hemor-rhages and becomes, as it dissolves into effluents and waste products. The alchemical, post-mortem transformation of a car (as art) yields toxic chemicals.

If a car dating to the oil-crisis era of the 1970s represents the most obvious of petroleum's many uses, other artists have sought to under-score the connections between petroleum and the planet. In *An Earthly Project* (2005) Marianela Orozco sold small, clear plastic bags of soil—some marked as rights to cultivatable land, some to an area rich in extractable petroleum—at a public plaza in Canada, highlighting the strange logics of extraction and property, of the idea of "owning" the earth at all. In 2008, photographer Glenda Salazar found out from a farmer friend that an oil pipeline had broken in the state of Matanzas. The pipeline, whose breakage was blamed on both a hurricane and human negligence, belonged to the Cuban oil company EPEPO (Empresa de Perforación y Extracción de Petróleo de Occidente). Crude spilled from the inland Valley of Yumurí through a river, and out to Bacunayagua beach in Matanzas. Salazar's *Línea negra* (Black Line, 2008–11) is a multi-media artwork comprised of the artist's documentation, photogra-phy, sculpture, and activist responses to the spill. These include: a series of photographs of the oil spill, a bust of historic environmentalist Antonio Núñez Jiménez made from oil residuums from the spill, a video that records the delivery of the bust to a representative of EPEPO impli-cated in the spill, the organization of a group of school children and chaperones to clean up the accident, and the reforestation of local land near the site of the accident.

Salazar's photographs register the black lines marking the reach of

Figure 4.8: Glenda Salazar, *Línea negra*, 2008–11.
Mixed media, variable dimensions.

the oily waves on tree roots, ocean-side cliffs, and rocks by the water's edge. Close-ups of rock textures picked out by darkened crevices suggest a painterly treatment, even as the series appeals to a documentary tradition of registering and exposing. Art critic Amanda Boetzkes has argued that what some call "earth art" typically creates works "out of the friction between the artists' attempts to make the earth visible and its resistance to signification."[62] *Línea negra* does not depend on such friction. Instead the photographs find signification written all too evidently on the earth. They don't struggle to elucidate, but instead simply record this signification, which Salazar multiplies across various media.

Línea negra encompasses various aspects of Salazar's practice, often a combination of photography and intervention. Salazar describes her work as an "activism by someone who inhabits a system and therefore acts like its conscience."[63] She has also written that she is more interested in survival than in the survival/duration of her art, her action being more important than its aesthetic register.[64] The system referred to is not merely the bureaucratic one whose channels the artist exploits to enact change. It is also that of an island ecology in which waterways, valleys,

and coasts are interrelated, and in which a viable network of local food production needs urgent help. Salazar forges projects out of the relations between artists, activists, and the environment. At the heart of her work in Bacunayagua, she has stated, was a desire to immerse herself in the unfolding effects of an oil spill in a predominantly fishing community.

Díaz's *Afluente No. 1* looked back, via the Maverick, to an earlier era of "petrodollars" and oil crises that undergirds our present. Salazar's work unfolds in the contemporary moment of intervention and "artivism" into local encounters with petroleum's perils. Jorge Enrique Lage's *La autopista: The Movie*, in turn, looks ahead to a dystopian future, one that similarly has roots squarely in the twentieth century.

Petroleum Fever: *La autopista*

Lage's highway, as discussed in the introduction, is, among other things, an allegory for petroleum-driven globalization. The "movie" within the novel, meanwhile—a documentary that records the construction of the never-ending highway—also serves as a metacritique of the novel. *La autopista* is a mélange of genres and affects that the highway, Lage writes, itself "remixes": "post-toon fantasies, atavistic illusions, the desire to flee to wherever possible."[65] Like Lage's prior writing, *La autopista*—emulating the form of a passing roadway—is more a sequence of vignettes than a narrative that arrives anywhere. The style builds on the conceit of road movies, taken to an extreme: if the moral of the traditional road movie is that getting there is all the fun, in *La autopista* getting there is the *only* option. In the novel's future land there is no place left to go *to*, nowhere to flee towards. Waterways and distant locales have all been pulled into the automobile's voracious network: the Panama Canal has been filled with rocks, the Galapagos Islands have been paved over for malls.[66]

Lage has borrowed from a cyberpunk or pop style for years. His style reaches its apotheosis here, as the narrative is ultimately pinned together only by the *a priori* conceit of simply driving onwards through a minimally changing terrain, accompanied by a flickering cast of mutant and mutating characters. It is almost impossible to describe what the book is "about," other than the macro story of a mysterious highway being constructed, and a set of colorful characters filming its "making of." *La*

autopista's main characters are old-fashioned allegorical types: the Autistic man (*el Autista*), engaged throughout in sessions with his virtual therapist; the Rasta; the Post-Traumatic man (a Puerto Rican perhaps traumatized by his status as a quasi-colonial subject, *Post-Traumático*); and a host of other historical figures drawn from US pop culture, Chinese politics, and Cuban history, in an indiscriminate fusing of history and fiction.

Like the extinct North Americans in *Habana underguater*, the bones of the extinct hominid *homo cubensis* are discovered by diggers of the highway.[67] (The construction of the highway generates giant mounds of fill, which inevitably become shantytowns, fusing geographies of inequality with future archeological treasure troves.) The attention to bodies is not just archeological, though. *La autopista* validates Beatriz Preciado's claims that the post-Fordist era is "pharmacopornographic," driven by body-altering chemistry created out of the petroleum-derived plastics industry, and the ceaseless selling of sexuality.[68]

The Autistic dreams up a faux natural history of the defunct *homo cubensis,* according to which the extinct hominid's "physiological adaptations" made him more flexible and versatile, while his baser qualities were subject to modification. This history of bodily adaptation has its parallel in the more willful one that the Rasta character dreams of narrating, and which recalls Oroza's interest in the "technological disobedience" of Cuban hacked objects: Rasta dreams of writing a secret history of Cuba's homemade technologies.[69] In the Autistic's imagined natural history, *homo cubensis's* most important achievements were his Monuments. This vision is both an "archeology of the present," Jameson's term for certain science fictions, and a parody of the monumental aesthetics to which the novel is implicitly opposed in its own barely coherent "trash" style and obsession with transformations. Like other examples of Lage's works, the novel is filled with transgender people, human-animal hybrids, and modern-day alchemical transformations.

The tautology behind the reigning model of economic growth, according to which humankind is condemned to a Sisyphean process of producing and consuming in order to produce and consume, is alluded to in the highway's superintendance by a Mexican named Hu Jintao. The Mexican "Hu Jintao" links the proper name of the Chinese premier seen as responsible for China's explosive recent growth and expansion into Latin America to a nation marked by *maquiladora* production.[70] The

crude fusion indicates how, on the novel's useless treasure map of the future, only gross stereotypes, placeholders, and metonymies stand out. It also restores the early-modern link between China and Mexico as two poles of the first wholly global market, linked through the Nau de la China or Manila Galleons, ships that moved goods between Mexico, the Philippines and China in the sixteenth and seventeenth centuries. We aren't far from the colonial labor practices of native peonage in the mines or Chinese "coolies," either: "The highway needs constructors. The natives need money."[71] (Of course, it turns out that the *autopista* doesn't *really* need workers after all: they have been replaced with "Constructicons," or digging robots.) Lage mocks his own orientalism with a swift allusion to Kafka's "The Great Wall of China," read aloud by Hu Jintao. Kafka's garbled account of the building of the Wall and depiction of an autocratic state was famously far from historically accurate. But for that very reason his tale is a precedent for the minor plot about the building of the highway.

Hu Jintao is not simply a "technocrat" masterminding construction and fixing broken *constructicons*, however. He is also a dark force furthering climate change. Workers have come from all over the Caribbean to build the highway, from all the "islands and coasts flattened by the fury of the hurricanes."[72] Hu Jintao fixes transformers and works in a laboratory in Isla Mujeres (Yucatán) run by a proverbial evil German scientist. The laboratory stores and transforms hurricanes, programmed by the US government in order to slow the building of the *autopista* (here the highway is an allegory, perhaps, of China's investment in Latin America, worrying a lagging US).

The transformers channel the essence of hurricanes and change female-named hurricanes into monstrous women. As one such storm approaches, the novel's protagonist seeks refuge in a container alongside the real-life US transgender gothic fiction author Poppy Z. Brite (née Melissa Ann Brite). Something ominous looms on the horizon, unrecognizable to the radar: Hurricane Katrina (about which the New Orleans-raised Brite has written extensively, as well as the Deepwater Horizon BP spill of 2010) announces, parroting Courtney Love, "'I am not a woman. I'm a force of nature.'"[73]

Such humor about the imbrication of the US, Chinese, and Cuban political economies has its counterparts in the visual arts. Alexis Esquível's painting *Live President Subtitled in Chinese* (2011), for

Figure 4.9: Alexis Esquível, *Live President Subtitled in Chinese*, 2011. Acrylic on canvas, 85 cm x 200 cm.

instance, is a bald allegory of a bicephalous Chinese–US economy. The painting depicts a $100 bill subtitled in Chinese (the translation reads "United States of America; Minister of Finance; $100 dollars.")[74] Barack Obama occupies the central oval on the bill. He gazes firmly into the future, backed by an apocalyptic landscape of barren fields and a lightening storm. An industrial city lies in the background, flanked by missiles; a palm tree leans by the bill's edge, over an aging anvil, with oil derricks pumping away in an ocean.

The Petro-Sugar-Industrial Complex

One of *La autopista*'s more ingenious set pieces places the history of Coca-Cola in relation to both petroleum and its potential sugar/ethanol replacements. (Sugar and petroleum are intimately linked: after 1961 Cuban sugar was sold to the USSR in exchange for petroleum, an explicit trade in energy; in 2004 Cuba signed an agreement to trade medical services [e.g. doctors] for petroleum.[75]) Coca-Cola here is emblematic not only of a relentless forging of new markets for a nutritionally empty product. In *La autopista* a local version of the drink (an example of import substitution) appears as a curious elixir designed to fill the same niche. The local version appeals to the popular but frequently disparaged music genre reggaetón, calling itself Reguetonic. Reguetonic's advertising asks consumers to share with their friends "the daily troubles of doing nothing, of nothing to hope for," a *dolce far niente* that parallels the novel's unchanging landscape alongside the highway.[76]

Lage delves into the history of Coca-Cola, whose company was helmed during the 1980s and 1990s by Cuban-born Roberto Goizueta (the grandson of a sugar businessman, and whom Lage turns into a character). A passage in Lage's novel anticipates the possible collusion between the current government and wealthy Cuban-American sugar families. Even as the state maintains a discourse of anti-imperial independence, it does business with families whose trade is linked to the very things the revolution claimed it was designed to end: sugar's monocultural reign, savage inequalities, exploitation of workers.

From beyond the grave Goizueta recollects the last dream he had before dying. In it, Fidel Castro, sole leader of the socialist state, gamely cedes pride of place to Roberto Goizueta, sole leader of capitalism's signature empire of sweetness. Both men employ the same "marketing" strategy of depriving people of commodities in order to introduce panaceas later. In the dream, Goizueta sits with the "Boss" in a presidential suite. Only "in the dream the Boss is not Robert Woodruff (former Coke president) but Fidel Castro." Goizueta shrinks before the Boss. It is a final judgment. "I know what you're thinking," Goizueta says; "you're thinking of the failure of New Coke." The *Jefe* shrugs. "Don't be so hard on yourself," Fidel comments, adding as an aside, "anyway, Diet Coke was pretty good, no?" Goizueta looks out the windows and takes in Coca-Cola's home city of Atlanta, "superimposed on the Havana landscapes of his childhood, sugar landscapes, landscapes defined less by the countryside than by the depth of the conjunction: *Habanacampo* (Ruralhavana)."[77] The shimmering superimposition of Atlanta over the sugar fields of Havana suggests the transmogrification of the raw sugar industries of 1930s *Habanacampo* into the processed global industry of Coke, with its sugar substitutes. It suggests too the failure to escape the curse of a Caribbean industry. The transformation from sugarcane to sweetened drink to sugarless drink, and then, finally, to Reguetonic as a new, post-carbon fuel, constitutes a miniature and abbreviated history of the twentieth century. A slavery-era monocrop cedes to a calorie-free chemical invention, which in turn morphs into an alchemical innovation substituting for petroleum.

Goizueta remembers New Coke as a pet project that never received the adulation it deserved. The implicit parallel is to many of Fidel Castro's quasi-alchemical projects that promised scientific breakthroughs, but failed. As the floor and walls turn to glass, Goizueta realizes that his fate,

fittingly enough, is to end up in a glass bottle. "We'll be Genies, the kind that grant wishes," Fidel counsels as consolation. "Must one always obey the desires of the consumers?" muses Goizueta. "I hope that now people know what wishes can be asked of us," answers Fidel.[78] Capitalism's false invention of needs and desires finds its mirror in an authoritarian "socialist" government bent on legislating desire.

The Autistic turns to the documentary's lens to speak of the business strategy shared by both men, revealed to him in a dream: lose massively for a few months by withholding sales, then recuperate your losses when a deprived public finally receives a longed-for product. Goizueta: "I lose a few millions in the first months, but then I go back and due to the abstinence the sales go crazy in the following ones. I've got them all by the throat." From inside the presidential suite the distorted voice of the Boss murmurs, "Mmm . . . an interesting theory."[79] Delivered as satire, this is, however, a grim scenario: frenzied consumption following punishing scarcity. In the novel, the margins of the highway suddenly fill with gas stations, workshops, cafeterias, restaurants, motels, souvenir shops . . . "we all end up winning," it concludes, with ambiguous irony.[80]

The motley crew filming the construction of the highway inevitably runs out of gas. Goizueta, now the Genie in the Bottle, offers them "another fuel. The best fuel. One that prolongs the life of the motor, produces much more power, reduces oil use, and is cheaper!" The group is stumped, but the reader assumes it is one of Goizueta's beverages.[81] Like the treasure whose nature we've forgotten or never fully grasped (like the secret formula supposedly organizing our beverage desires), Reguetonic is a substitute for that other modern elixir, petroleum.

From Post-Traumatic we learn of the "Petroleum Fever" era, a future, now past, in which petroleum was discovered in Cuba, "and tons of it! The island as a giant platform."[82] Post-Traumatic had been one of the first to join the planeloads of wildcatters. He recalls a primitive accumulation: "Cuba wasn't what I expected. Chaos reigned. The military and civilians blurred. There was no tradition of private property, contracts, taxes . . . It was a lawless territory . . . wells were dug everywhere." Over drinks at night, prospectors discussed the "millenarian rocks, generators of crude (the result of the decomposition of marine organisms), the need for more fuel to look for more fuel."[83]

This is the lost highway of endless growth in a nutshell: petroleum in order to find more petroleum. Lage narrativizes what Rob Nixon has

argued about petroleum-based societies that borrow against both past and future. The very term "fossil fuel," Nixon points out, implies a "double relationship to planetary time": one that both reaches back to "the stratified death compacted over millennia," and suggests a "built-in obsolescence inadequate to future needs."[84] Similarly, Lage's millenarian rocks and decomposing organisms produce the crude that powers industries whose temporal horizon is an ever-receding future of steady production.

This subtle reminder of the past lives that create energy—also referred to as "buried sunshine"—has a precedent in Cuban literature in the 2001 novel by Mariel emigré Juan Abreu.[85] *Garbageland* featured a post-petroleum future in which a morass made of our decomposing present becomes the black goo for another future: "*Black* was a sad liquid . . . Thick molasses. A soup accumulated over centuries in the immense receptacles of used-up petroleum. The subsoil sucking in, transforming the waste products."[86] The waste is comprised of the stuff of modern life: "residuum from wars, cities, countrysides, libraries and arsenals. Years of excretions brought from New York, California, and other regions of Terra Firme. Generations of robots who turned out too intelligent and had to be discarded. Dreams of splendid, invincible machines. Failed clones."[87] Abreu conceived of an entirely different planet on which to play out his post-petroleum nightmares. In *La autopista* petroleum speculation is also in the past, but petroculture lives on.

Havana, for instance, has been paved over, indeed erased: "What Havana was. What it never was. Whatever it may have been. The highway has erased it from the map. In its place, the endless asphalt that fills our nightmares."[88] This future is connected to nightmare scenarios of an invasion of predatory capital, figured here as the arrival of someone named Santos (Saint), self-identified, in a joke about the Cuban state's (former) anti-imperialist rhetoric, as "*de la Mafia de Miami*," from the Miami Mafia. Santos opens a casino in the back of a Havana *paladar*, or family restaurant. Meyer Lansky, the 1940s casino *mafioso* and friend of Batista, returns as a "*gusano*" (worm). To be clear: he is not an exile, for which "*gusano*" was derogatory slang during the first decades of the revolution, but a small, colorless, phallic worm. Lansky is Santos's pet, and he whispers into his owner's ear that their new business should be a sex shop named *La Gusanera*, a term from the pre–Special Period years for Cubans critical of the government (Beatriz Preciado is vindicated again: the store's inventory includes "hormones").[89] In this respect, the

novel is not so futuristic. Cuban-Americans are already investing in nascent businesses on the island, many to more promising ends than in Lage's patent joke: indeed, the recent explosion of new small businesses owes much to such investment.

In Lage's satire of a future exploitation, no resource goes unsiphoned. With natural resources ever scarcer, subjectivity has become the last well to be tapped. Post-Traumatic considers writing a book, *Mi vida con los salvajes* (My Life with Savages) but cautions his readers: "if you're into indigenous issues, underdevelopment or any of that shit, frankly, I recommend you don't read further."[90] In short order, however, he discovers in the natives' oral histories "an inexhaustible well," their accumulated personal histories replacing the exhausted oil reserves.[91]

At this point the novel begins to disintegrate into ever-shorter fragments. Additional characters with allegorical names are introduced and dispatched in a single sentence, never to appear again: allegory further stripped of any character. Suggestive allusions are invoked, but left unexplained. Portentous figures appear, but remain extraneous to the plot, including Christopher Arendt, the guard stationed at Guantánamo Bay who testified about prison torture at the 2008 Winter Soldier Hearings in Washington, DC.[92]

By the novel's end we realize that we do not even know who the narrator has been all along. In the final pages, some "girls gone wild" tear off his skin to make bikinis. The skin grows back, but he now has the Autistic's face. Who is he? Where is he going? In the final scene, the narrator sticks out his hand to make one of the coded gestures used in Havana to indicate to passing cabs, with a thumb pointing upwards or out, whether one is bound towards one sector of the city or another. But Lage does not tell us which way the narrator is pointing. The scene recapitulates a reflection by a Seminole Indian from early in the book: "Back luck, ours . . . always arriving late. But arriving where?"[93]

Memoria de la era del carbón

In a final set of works that brings together these overlapping concerns of energy, power, and nefarious states, Harold Vázquez Ley's series of staged photographs entitled *Memoria de la era del carbón* (Memory of the Coal Era) explicitly seeks to address

a dimension of the present from a future perspective, generating narrations in the past tense that relate to the ambiguity of the moment and recent history. Inspired by conspiracy theories, which promote the idea of a reality controlled by shadowy powers—global governance—multiple references help focus attention on degrees of construction and manipulation of reality.[94]

The temporality implied in the future anterior—what our present will have looked like to future eyes—is ambiguous. Coal (*carbón*) and carbon (*carbono*) are symbols for global warming. The image of people floating in the ocean without rafts suggests a primitive locomotion available in a post-carbon era. *Memory* of the coal era suggests a future in which we will no longer be actively sending carbon into the atmosphere, but which will also be irrevocably warmer.

Vázquez Ley has undertaken a complicated process to doctor daytime shots so that they appear to have been done at night. The series' production process parallels the kind of manipulation of time that the content describes. As Claire Colebrook observes, "Carbon emissions . . . do not simply damage or deplete ecosystems; they alter the temporality, volatility and relations of ecosystems."[95] The confusion of day and night, and of future and present, mimics the disrupted temporalities associated with climate change.

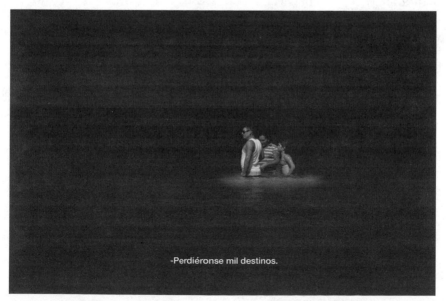

-Perdiéronse mil destinos.

Figure 4.10: Harold Vázquez Ley, *Camino Largo*, "Memoria de la era del carbón" series, 2012. Lightjet print on archival paper.

Each of the photographs is accompanied by a text written with an inverted syntax typical of literary works from the sixteenth or seventeenth centuries: "*posó en mi la salvación*" (in me rested salvation); "*luces de Yara se vieron*" (seen were the Yara lights). Why this baroque phrasing? Walter Benjamin famously saw in the baroque an attempt to confront absolute sovereignty as it transited from the transcendental to the immanently political.[96] Perhaps the fear of a single global government overseeing ever-scarcer resources suggests to Vázquez Ley a return of the baroque's concerns. Hobbes's *Leviathan* is openly cited in one of the photographs' titles: an ominous—though also comic—scene of two eyes/lights hovering above splashing Caribbean waters reads "*Presagié su llegada cual Leviatan*" (I foresaw its arrival like some Leviathan). If in the first baroque period Spain wrestled with how to rule a global empire that spanned the Pacific and Atlantic oceans, the dark, future empire suggested in Vázquez Ley's images has so completely connected the "four corners" of the world, so fully squeezed out light and possibility, that only the watery depths of the ocean remain.

Vázquez Ley packs these various allusions into his photos. The images suggest that someone has switched off the lights. Such a post-apocalyptic feel characterized much art and literature from 1990s, when lights really did go off for long stretches of time. Post-Soviet Cuba had already put to the test a post-fossil fuel era, as Bill McKibben suggested. In Vázquez Ley's photographs, however, the post-hydrocarbon future witnesses a new Leviathan, a massive global power adjudicating resources. In this state of vigilance and abandonment, as one photograph caption puts it, *Pocos de salvarse hubieron* (Few there were to be saved).

CHAPTER 5

Free Time

In 2008 *Letras Cubanas* published a thick, idiosyncratic study, one that became a quasi-cult curiosity among poets and critics. The book, with the almost nonsensical title *Eliseo DIEgo: el juEgo de diEs?* (Eliseo DIEgo: the gAme of *tEnn?*) was written by the Camagüey-based essayist and poet Rafael Almanza.[1] Eliseo Diego is one of Cuba's best-known mid-twentieth-century poets, and Almanza's study is devoted to revealing the ludic core of his oeuvre. Some twenty years earlier Almanza had written another classic study, *En torno al pensamiento económico de José Martí* (On José Martí's Economic Thought, 1990).[2] The two books may seem unrelated. Almanza himself dismisses the first as belonging to an earlier Marxist phase, since abandoned. In both, however, Almanza connects poetics to form, measure, chance, numerology, and freedom. They add up to a cumulative investigation into the intersections between aesthetics and time, of lives divided between work and non-work.

Almanza's study of Diego appeared alongside a growing body of literature and art interested in what free time and play mean today: video games that cannot be won, an artist who pays workers to excuse themselves from their jobs, literature that contrasts sport with digital play. These and other recent artworks "play out" questions surrounding the nature of occupation, unemployment, play, dreaming, non-work, and artwork. In this chapter, I move from Almanza's poetry and performance to a number of pieces about what work, non-work and leisure mean in contemporary Cuba and beyond: Adrián Melis's art about jobs and non-productivity in contemporary Cuba and Europe; Celia y Junior's

food and lottery art; Rewell Altunaga's video game *mods* and *machinima*; and recent literature's engagement with scenes of play.

All highlight specifically Cuban, and often masculine, forms of non-productivity. Yet they also attend to global forms of work and non-work today. Indeed, the Cuban manifestations, while singular, resonate with problems faced elsewhere. One might, for instance, see them as *simpatico* with what Jasper Bernes, Joshua Clover, and Juliana Spahr analyze with respect to a street dance called "turfing" in Oakland, CA. Noting that its very name marks a hyperlocal place—as in defending one's turf—Bernes et al. situate turfing as both specific to certain neighborhoods of a Californian city (an "intense localism") and globally shared. The dance's lyrical, machinic, elegiac performance by young black men living amidst poverty and violence puts it in conversation, the authors claim, "with Detroit and Athens, Madrid and Dhaka, with the *favelas* of São Paulo; a quiet confrontation with the world as it goes, after the global slowdown, after the social factory could put any kind of good life on offer."[3]

The article suggests that turfing and other innovative aesthetic practices emerge from places associated with the ravages and counter-innovations of post-industrial economic crisis. In the most optimistic reading, such art forges beauty and creation out of struggle and unemployment. But Bernes et al. are at pains to point out that in fact turfing resists any celebratory reading as a "post-human" or "post-production" aesthetics that might be "utopian, emancipatory, freed from the factory whistle." Quite the opposite. As industrial work has evaporated but no new forms of "immaterial" labor have taken its place, the dancers occupy a strange limbo. Neither riffing on the mechanized physical routine that factory work demands, nor celebrating the body's freedom from drudgery, the dancers simply announce that "There are bodies. They have neither an obvious way out nor a persuasive way back in. This surely is the peculiarity of our moment . . ."[4] In short, while radically excluded, transforming bodies grope towards a form of emancipation, material change has yet to arrive—either to Oakland or to Camagüey, Alamar, or Santiago. The dancing bodies forge moments of beauty, insight, and transformation that can exist within a system that won't yet let them in or out. The article is cautionary. Play and aesthetics remain tools for creating pleasure, liberation. But they do not necessarily change the overarching systems in which they unfold.

Álvarez on Almanza on Diego: A Series of Plays

*E*liseo *DIEgo* painstakingly reveals a ludic core to all of Diego's poetry and fiction. Almanza grounds himself in, but departs from, Roger Caillois's classic study *Man, Play, and Games* (1958), itself in many ways a revision of concepts from Johan Huizinga's *Homo Ludens* (1938).[5] Caillois' book immediately challenged Huizinga's claim that games are *necessarily* divorced from material interest. Caillois, by contrast, took gambling and games of chance very seriously. An important case study in his book is Cuba's Chinese *charada*, for instance, a lottery of sorts that Caillois learned of from the Cuban ethnologist Lydia Cabrera. Still, while Caillois insisted that money and play need not be separate, he maintained that playing for money remained "completely unproductive," and that a "characteristic of play, in fact, is that it creates no wealth or goods, thus differing from work or art."[6] In Caillois's definition, art is lumped in with work as productive, while play is "an occasion of pure waste."[7]

Caillois published his study in the late 1950s. He moved from games of chance to daily challenges under what, by the late twentieth century, would become Ulrich Beck's "risk society," in which risk (like wealth) is unequally distributed.[8] Caillois wrote that "competition is a law of modern life. Taking a risk is no longer contradictory to reality," adding that games and gambling were not merely diversions outside of the workaday world but intimately part of it. Such a world was one in which by merely "waking up in the morning, everyone is supposed to find himself winning or losing in a gigantic, ceaseless, gratuitous, and irresistible lottery which will determine his general coefficients of success or fortune for the next twenty-four hours."[9] In other words, Caillois moved beyond the efforts to define play transcendentally, characteristic of Huizinga and Schiller's studies, which separated play out from nonludic spaces. Caillois examined—at least in part—play's intersection within modern economies. He anticipated the increasing collusion between play and market that in some spheres and places would define aspects of the late twentieth and early twenty-first centuries. In Cuba, the 1959 revolution constructed something of a welfare state opposed to a risk society defined by competition. But little remains of that state, and risk is increasingly the order of the day.

What does it mean that Almanza returns to these concepts of play, free time, and work today? Might his reflections illuminate a number of contemporary works concerned with time, play, and labor in twenty-first-century Cuba? Almanza's poetic study links questions of play both to modern work regimes and to reactions against them.[10] Kant and Schiller helped create a myth of liberty and of open-ended, imminent possibilities for "man," Almanza writes. These in turn led to

> the strengthening (*afianzamiento*) of nineteenth-century capitalism and workerism (*laboralismo*), in which the traditional opposition play/work (*juego-trabajo*), which comes from Aristotle, is "settled" in favor of work, since play is conceived as something infantile, unbecoming of serious men, and ultimately as training for work itself. Spencer will affirm that "play is a dramatization of adult activity," and Wundt: "play is the child of work, there is no form of play that does not find its model in some serious occupation that precedes it in time." In 1896 Karl Groos can still be found insisting on similar concepts.[11]

Almanza reprises a history of modernity that segregates out and relegates play to the era of childhood, then hijacks its liberatory facets by recoding it as mere preparation for adult work. More specifically, Almanza is old enough to have lived through a 1971 Law against Laziness that sought to force workers' productivity. Even Adorno and Horkheimer's theories, which eschewed the teleology of play as juvenile training for work, nevertheless presented the culture industry as capitalist pablum or distraction that enables grinding productivist regimes. Against such a quarantining of play, Diego approaches it nonteleologically. That is, play is an end in itself. It is neither preparation for, nor alternative to, work. For Almanza, Diego offers "a philosophy incompatible with the productivist ideology of capitalism and of real [existing] socialism."[12] It is Diego's nonteleological conclusion that Almanza is keen to recuperate.

A recent philosophical study of play considers some of these terms rather differently. The Ancient Greeks, Mechthild Nagel argues, saw play and leisure as *ethical*, a "gambling between life and death."[13] Ethical play was opposed to seriousness. But in modernity, play came to be seen as a primarily *aesthetic* activity, manifested in bourgeois arts.[14] Now play was opposed to work.[15] The positing of play and aesthetics as an alternative to work continued throughout the twentieth and twenty-first centuries,

with differing emphases. Caillois, again, distinguished between the two: for him art was productive, while play was pure excess, even when lucrative. More recently, Julia Bryan-Wilson has explored how art has been considered alternately as work *and* its opposite, in her study *Art Workers*, focused on a group of post-war US artists.[16] Since the late nineteenth century, she writes, art has been imagined as an antidote and outside to capitalist work, a nonutilitarian or even utopian activity.

If art has sometimes been figured explicitly as an alternative to capitalism's grind, how has it functioned under Cuba's "socialism"? After the revolution, artists were recognized as workers and incorporated into organizations such as the UNEAC (the Union of Writers and Artists in Cuba), which, however, excluded those considered non-professionals.[17] Today, many musicians, visual artists, and writers operate outside the state agencies established to manage their work.

After 1991, revolutionary injunctions to produce bumped up against the reality of the informal economies necessary for survival. Time dilated in the face of production's abrupt halt. Through tourism and the export of health-care professionals the economy adopted more post-industrial service-sector organizations of time, labor, and leisure. These changes require a new theory of what "free time" means in a system of production and consumption in which divisions between work and play, public and private are often blurred.[18] The anthropologist Noelle Stout has documented this tension in her ethnographic portraits of Cubans who work in the tourist industry, some of whom are also sex workers and for whom public and private, work and pleasure, mix. Stout found that some service workers wished to separate "private authentic affection and commodified forms of intimacy in the marketplace."[19] But at least one of her subjects found that work in the tourist sector had "reshaped" her "subjectivity, readying her to interact with foreigners in particular ways that would inspire patronage."[20] New conditions of labor had shaped new subjectivities.

In many places in the world free time is no longer an antidote to the time of labor. In Cuba, where work for the largest employer, the state, barely allows for subsistence, the nature of free time is hard to parse for slightly different reasons. On the island, but surely elsewhere too, lucrative work may take place during ostensibly free time. And many Cuban workplaces are, paradoxically, spaces of non-work, with absenteeism or low productivity allowing workers to start their own informal businesses elsewhere.[21]

Alessandro Fornazzari has argued with respect to neoliberal societies such as that of contemporary Chile that their discourse of "human capital" means that we cannot go on thinking of capitalism as something that cruelly excludes human "desires and subjectivities," romantically set in opposition to "the logic of the commodity form."[22] Instead, Fornazzari joins other theorists in claiming that capitalism operates through such desires and subjectivities. As we saw in the last chapter, Lage's Post-Traumatic character likewise described "native" subjectivities as an untapped well to be mined for both fiction and post-extractivist economies. Subjectivities are commodities, these authors intimate. If this is true, we cannot simply oppose Schiller's notion of creativity to a juggernaut of labor extraction that crushes the free play of selfhood. Nagel argues that Kant and Schiller essentially understood play to be the "individualist play of the self."[23] Today, self-construction through ludic exploration is shaped by play industries.[24]

Yet neither should we imagine free time and Schillerean—or Huizingan—play to be *mere* raw resources harnessed for a voracious capitalism. This is an especially dubious proposition in Cuba, which in many ways remains outside of a full market economy. Free time and play remain to some extent spaces of innovation, creativity, and leisure, forms through which to explore both individuality and community.

Almanza stakes his project on this utopic space of pure creation. At his home in Camagüey he writes poetry and hosts performances, which include theater, readings, and video art. Many of his performances have been structured around Herman Hesse's exploration of play as proposed in *The Glass Bead Game* (1943).[25] Almanza describes the ludic as a space in which the virtual—not the digital but, following Greek poetics, simply poetry—confronts "the real": politics and society.[26] His *peñas* (playful get-togethers) have, in turn, drawn the interest of the young artist Lester Álvarez, who has made a documentary about Almanza's amateur happenings, and who also included the Camagüeyan writer's visual poems made of neon in Havana's 2014 Contemporary Art Salon.

Almanza works at the interstices of the two concepts of play outlined above, both ancient and modern. For him, play is both the classical (ethical) "work" of play, and the modern (aesthetic) antithesis to work. He explores the ludic in Eliseo Diego's poetry with recourse to four of its expressions, as defined by Caillois: *mimicry* (theater, pageantry),

ilinx (activities that induce vertigo), *agon* (contests), *alea* (games of chance), adding from Jean Duvignaud, *plauderei*, or word games, play with discourse. Almanza finds ludic principles structuring virtually all of Diego's works, from the most explicitly playful such as *Divertimentos y versiones* (Diversions and Versions, 1967) to less clearly gamic works such as *Muestrario del mundo o el libro de las maravillas de Boloña: La Habana 1836–1967* (Exhibit of the World or the Book of Boloña's Wonders: Havana 1836–1967, 1968), a sort of modern emblem book of illustrated poems.[27]

Almanza's research into Diego's use of play resonates in a couple of key areas with other recent meditations on play explored below. First, Almanza recovers Diego's canny reflections on play's collusion with (and divergence from) military games. Secondly, he highlights the special *time* that emerges from play. And finally, he reminds readers of specifically Cuban games and theories of the ludic.

The product of intensive research into Diego's archives and life, *Eliseo DIEgo* includes reproductions of photographs of Diego's hand-drawn maps for his toy soldiers. The maps were part of a game that Diego created, which he called *Shambattle or The Game of Toy Soldiers*. *Shambattle* comes complete with invented place names. "*Plauderei*" and "*agon*" unite in Diego's humorous names for the imaginary lands making up *Shambattle*'s two contiguous islands, names that play on existing English, Portuguese, Spanish, German, and French words and places: "Shaneland, Gaitaña, Muito Grosso, Fritzlandia . . . Youllbesorry, Jazzpoint," etc.[28] The overt *agon* of the military game is transformed by the silly names, in what Almanza sees as "a lighthearted and very Cuban cultural challenge."[29] Diego's battle game links language play and poetics—it is a commonplace that such jesting or "*choteo*" is dear to Cuban culture—with military strategy, incarnated in the Cold War-era popularization of military games and game theory by the Rand Corporation, the basis eventually for video games.[30]

The more ethical notion of play as the deciding of life and death is present, too, in these militaristic works. In the series of poems titled *Singular and Curious Book of Chess*, the titular chess game is life itself.[31] A poem from the series reads: "Not being and being, light and shadow, always/ the sadness ceding to happiness/ and again to death, which approaches/ like the face of a child to windows/ and watches us, secretly, from afar."[32] The alternation between the black and white of

chess becomes the flicker of light and shadow, life and death. The poem ends by musing on the inclemency of the weather, concluding: "For after all such goings out/ is it not the game/ that matters for returns?"[33]

Diego reaches further back into military and gaming prehistory in the poem "Pregúntase por la invención del juego" (Asking After the Invention of Games). The poem establishes parallels between chess and the rhythms of everyday life. Set in a Southeast Asian jungle, it ends: "The military game, who invented it,/ Who conceived its vast maneuvers/ Like the movements of the heavens,/ Its comings and goings on the frost?"[34] For Almanza, the poem is about the hypostatization of entertainment in military games like "Shambattle": a sham of a battle, a simulacrum and a more ludicrous version that disarms the aims of conquering, founding, accreting, and killing.

Ludic principles are inextricable from meditations on temporality. Games themselves often depend upon a timed unfolding. In Diego's work, games cannot be wholly divorced from their existence as pastimes. In his short story "El alquimista" (The Alquimist), for instance, a man finds a recipe to live for 150 years. He uses it first to find out how to live forever, then, desperately, to find out how to die. The gnomic parable "Los tiempos," from *Divertimentos y versiones*, is pointedly about both weather (*tiempo*), time (*tiempo*) and attempts to order time through cards and games. Here the time of Paradise is a gentle drip of water between the plantain leaves, while the time of Hell is defined as "the King of Cards."[35] Card games, characterized by their play with chance, calculation, and gambling, are somewhat diabolical, as the ethical understanding of the tragedy behind playing with life or death understood. Almanza traces games of domino, chess, and chance throughout Diego's works, locating the importance of such games in Cuban history and arts. In the early nineteenth century, José Antonio Saco's *Memorias de la vagancia en la isla de Cuba* (Memoirs of Idleness in the Island of Cuba, 1830) had identified the first cause of laziness to be *juego* (gambling), which Saco called a "devouring cancer." In the 1950s Lydia Cabrera took up the term, and Caillois, having read Cabrera's ethnographies, included it in *his* treatise on play.

Saco set out to examine the slavery-era Cuban economy. He worried that gambling diverted flows of money and energy from more legitimate economies. He proposed recuperating this wasted labor time:

If we could identify those people given over to this infamous vice, and compute the value of what they would earn working in the time that instead they are busy gambling (*juego*): if we could know, even approximately, to what amount the lost quantities ascended, and follow the long chain of disasters that necessarily ensue, then we would know our deplorable situation, and would stop calling ourselves opulent and happy.[36]

For Saco, "gaming" (or gambling) is not only philosophically opposed to work. In what he imagines as a kind of economy, it consumes time and money that would otherwise be spent on more "honest" labor. Saco claimed that one cause of idleness was the sheer lack of journals or scientific papers in an Atheneum; the lack, in short, of what he saw as an enlightened society.[37] He furthermore attributed idleness to a geographic determinism by which Cuban land was seen as so fertile one hardly needed to work at all.[38] But the final reason intimated in his treatise was significant for comprehending the importance of his treatise as the product of a slave society: Saco bemoaned the creation of a class of aristocratic and mainly white non-workers in a society based on African slavery. Although he perceived the racialized character of idleness, he to some extent only partially described the nature of the problem. The issue, of course, was not only "white idleness" but black coerced labor. Undergirding this treatise on idleness written by the author of the monumental *Historia de la esclavitud* (History of Slavery, 1875) is the slave society underpinning the island's wealth.

Debates about labor and idleness, from the Special Period back through the revolution, the Republic, and the colonial period before it, must be considered in light of this long history of racialized slavery on the island. Julio Ramos has argued that Saco's text is itself the product of a metaphysics of racialized productivism, and that "the so-called question of work has, since the nineteenth century, an inescapably racialized and racist dimension in Cuba and in all of the Caribbean and Latin America, where the very theme of discipline and idleness assumed with much naturalness the privilege of the white man's 'free' time."[39] "Free time," in Cuba, has long been a charged concept rooted in an evolving or accruing Atlantic labor history.

In the late nineteenth century Paul Lafargue offered another connection between slavery and post-slavery societies and idleness. Lafargue was the Santiago-born son-in-law of Karl Marx and the author of the

famous "Right to Laziness" (*Droit a la peresse*), which he published in France in 1880, six years before abolition in Cuba. In many ways, he was only nominally Cuban. He left the island around the age of ten, thereafter residing in France, Spain, and England. Yet his Cuban childhood may not be as immaterial as it at first seems.[40] Nor, perhaps, is the 2007 re-edition in Cuba of his selected writings incidental.[41]

Lafargue was born in 1842. His paternal grandparents were a French-born landowner who fled the Haitian Revolution and a Dominican mixed-race woman who fled the mid-century wars in the Dominican Republic. The two moved to Louisiana after 1808, along with many other former slave- and land-owners escaping a post-slavery, newly independent Haiti. His maternal grandmother was indigenous (Taíno or Siboney), while his grandfather was a French-Jewish businessman.[42] In 1851, at age nine or ten, he moved to Bordeaux. He eventually participated in the Paris Commune, worked in Spain, and opened a photography business in England. If his family's Afro-Dominican past and ties to slave-holding in Haiti left little obvious mark on his own life or work, he closely followed politics and culture in the late-nineteenth-century, post-slavery United States, drafting "a Marxist analysis of the Civil War" that depicted African Americans "as a new proletariat." He suggested that they had "exchanged one kind of servitude, slavery, for another, wage earning."[43] At the same time that he was reflecting on the "right to laziness," he was writing about the legacies of racialized slavery in post-slavery labor regimes.

In *Fantasía roja* (Red Fantasy, 2006), a study of various leftist, at times neocolonial utopias that have been projected upon the Cuban revolution, the Barcelona-based cultural critic Iván de la Nuez finds in Lafargue and in Bertrand Russell welcome thinkers for a future post-communist culture of laziness, pleasure, and leisure.[44] Indeed, de la Nuez ends the book with a rousing endorsement of Lafargue as key to a future that wasn't (and that could still be), "in a minor key, individual and free."[45] On the island, meanwhile, at a time in which the state's prior Marxian discourse has been replaced by nationalist slogans and euphemisms, avoiding discussions of inequality or of actually putting production in the hands of workers, we see an intellectual recuperation of a Cuban antecedent and alternative to twentieth-century Marxism. The recuperation stresses Lafargue's *criollo* roots, while acknowledging a more heterodox left.

Perhaps the editors of the 2007 reissue of Lafargue's works had in mind the changing nature of labor. As Paolo Virno essayed more than a decade ago about post-industrial work, what in nineteenth-century industrial society was deemed "laziness" today is sometimes indistinguishable from labor itself: "labor and non-labor develop an identical form of productivity . . . Working endlessly can be justified with good reasons, and working less and less frequently can be equally justified."[46] Both trends, however, also define the contemporary Cuban workforce, which increasingly opts out of under-remunerated state jobs and embraces "cuentopropismo," "self-employment" or "onyourowndimeness," the term for work in the private sector.

Eliseo Diego's *Divertimentos* were already tracing some of these connections, albeit in muted tones, in the mid-twentieth century. One short story, for instance, grounded wealthy children's time—a freedom from work—in a specifically postcolonial Caribbean setting. In "La penumbra" (Shadows), indolence, silence, and quiet (like the quiet of the *quinta* where Diego lived as a child) are shown to rest on the servitude of Jamaicans, many of whom immigrated to Cuba in the early twentieth century to cut sugarcane. A colonial house, a garden in ruins, shade from the great trees planted in colonial times:

> Maud is the regal Jamaican, of snowy tunic, who takes care of the house. The owners never come. Maud is only visible through the windowpanes with their pretty curtains, forever closed against the dust.
>
> One afternoon a child crosses the small house alone and presses his face to the windows. Inside all is quiet, though outside the air stirs the great trees of the Colony.
>
> And suddenly the child has fled, because he has seen a door open in the glass world, and the golden hand of Maud, the regal Jamaican, on the golden doorknob.[47]

Here the ghostly labor of the Jamaican servant presides over colonial indolence, children's games, and the stillness of absentee ownership.

But why does Almanza recuperate Diego now? And what is compelling about Almanza's idiosyncratic research into play for Lester Álvarez, an artist who works in painting, participatory pieces, and video art? Why do explorations of free time have renewed purchase today?

To understand the urgency of these questions we might begin by noting their uptake by other artists, whose explorations of play thematize many of these same questions and similarly focus on how aesthetics intersect with forms of labor that are not "work." For decades now, cooking, for instance, has been a mainstay of global "relational aesthetics." An expanding variety of regional cuisines produced as art now approaches culinary tourism: Rirkrit Tiravanija's curries have been replaced with Subodh Gupta's $90,000 budget for cooking Indian food that would be, as his cliché had it, the kind made "in your mother's home."[48]

Cuban artists have also used food to explore the everyday. The celebrated artist Kcho (Alexis Leyva) cooked with Tiravanija. He also constructed a piece out of *marabú* that included an oven for cooking for his public, entitled *La jungla* (The Jungle, 2001, the title of Wilfredo Lam's most famous work and an homage to Vladimir Tatlin's *Monument to the Third International*).[49] In a place where procuring food remains a daily challenge, such art loses its status as a medium for producing sociality among biennial-goers and becomes a vehicle for procuring a necessity and, at the same time, pleasure.

In *Un olor que entra por mi ventana* (A Scent That Enters Through My Window, 2010/11), Celia y Junior brought together questions of daily sustenance with questions of play and chance through the staging of a lottery (*la bolita*). The lottery recalled the Chinese *charada* or *Rifa Chiffá*. The *charada* is a numerological exercise in interpretation; an art, really, as Caillois himself describes it, that exceeds mere luck to encompass aspects of divination and of meaning-making, drawing on Chinese religion. (In 1894 one Ramón de Perseverancia published a racist diatribe against what he called an "immoral game" that "industrious" and "astute" Chinese used to "exploit" Cuban citizens).[50]

In *Man, Play, and Games* Caillois himself outlines the principles of such a Chinese lottery. After choosing from thirty-six emblems of animals, humans, or allegories mapped onto the image of a person divided into thirty-six parts (known as "hanging the animal"), the game's banker announces a *charada* with an "ambiguous statement." Others interpret the statement in nonobvious ways:

"A bird pecks and goes away." Nothing is more transparent. The dead fly. The soul of a dead man is comparable to a bird because it can go anywhere at will, in the form of an owl. These are souls in pain, famished

and vindictive. "Pecks and goes away," i.e. causes the sudden death of a living person who was suspicious. It is therefore necessary to play 8, the dead man.[51]

Such a "game" draws on *mimicry* in the use of a kind of pageantry and *alea*, insofar as it is a game of chance. It involves gambling, meaning-making, and art.

According to one of the artists who participated in *Un olor que entra por mi ventana*, Celia y Junior first conceived of the work when they secured a Havana Cultura residence, sponsored by Havana Club. They asked one another, "What would we really like to do? What would be fun?" The participants, artist friends of the duo, played their version of the lottery from November through April. Each participant chose a number that corresponded to an edible animal, and only ever bet on that number. When an animal was drawn, the participant possessing the image of the winning animal had to cook a real version of it for the group. The players marked the numbers on a table built for the piece, where they ate, registering the process daily. Each day, six clean plates were stacked in the losers' places, while in the winner's place the dirty plates from the cooked food accumulated. At the end of the five months, 1,008 clean plates were stacked on the table amidst dirty ones, stains, and the winning lottery numbers.

The lottery described an alternative economy of sorts, fitting with Celia y Junior's interest in mapping alternative (unofficial) networks. It made the everyday vagaries of food procurement—which vegetables are in season, at what agro-market; which store carries gouda cheese; where to find black-market groceries—the imposed, productive, limits of the art. Thanks to the budget for the piece, the game generated tasty, meat-based meals, the aleatory play flirting with the tragic aspect of toying with the life and death of animals. And it seems lotteries, both underground and national, are again on the rise: in January 2015, the Catholic journal *Espacio Laical*, noting the existence of many blackmarket lotteries, called for the re-instutionalization of the National Lottery.[52]

Adrián Melis's Post-Work Dreams

Of the same generation as Celia y Junior, Adrián Melis has devoted his entire ouevre to questions of work and non-work, in both contemporary Cuba and Europe. As a press release for a show at the Kunsthalle Basel put it, Melis's art is about "workers without work" in different political economies. Melis aims to infiltrate failures in a system and make them useful.[53] He makes art out of dysfunction, and suggests that if twentieth-century industrial production is no longer the site of dreams, neither can be *non*-productivity.

In Melis's pieces, then, art becomes the last realm of productivity. But what is the nature of such production? Is it, as one cultural critic has suggested, cynical?[54] The charge may derive from the impression that while Melis seeks to explore the unproductivity of Cuban industry, he does so by asserting a divide between himself as an "art worker" and the more menial workers in factories and offices featured in his pieces. It is not just that Melis's work is different than theirs; it is, at least partially, that his work is made out of a lack of activity by redundant factory workers. Their non-work becomes his artwork.

Melis, though, has thought a lot about these questions. He may be alluding to a tradition of factory-based art in Cuba, attempting to make it adequate to the contemporary moment. In the 1980s, Flavio Garciandía and Grupo Hexágono created *Arte en la fábrica* (Art in the Factory), in which they engaged workers and made art out of factory materials.[55] Today such projects are gone along with many factories. In their place, a new form of artist collective is perhaps embodied in La fábrica (The Factory), an art space founded in a renovated cooking-oil factory in Havana, run by and for artists, and spearheaded by the pop singer X Alfonso.

Julia Bryan-Wilson has written about artists who fashion themselves along the lines of artisans and blue-collar workers, and about others who push the boundaries of what "work" may be. Her reflections on the peculiar work that is art-making are important for considering Melis's gestures. As Bryan-Wilson clarifies:

> not all art is work, not all work is art, and the class distinctions embedded within these terms still matter. Cultural production is a specialized, or as

Hans Abbing calls it, "exceptional" form of work, one that has ties to markets, alternative or gift economies, and affective labor . . . We should not erase distinctions or lose a sense of nuance in order to call for solidarity.[56]

Ultimately, Bryan-Wilson concludes, "If art were already work, or work were already art, these projects that redefine art as work and vice versa would simply fail to register as inversions, as conceptual frames, or as critiques," confirming that the very difference between "art work" and "work work" is upheld, not obliterated, by such art.[57]

Unlike some of Bryan-Wilson's subjects, however, Melis does not position himself as a blue-collar worker. Nor does he erase these distinctions between his art and the workers in whose careers he is interested. Instead, his goals seem more in line with Jacques Rancière's *Proletarian Nights*, an exhaustive study of nineteenth-century factory workers' leisure-time aesthetic production and aspirations.[58] We might think of Melis's work as posing the question that the Chile-based art critic Federico Galende has recently asked: "if an artist is a special kind of worker, in what way can a worker be an artist?[59]

Melis's 2008 video *Elaboración de cuarenta piezas rectangulares para la construcción de un piso* (The Making of Forty Rectangular Pieces for the Construction of a Floor) was shot in what appears to be a construction-materials factory in Havana, inoperative due to lack of inputs. Yet the workers continue to show up daily for a few hours. According to existing laws, if they do so for half the day, the workers continue to receive their salary.[60] Into this "unproductive" time and space Melis entered with the aim of repossessing a "paralyzed time" in order to animate the factory anew—now in a "virtual" manner.[61] Melis asked the workers to imitate the sounds of the machines they formerly used to make products: sounds of a concrete mixer, of shovels, trucks, carts, and of moving machinery.

The video begins in black. We hear only workers' voices. One man responds to an inaudible question posed by the artist, presumably about the worker's typical output: "Listen man! We've got no materials, no work, nothing. What do you want me to produce?" A convincingly machinic, but human-made hum then opens into a symphony of whirring, screeching, chugging, and cutting sounds. A spot-on imitation of a switch flipping and a machine starting up lends excitement and narrative thrust. The still images that accompany the soundtrack are

photographs of the idle machines whose sounds are being featured. Melis's request that the workers at a former factory create the machines' sounds recalls the analysis of turf dancing as "scored and choreographed to the rhythm of machines but without their presence."[62] A crucial difference obtains, however: the turf dancers themselves shaped the magical, if "elegiac," form, while Melis has orchestrated it.

Elaboración de cuarenta piezas rectangulares . . . registers regimes of unproductivity while raising questions. A reading of the work as cynical may assume that the factory workers would rather be gainfully employed in material production than asked to rehearse the empty motions of lost work. But should we make such an assumption? The workers are invited to create a symphony of sorts in lieu of manual labor. Wouldn't many people rather make art than work? From another perspective, we might also see the video as sharing an artist's interest in materials with workers who may themselves have a similarly special relationship with the materials they handle daily.

Is this high art liberating manual laborers from drudgery? We can rephrase the situation once more: Melis's art liberates unemployed workers from a dead time imposed by arcane laws and a dysfunctional economy. Or is it a parody of what might be considered work in contemporary Cuba? And what is the relation of the artist to the factory workers, once he is outside the struggling national economy, successfully circulating among elite artist residencies, while the workers are within it? (Or might they also be operating outside of it, in a black market?)

In *Vigilia* (Night Watch, 2012) art again substitutes for economic production in a nation where stealing from the state is *de rigeur*: Melis robbed a woodshop (through an arrangement with a watchman who worked there) and with the stolen materials constructed a "watchman's hut" from which the watchman could supervise the protection of further materials. Again the seemingly useless—a watchman who, rather than standing vigil, facilitates theft—is made effective, equipped with the materials to be gainfully employed. His uselessness in guarding the wood produces something useful, thanks to "art."

In *Here Everybody Takes Care of Me* (2007) Melis secretly filmed an interview with a business manager suffering from schizophrenia, whose illness has allowed him to establish a work environment where looking the other way is institutionalized. In *The Value of Absence—Excuses to Be Absent From Your Work Center* (2009–10) Melis paid employees the

Figure 5.1: Adrián Melis, *Vigilia*, 2005–6. Video still.

same amount of money that would be deducted from their salaries for missing a day's work in exchange for the rights to the telephone conversations they had with their centers of employment to falsely excuse themselves (a total of 60 Euros for 114 excuses). The work highlighted, again with echoes of Saco, the actual economic value of not being gainfully employed. It also highlighted the value of Melis's art, equal to their salaries.[63]

Value is at the heart of Melis's work: the value of lives wasted at non-productive work sites, and the value of lives wasted at productive work sites. Above all, Melis is interested in the value of art as simultaneously "useless" and more meaningful than the uselessness of non-productive jobs. He is also interested in the ways in which people turn their own uselessness in a poorly functioning economy into "an art": "Cubans have dedicated themselves to refining the exercise of not doing anything to the point of making an art of it."[64] In *Plan de producción de sueños para empresas estatales en Cuba* (Plan for the Production of Dreams for State-run Companies in Cuba, 2010–12) Melis asked workers from a number of businesses across the island to write down, over a period of four months, the dreams they had when they fell asleep on the job. Melis claimed rather sardonically that "The dream, in

contradistinction to the low productivity of the worker, is the individual's most productive moment."[65]

Producción de sueños para empresas estatales en Cuba is "playful" in some senses. Despite its scrupulous attempts to quantify the value of time and thought, it creates something out of nothing. It is about non-productive creation. Like Rancière in *Proletarian Nights*, it wants to get at workers' "dreams." Bryan-Wilson addresses such art directly when she asks: "What does it mean to be at work but not occupied—that is, not fully devoting one's attentions to the task at hand? Is this partial focus assumed to be the condition of most contemporary work? How might art also speak to this space of mental elsewhereness?"[66] Melis tweaks this situation of "at work but not occupied": the workers in his pieces are occupied but not at "work." Instead they are making (his) art.

Again an attempt to convert the useless into the useful, Melis's *Imports* (2012) consisted of a bin filled with illegal imports, mainly technological goods banned by the government. Through acts of sheer decree, these

Figure 5.2: Adrián Melis, *Plan de producción de sueños para empresas estatales en Cuba*, 2010–12. Installation: wood, paper.

eminently desirable and useful objects were deemed "not useful for the country, according to the law."[67] The consumer objects were transformed, by magical utterance, from useful and sought-after things into objects defined by a characteristic of the aesthetic: their uselessness. The state created art.

More recently Melis has turned his attention to post-crisis Southern Europe. *Time to Relax* (2013) focuses on the post-2008 economic crisis in Spain. A series of photographs depict drab, decentered, partial views of houses, streetlamps, or scenes from a window. Accompanying text informs the spectator that the images are of sixteen Spanish homes expropriated by banks when the owners could no longer pay the mortgage (the photographs include the date of repossession and the name of the new bank owner). Melis here works in a tradition of conceptual photography in which images depend upon external information (and the photographer's sometimes risky labor) to reveal the backstory to an otherwise opaque situation. The title suggests with a bitter humor the new kind of time available when one is dispossessed of even basic shelter and, presumably, the anxieties produced by being in arrears.

The related series *Stock* (2012) is a collection of twenty otherwise undistinguished and information-poor photographs of walls, warehouses, and the like. The photographs document the theft of materials from construction sites. Each photograph is accompanied by an image that describes the stolen goods. "The words replace what is absent, giving back what has disappeared and reintroducing the indexical condition of the photographic images."[68] Words (information) substitute for something more material, as in Melis's work with dreams. The theft would remain hidden were it not for the information contributed by the words. Yet the words do not actually reintroduce the indexical, since they remain outside the visual frame. The series comments on the simultaneous surfeit and illegibility of images circulating today. It comments too on the disjuncture between patent information and hidden realities, and the chasm between discourse and reality.

Melis's works have a ludic side, sometimes flirting with becoming one-liners. The humor can also be savage, though, directed at giant economic and bureaucratic systems that unblinkingly throw millions of lives into chaos. *The Best Effort* (2013), for instance, targeted exploitative companies and deceitful politicians, but also involved the unwitting participation of the job-seeking unemployed. Melis advertised four job

openings in Spain and gave contact information for those seeking interviews. When jobseekers called to apply, the phone calls were directed to the gallery where the exhibition took place. The calls went unanswered, but triggered the replay of recorded speeches by four of Spain's prime ministers—Felipe González, José María Aznar, José Luis Rodríguez Zapatero, and Mariano Rajoy—all celebrating Spanish growth and speaking positively about job creation. Again, Melis used casualities of failed economic policies to bring his artwork into being.

Poetics of Play

These artworks ask what becomes of creativity, time, and life itself in economies of underemployment. Almanza pursues this too. So does Franco Berardi in his book *The Uprising: Poetry and Finance* (2012). Both suggest that poetry offers unique insight into these transitions. One of Cuba's leading poets, Juan Carlos Flores, has posed similar questions. "Apuntes destinados a una foto en un álbum familiar" (Notes For a Family Album) describes a child's swing that pivots between the earth and heavens. In the careening rush through the air, children and animals blur, and "the place and time of games belongs to another order, barely observed by the mutants [*mutantes*]."[69] "Secadero" (Dryer) emphasizes play as a space for practicing chance:

> There is, to the south of Havana, between the green and the gold, a place designated for games [or gambling]. It is a tranquil place, they say, very good for mutations. I, have never been to that place, for fear of never returning. You, have never been to that place, for fear of never returning. He, has never been to that place, for fear of never returning. There is, to the south of Havana, between the green and the gold, a place designated for games. It is a tranquil place, they say, very good for mutations.[70]

The choice of the word "mutaciones," mutations, like the "mutantes" in the previous poem, stresses the kind of freedom to change, reconfigure, and lose oneself that play enables. It also invokes the more common synonym *not* chosen: *cambios*, changes. The Spanish, like the English, is linked etymologically to monetary "change," the kind associated with small-time gambling. One thinks too of the Chinese I-Ching, or *Book of*

Changes, a set of procedures similar to the divination practices of Santería, or to the Chinese *charada*.

Flores's poems, with their strange repetitions and their sonic emphasis—he produces many recorded versions of his poems, sometimes set to music—are interested in how change can arise from apparent sameness. Each reiteration of the same lines produces a new, cumulative understanding. What might these seductive and perhaps lethal changes be? Changes of fortune, perhaps, as sudden as a gamble's outcome.

A frightening kind of "play" and mutation is explored in Jorge Enrique Lage's futuristic worlds too, as we have seen. Lage's book of philosophical micro-narratives or prose poems *Vultureffect* (2011) opens with a first entry explicitly on this topic. "Perdidos" (Lost) plays on the premise of the television series *Lost*, that hypothetical, Crusoe-like situation of being stranded on a tropical island:

> We have nothing, but we have a soccer ball. Rather than relax and watch a soccer game or the series *Lost*, we head outside to run and kick around the ball. While sitting in the shade, some children ask if they can play with us. I tell them that we are not playing . . . It is quite definitely not a game . . . We destroy our shoes and ankles, we begin to get dehydrated, to consider exhaustion, desperation.[71]

At first the parable seems to redeem the simple pleasures of physical play in place of the more mediated, passive ones of watching broadcast games or television series. But this cliché of making do—the best things in life are free, etc.—is exposed as a cheap patina laid over the violent undercurrents of society, suggesting again the militaristic origins of games. Indeed, the apparent game is not a game at all, but a contest unto death, a kind of *Lord of the Flies* situation. It may reference aspects of post-1989 Cuban society too.[72]

Just as Almanza revisited Eliseo Diego's *Shambattle*, Lage returns to a prehistory of contemporary gaming culture in Cold War military strategy history. A scene from *La autopista* has Bobby Fisher recall his Cold War-era chess games against Boris Spassky (who lost to Fisher in 1972). Lage paints Fischer as a loony anti-Semitic paranoiac convinced of a Jewish conspiracy gleaned from *The Secret World Government* by the anti-bolshevik tsarist Arthur Spiridovich (based on the chess player's real-life delusions).[73] Strategy games lead to rationality's undoing, from

Cold War dangers to racist fantasies. The artist Adonis Flores, whose work I discuss at greater length in the next chapter, likewise reminds us of war games in his production of chess boards and pieces printed with a camouflage pattern (*Untitled*, 2007–8).

Sport and games are linked to the military in Lage's *Carbono 14*, meanwhile, through the symbol of the amusement park.[74] The aging park becomes an allegory of society and a topos that Antonio José Ponte has called a "theme park of the Cold War."[75] The portentously named "Villa S," which recalls the sinister Villa Marista, seat of Cuba's state security and the site of Lage's own obligatory military service, is an abandoned park that has acquired "a certain air of a military zone." The fields, whether for play or military exercises, are in ruins: "a roller coaster has fallen into pieces . . . swings are strangled by their own chains."[76] The swings are only the first indication that the site of intended "fun" can easily flip into the sinister. Flores, again, similarly performed a piece titled *Divertimento* (Amusement, 2006) in which he spent a day at simple amusement park, mounting rides while clad in fatigues.

Here rides are "torture apparatuses" unable to evoke nostalgia for some happier past:

> When I see all these torture apparatuses what I least think of is the past they might possess, the fun [*diversión*] and screams they may have witnessed . . . without doubt, times had changed and now the kids had other diversions with which to spend their time. Frank continued: —It's as if here one couldn't recall any past. Automatically one thinks of the future. And if there is something that one should not forget, it is the future. *Remember the future!* Ronald Sukenick said.—Who?—Someone should put up on the various channels of this zapping city signs that warn: FUTURE . . . Frank ended up admitting to me that an amusement park in ruins (or a park of ruined amusements) didn't make him think of children either: —Although something remains of the game-like atmosphere, of the ordered disorder, of spinning and getting dizzy or lost. But now with different creatures.[77]

The ruined amusement park recalls not innocent play but the ruins of attempts to force a utopian future. These physical ruins are placed beside some literary relics from the postmodern 1980s in the form of the avant-garde, Brooklyn-based Fiction Collective, of which Ronald

Sukenick was a member. The park provokes not nostalgia but the recognition of a new era of gaming, which produces "new creatures/children" with new ways to "spend time." *Ilinx* (vertigo, dizziness) moves from the bodily, from the swing or carrousel, to the affective. Lage fuses twenty-first-century capitalism's culture of play for profit with a "right to idleness." Later, a character plays a video game on a Playstation, a typical "strategy game" in which players build a universe from a primeval soup: "Each level is a strange ecosystem. In any case it's not clear what planet we are on."[78] The description of a standard video game trope (alien planets, unknown ecosystems) speculates on a new "species" of homo ludens: humans shaped by their Wii's and Xboxes, their new forms of "play" and of "spending" time.

Rewell Altunaga's Video Game "Mods"

If Lage imagines future video games, Rewell Altunaga modifies actual ones into game art. Altunaga favors "machinima" (works that use games' graphic rendering engines to produce novel sequences), "moding" (modifications of existing games), "mapping" (creating game levels/missions etc.), and the creation of wholly new video art games. Like many game artists, Altunaga is interested in aspects of temporality: mortality and the chance to live again, and the peculiar irony of spending one's waking life playing games about other lives. Many works highlight the genre's militarism, while others concern imminent environmental disaster.

The meaning of game art—often "mods" of popular games based on real wars—varies according to place. New media art made in Cuba confronts specific challenges. While digital photography and video art flourish, access to the internet has long been scarce, slow, and state-controlled. Market-savvy game creators know that this context matters: they even employ localization engineers to make culturally specific changes.[79] But what precisely constitutes "localized" culture today? Popular games based on real wars are as virtual to players in Cuba as they are to young players anywhere (not at all virtual, of course, to citizens of the afflicted areas).

Harun Farocki's *Serious Games* series (2009–10) shared its title with a subgenre of game art designed to make us think. The ontology of this

kind of game-based art was analyzed in an influential article by Shuen-shing Lee, "'I Lose Therefore I Think': A Search for Contemplation Amid Wars of Push-Button Glare."[80] Lee argued that by playing a small subset of purposely unwinnable ("serious") games, players snap out of entertainment's lull and awaken to the reality of a military-entertainment complex. Failure returns players to the real world, armed with a fresh critical sensibility.

Lee analyzes a few such unwinnable art games, including Stef & Phil's *New York Defender* and Gonzalo Frasca's *Kabul Kaboom*, both of which critique game design as well as global politics, such as anti-terrorist military missions.[81] He points out that whereas there have long been video games in which losing is inevitable, and high scores are instead the objective, art "games" like *Kabul Kaboom*, in which food drops are interspersed with bomb drops, effect a meta-critique: "there is no winner in a situation in which buildings are toppled or bodies are turned into 'hamburgers.'"[82]

Altunaga's serious games set up violent situations but hobble their players: for instance, they may be shot at but are unable to shoot back. His mod *Coward* (2007), adapted from *Delta Force: Black Hawk Down Team Sabre*, depicts both real and fictive UN missions in Somalia, Colombia, and Iran. *Coward* raises questions not usually posed by players. Arab, Latin American, and African figures crouch in submissive positions: of prayer or imminent execution?[83] And who is the "Coward"? The player walks among the crouching bodies, but can take no action. Other pieces use built-in cheats to bring to the surface the violence secreted at the heart of the games, whose technology often derives from the military.[84] *Ammu-nation* (2006) modifies *Grand Theft Auto IV: Vice City* by over-firing the "Panzer" cheat, producing a plague of tanks that rains, like so many biblical frogs, upon a Miami guns'n'ammo store, highlighting gun culture and urban decay.[85]

Altunaga first played video games on an illegally rented Nintendo that a neighbor had brought from the US (in 1980s Cuba, video games were considered a mode of capitalist alienation). He is part of the first, global generation of players, and is not the only Cuban artist making mods and repurposed video games. He has, however, worked most consistently in the genre, and in 2013 he co-curated with Liz Munsell of the Boston Museum of Fine Arts a show of Cuban "digital" art at Tufts University's art gallery.[86] Popular interest in gaming in Cuba was ratified in the

summer of 2013 by the opening of newly legalized private "cinemas," most with dedicated video-game salons. By the autumn, however, the state had closed the spaces, alleging poor taste.[87] As internet access remains scarce, thousands of young engineers and game aficionados have forged unofficial, DIY intranets reaching thousands of users, to play multiplayer online games with one another.

In 2008 Altunaga reflected on the limited scale of internet-based art in Cuba, lamenting its surprising absence in a nation that historically "had always been at the avant garde of contemporary art," and where a scarcity of materials ought to have made digital possibilities appealing.[88] Altunaga pointed out that Vuk Ćosić, who in 1995 coined the term "Net Art," was from Eastern Europe, a biographical detail that media theorist Mark Tribe also finds relevant, arguing that Cosic's geopolitical positioning uniquely enabled his prescient insights into early Net Art, which often described the transition from communism to capitalism and the ensuing privatization of the internet.[89] Altunaga suggests that a revitalized Cuban Net Art today might reveal insights into contemporary changes. Perhaps, however, Net Art's moment has passed, and it is to new digital forms that we might better turn for critique.

Contextualizing Appropriation

Altunaga's work adapts the language of "universal" gaming—in the sense of the games' global marketing, but also in the sense that they presume common *universes* shared or constructed by players. The media theorist Alex Galloway has written that the *meaning* of video games depends entirely on context. His example includes a contrast between the US Army game *Special Forces* and the Hizbullah-developed *Special Force*. As Galloway observes, "video games absolutely cannot be excised from the social contexts in which they are played. To put it bluntly, a typical American youth playing *Special Forces* is most likely not experiencing realism, whereas realism is indeed possible for a young Palestinian gamer playing *Special Force* in the occupied territories."[90] Galloway's example works well, with its neatly matching titles. But context itself is contextual. Few comparisons are as stark as US/Palestinian players, *Special Forces/Special Force*. Many players exist in more comparable, if

inescapably singular locales. And what of contexts that are at once radically different and somehow essentially equivalent? Cuban and US culture is not only often shared, but is historically mutually constitutive. At the same time, few governments today have engaged in such long-standing enmity. Altunaga's work thus manages to highlight aspects of a generic language—itself strongly marked by the accent of Cold War discourse of good and evil, and of imminent apocalypse—that reverberate with aspects of contemporary Cuban life.

A shared approach from ostensibly opposed positions characterizes the convergence between Altunaga and the US artist Cory Arcangel. In 2002 Arcangel made *Naptime*, a mod of the classic game *Super Mario Brothers*, which Altunaga has called the "emblem of a generation"; in 2011, Altunaga modified Arcangel's artwork in his own machinima, *El sueño de Mario* (Mario's Dream). Arcangel has been characterized as pursuing "an abject beauty in the way that modern technology is doomed to obsolescence."[91] A similar fascination on the part of people not living on the island with the functional yet "obsolescent" material culture of Cuba has been common in the post-Soviet period. The purported charm of this material culture implicitly derives from what is seen as a heroic or romantic withdrawal from capitalist rhythms of planned obsolescence, but that might well be the inevitable result of scarcity born of both the US embargo and poor economic policies, or what is sometimes referred to as an internal embargo. Yet Altunaga, too, works with obsolescence and nostalgia for earlier technologies. Born just one year before Arcangel, he shares many of the same gaming watersheds with his peer. But he also draws on commemorations of 1980s Soviet cartoons such as *The Musicians from Bremen*, appropriated in the interactive video installation *Y si la memoria no me falla* (If My Memory Serves Me, 2010).[92]

The two artists' mods of *Super Mario Brothers* together reveal how the genre's patina of appropriation and mass culture does not necessarily represent a populist hacking of the medium and its aesthetics. Instead, they highlight the art market's increasing need to isolate singular "art" now that the tools of the trade are widely available via platforms like YouTube, and "skins" and "mods" are produced with tools included by game-makers themselves. The video artist Dara Birmbaum called attention to this paradox of a lone artist mining mass-entertainment media. In an interview with Arcangel, she noted

that the artist's "star status" owed to the art world's demand "that some-one's got to 'crack the code' of popular culture."[93] It was particularly ironic, then, that the popular code that Arcangel cracked was precisely the relocation of the means of production into anyone's hands. In other words, the art market responds to the potential eclipse of singular genius by masses of amateur artists by canonizing the codecracker himself as outside of (above) the code. In so doing it salvages a genius from the masses of creators.

Now based in New York City, until 2014 Altunaga operated, albeit only partially, outside a global art market, supported by Cuban art institutions such as the Asociación Hermanos Saíz, a government agency that helps young writers and artists. Still, despite the markedly different environments in which he and Arcangel operate—Altunaga with, until recently, limited access to the internet, Arcangel with cutting-edge tools—both make a similar move. Arcangel creates art by curating clips from the masses of anonymous people who post videos of themselves playing Bach, for example, and turns them into a valor-ized, single piece, with the signature Arcangel (*Here Comes Everybody: A Couple Thousand Short Films about Glenn Gould*, 2010–11). Altunaga, for his part, removes video games from relatively cheap black-market networks and reinserts them into one of the more lucrative official networks on the island, where artists—and now some other profes-sions—long constituted a privileged few with easier access to cash and travel opportunities. In other words: modifications of media every-where position the resulting artworks beyond the original site of consumption (YouTube, the console, insular gaming networks) to produce an object with added value.

This elevation of games from pastime to art is at least partially a modernist move, which combines with Altunaga's organizing interest in exploiting errors.[94] The pieces *Welcome* (2008) and *Ciudad Sobreexpuesta* (Overexposed City, 2012), which modify *Halflife II* and *Hitman* respec-tively, similarly nod to modernism. By interrupting the communication between a game's software and hardware, Altunaga yields fragmented images that he aligns with Rodchenko and other Futurist or Cubist styles.[95] Modernist critical distance is also created when games fail and force the player back into the real world.[96]

Altunaga subtly explores redemptive failure in the mod *Aftermath* (2009), which borrows from the games *Modern Warfare* and *Call of*

Duty to describe an ecological apocalypse by means of a character who stumbles through it in typical "first person" perspective, and, only moments before dying, comprehends the nature of the disaster. Alex Galloway and McKenzie Wark have insisted that games are allegorical.[97] If so, the solitary nature of first-person shooter (FPS) games, whose protagonists face supra-individual environmental apocalypse, suggests the limits of the subjective genre in the face of planetary challenges. The tardy realization of contemporary mining and under-mining of the very substrate of human and nonhuman existence is previewed as if it were a morality tale designed to prod players/viewers towards action.

"What do video games, which tell us more about our unconscious than the works of Lacan, offer us?" Chris Marker asked rhetorically while meditating on the theme of doubling in Hitchcock's *Vertigo*. "Neither money nor glory, but a new game. The possibility of playing again. 'A second chance.' A free replay."[98] Video games' frisson lies in the tension between "a second chance" and the looming "game over." Altunaga's *Inmortal* (Immortal, 2007) capitalizes on this space of brief hope by eliminating most of the "meantime" in which players move through a game. In *Inmortal* the spectator/"player" is forced time and again straight to her death. By reducing the time between a new life and "game over," *Inmortal* reveals second chances to be as doomed as the first. Rather than live again, Altunaga allows us only to die an infinite number of times. *Inmortal* thus meditates on the illusory hope that Marker attributes to video games (Altunaga conceived of *Inmortal* as a dialogue with the medium itself).[99]

Altunaga's "mod" *Flash Point* (2007) similarly reduces the game *Operation Flashpoint* to its implicit, almost Heideggerian being-to-wards-death. *Flash Point* is an artwork that curates the many deaths possible in the original game, which blazons each fatality with a famous quotation about death: Nancy Reagan, "I believe more people would be alive today if there were a death penalty"; Stalin, "A single death is a tragedy: a million deaths is a statistic." *Operation Flashpoint*, created by Czech game developers, is set in 1985 amid a Cold War crisis on three fictional islands. The situations and setting are commonplace in game narratives. But they reverberate here with the added assonances that owe to its modification as a post-Soviet reflection on death during the Cold War, made on an actual island.

Figure 5.3: Rewell Altunaga, *Shoot in War*, 2008–ongoing. Screen shots.

The blurring of militarized reality and representation feed off one another in Altunaga's *Shoot in War* (2008–ongoing), a series of screen shots/photographs that Altunaga adapts from video games based on real wars. Imagining his piece as virtual photoreportage documenting representations of real wars, he plans to share these images on the internet with soldiers who have served in the wars represented. The goal is to place virtual gaming experience alongside real life and death situations: to play the game even as the soldiers are fighting the same war in reality.

Altunaga documents a virtual apprehension of the globe. In lieu of travel, we have video games; in lieu of bodies, the FPS carries a weapon as his prosthesis.[100] Altunaga's plan for the unrealized *The Search* (2002) depended on a telescope (which proved too costly for Altunaga to actu-ally procure) as a related prosthesis to explore a receding reality. Although Altunaga describes *The Search* as interested in a transcendental search beyond human limits, the apparatus more specifically conjures the allu-sively cinematographic telescope associated with the modernist, bourgeois protagonist Sergio in Tomás Gutiérrez Alea's 1968 film *Memorias de subdesarrollo* (Memories of Underdevelopment). Sergio's ambivalence vis-à-vis the revolution is palpable in his distanced observa-tion of the city through his telescope, stated in voiceover: "Has the city changed or have I?"[101] Altunaga's work suggests that today what has changed are the technologies for experiencing wartime—and peacetime.

CHAPTER 6

Surveillance and Detail in the Era of Camouflage

I t would be hard to overestimate the influence on young Cuban partici-
patory and conceptual artists of Tania Bruguera's *Cátedra Arte de
Conducta* (2002–9), a series of workshops that the artist coordinated
through the Instituto Superior de Arte and that was geared towards
producing an "Art of Conduct," or art that uses behavior, power, and
interactions as its raw materials. Bruguera's own work, realized in differ-
ent sites and situations throughout the globe, is concerned with
intervening into social networks, or the "social body."[1] Often involving
witting or unwitting nonartist participants, her pieces draw on earlier
performance and conceptual traditions.[2]

Bruguera has at times combined this interest in the social body with
new media networks. *Tatlin's Whisper #6 (Havana Version)* (2008), for
instance, made for the 10th Havana Biennial, consisted of a podium
flanked by a man and a woman dressed in military garb. *Tatlin's Whisper
#5* (2007) was peformed at the Tate, and consisted of mounted police
using their police academy skills for crowd control. In the Havana
version, anyone in the audience, comprised of Cubans and international
biennial attendees, was permitted to speak into the microphone (or
stand before it and say nothing at all) for up to 60 seconds, after which
the speaker would be hauled off by "guards." While at the podium, each
speaker had a white dove placed on his or her shoulder, a visual echo of
a moment during a 1959 speech by Fidel Castro in which a dove landed
on his shoulder, taken by some as a sign that he had been anointed.

Although Bruguera was prepared for no one to come forward, a variety of "speeches" were delivered by audience members throughout the performance, ranging from silent tears, praise for the government, boring soliloquies, and several notable interventions critical of the state by journalists, lawyers, and others. The piece occasioned a censorious response from the biennial's organizing committee.[3]

Since January, 2015, however, *Tatlin's Whisper* is better known for a subsequent, thwarted reenactment. In the immediate wake of the December 17, 2014 announcement of the normalization of relations between Cuba and the United States, Bruguera proposed to stage a version of the work in the Plaza de la Revolución, granting speakers one minute to reflect on the normalization of relations. Bruguera negotiated with officials, who wanted the piece performed in the Museo de Bellas Artes; the artist then suggested it be staged outside, between the art museum, and a monument and museum to the revolution. The officials refused, and when Bruguera insisted on staging the piece at the Plaza de la Revolución she was preemptively detained, as were artists and others who attempted to witness or participate in the performance. In the days and weeks that followed a flurry of articles explored whether the piece had been frustrated, or whether, unwittingly, the state security and police had played their roles perfectly; Bruguera, for her part, insisted she had indeed hoped to see the piece more specifically realized.

A darkly poetic coda followed. Bruguera's gallery manager and sister posted a photograph and update on Facebook in which she alleged that the state security had placed on a roof opposite the Bruguera residence a small antenna (that looked much like a microphone) in order to listen in on the Bruguera household. Bruguera's sister concluded: "the art critics are working as police and the police as art critics in this 'case.'"[4] This same sense of criss-crossing lines of art and (internal) espionage will recur in the work of novelist Ahmel Echevarría, discussed at the end of this chapter.

For now, however, I want to move away from Bruguera herself to the work of the numerous graduates of her workshops, who have been more notably interested in exploring surveillance systems and charged militarized spaces. This focus on surveillance emerges out of, but departs from, the participatory art championed by Bruguera, which does not eschew new media *per se*, but is simply more concerned with actions, power, and behavior than with technological systems. Bruguera has, to

be sure, made ample use of virtual communities in recent projects on migrant life in the United States and Mexico (*Immigrant Movement International*, 2010–ongoing), and she relied on spectators' photographs and videos to broadcast the unfolding of *Tatlin's Whisper #6 (Havana Version)*. But while Bruguera tends to work with bodies when she intervenes into local situations, some of her protégées increasingly undertake what Geert Lovink terms "tactical" interventions—breaking into technological systems and using them to other ends.

In a way, this interest should come as no surprise. Contemporary art looks on with fascination and even envy at the ubiquitous new technologies dedicated to visuality or dissimulation, designed to read surfaces, to cull language and meaning from metadata, or to assemble and disturb patterns. And surveillance art is not new, of course. José Quiroga has noted that in Cuba "surveillance has been validated in political as well as artistic terms" since the 1960s.[5] But the turn to the more globe-spanning systems reveals an awareness of the new scale with which artists must grapple.

The US military prison in Guantánamo is one site of surveillance that is easily at hand and eminently iconic, and it is the topic of a number of recent works that the critic Esther Whitfield has studied.[6] Pedro Frank Gutiérrez Torres and Alexander Beatón Galano, for instance, have made a piece about forms of surveillance standing off against one another on the Cuban and US sides of the "no man's land" dividing the prison from the Cuban town Caimanera. José Ramón Sánchez's newest book of poems, which follows his more environmental concerns in the books *Marabú* and *El derrumbe* discussed in Chapter 2, is also dedicated to the prison, and Sánchez edited a 2014 issue of the Santiago-based literary journal *La Noria* on the prison in contemporary Cuban life and culture.

Closer at hand still is the monitoring of Cuban citizens by state security (G-2), or what national leaders once "proudly called 'a spy network,'" as Lillian Guerra documents.[7] Cuban art has long addressed its own security technologies and vigilance. The most mainstream Cuban novels and films have, for decades, featured informers, gossip, surveillance, and paranoia, whether for cheap laughs, mild critique, plot thickening, or local color. The more rarified visual arts, traditionally spared from state meddling to a greater degree than literature, have also addressed censorship and media (often thematized in paintings and performances involving looming microphones, speech bubbles, gagged mouths, and

the like). So ubiquitous is the trope that non-Cuban critics discover it even where it may not have been intended, yielding, for instance, readings of Abigail González's quiet interior photography as characterized by a look of "pseudosurveillance" and of Ernesto Leal's photographs as "physically invasive of both personal and private space."[8]

The subject cannot be solely attributed to a voyeuristic gaze or to calculated selling of political art for a middlebrow market. The comedic video *Monte Rouge* (Eduardo del Llano, 2004), which parodied the bungled and overt installation by security agents of a surveillance system in the home of a reluctant informer, "went viral" among Cuban viewers both on and off the island. Antonio José Ponte's 2010 book *Villa Marista en plata: arte, política, nuevas tecnologías* (Villa Marista in Silver: Art, Politics, New Technologies) analyzed del Llano's video alongside a series of other artworks that have recently exposed the government's "repressive organs" on a scale now possible thanks to digital technologies, and documented the fear that dogged the video's cast.[9]

Indeed, so *much* art in Cuba addresses censorship and surveillance that taking it as a theme for study risks banality.[10] Unlike the globe-spanning tentacles of the United States' National Security Administration (NSA) or the coordinated multi-national surveillance systems such as ECHELON (in which Australia, Canada, New Zealand, the UK, and the US collaborate), Cuban surveillance produces the illusion of a more manageable and closed system. This relatively insular circuit and decades of restricted travel for Cubans have yielded the sense of a closed set of possibilities and decisions, as reflected also in Lázaro Saavedra's satirical *Software cubano* (Cuban Software, 2012). The hand-drawn, deliberately low-fi flow chart orders the sequence of options for Cubans according to a chain of decisions that follow from an initial question: whether to separate oneself or not from "common doctrine, beliefs or conduct." This first decision leads inexorably to a subsequent series: "dissent" or "simulate," "emigrate" or "closet opposition," and so on. When the possibility of travel appears, options include defecting, and departure itself is subdivided by means: if through an embassy, by plane; if not, by sea, and so on.

Over the past decade, however, the staggering, indeed totalizing scope of US-based and collaborating surveillance regimes has been exposed to an unprecedented degree. And it turns out that surveillance technologies may owe less to Soviet-style monitoring than to capitalist

bureaucratic and gambling technologies.[11] Not surprisingly, then, artists such as Bruguera, Celia y Junior, Susana Delahante and Fidel García are training their analysis of contemporary surveillance both on the national context and beyond.

Camouflage is the New Paranoia

In 2010, Altunaga curated an exhibition of young Cuban artists working in both "old" and "new" media entitled "El extremo de la bala" (The Tip of the Bullet). The name evoked a straight-shooting avant-garde worthy of the term's military origins: art as a bullet aimed at the future. Bullets echo the militarized language of the government. Yet they also leave it behind, for while they may conjure lingering Cold War discourse or nod to the current leadership by Raúl Castro—former head of the armed forces—their real target is militarization in contemporary visual culture. Unlike Cuban artists from the 1990s, who grappled more visibly with post-Soviet economic and ideological crises, a few of the artists in "El extremo de la bala" addressed a pervasive society of control underpinned by widespread military force.

There is a sameness about militaries, about their sartorial and social codes, that belies their own avowedly nationally specific goals. Camouflage, for instance, is adopted by national armies, but actually depends upon site-specific uniforms, adapted to generically urban, desert, or jungle locales. One artist included in "El extremo de la bala," Adonis Flores, served as a teenager in Cuba's armed forces during the last year of the Angolan civil war. In his series *Camuflaje* (Camouflage, 2007–ongoing) he carries out a series of playful performances.[12] He has swirled a hoola hoop dressed in fatigues, painted his uniform with a pattern of small white flowers and posed in a field of white daisies, and strolled the streets of Nottingham, England, in uniform. A 2009 performance in Canada had him wandering around on all fours in camouflage, and ending up at a gasoline station. For a riskier piece planned for an upcoming exhibition in Colombia, Flores plans to sleep on a waterbed filled with gasoline.

In *Lenguaje* (Language, 2005) Flores painted an intricate camouflage pattern on his tongue (*lengua*). The image might suggest the dissimulation of one's language and thoughts: masking one's words in military

symbols. Or it could be seen as a familiar commentary on self-censorship, a queer critique of the kind of conformism and blending-in required by military codes. But this is all perhaps too easy. Flores's camouflaged tongue does *not* blend in with other tongues, since its painting separates it out and marks it as belonging to the military, or at least to a clandestine forested setting. Language may, under some circumstances, hide behind military hues. Here, however, such trappings make it stand out (or stick out) as artifice, as *un*natural: an inversion of the very logic of camouflage. The art critic Elvia Rosa Castro has written that *Camuflaje* is a commentary on how "contemporary language is plagued, to a high degree, with militaristic obsessions and with vacuous fundamentalisms and nationalisms, making paranoia one of our attributes."[13] Castro suggests that in the same way that camouflage toes a line between nature and artifice, visible and invisible, militarized speech has become both natural (part of an everyday environment) and empty (vacuous), ever-present and severed from any referent.

The historian of science Hanna Rose Shell has recently documented the intimate ties between photography, military technology, biology,

Figure 6.1: Adonis Flores, *Lenguaje*, 2005. Photograph, 90 cm x 67.5 cm.

and camouflage. We tend to think of camouflage as a patterned effort to hide soldiers in foliage. Yet the history is more complex. Camouflage, Shell reveals, "came into being as a way to refer to systematic dissimulation for the purposes of concealment from photographic detection."[14] That is, the signature pattern was developed specifically to resist photographic technologies that captured images of enemy territory to be searched for marks. Flores, who primarily works in photography and performance, may be aware of the intertwined histories of camouflage and photography.

Maleza (Weed, 2005) is a large format print that teems with soldiers in army crawl, outfitted in camouflage—all digitally replicated copies of Flores himself—inching their way across what appears to be desert. The foreshortened perspective eliminates any space between the most distant soldiers, who bunch into a bright green pattern punctuated with skin-colored faces. The ramifying soldiers have become the titular "weed," erasing singularity through multiplicity: the sameness of a single image becomes something larger than itself. The environment into which the soldiers must blend is not weeds but other people, or other copies of oneself.

In the video *Honras fúnebres* (Funeral Rites, 2007), Flores, dressed in camouflage, spins a hoola hoop made of flowers about his waist. Humor

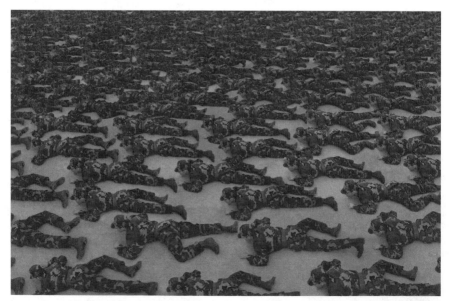

Figure 6.2: Adonis Flores, *Maleza*, 2005. Chromogenic print, 9.5 cm x 134 cm.

and flowers, signs of peace, here mark a generational divide between a proud militancy that characterized much of the generation that partici- pated in the late 1950s battles leading up to the revolution and the ominous charge that militancy had for many decades later. One reason for these changing valences was the very Angolan war in which Flores fought, and which catalyzed a widespread disaffection. In 1989 Arnaldo Ochoa, a decorated general from the war, was executed following charges of narcotics trafficking and corruption. For many who still believed in a revolutionary project, the execution produced a loss of faith.

Rachel Weiss has described in detail the 1980s artist Leandro Soto's more uncomplicated, celebratory use of toy soldiers and images of his own family in militant gear. Flores shares with Soto an interest in perfor- mance, play, and the reinsertion of segregated military cultures into everyday public space and the street. But Flores's commentary on the military, on masculinity, and on soldiers' ethics departs from the revolu- tionary epic. Instead, it participates in a general critique of military aesthetics. At the same time, it is marked by his personal experience of the Angola war, off to which he went enthusiastically, embracing the discipline and clarity of the military, but from which he returned changed. While Flores's personal trauma is suprapersonal and genera- tional, it eschews the grand rhetoric of Soto's generation.

Elvia Rosa Castro's reading of *Camuflaje* as ultimately about a gener- alized paranoia is also instructive. Camouflage's military pattern was, after all, originally designed to hide something necessarily operating in plain sight. In a world that demands camouflage, there is no depth in which to hide. Surface disguises. One reads the surface not for what announces itself as there, but for what hides in the open. Camouflage therefore demands a reading situated somewhere between "surface read- ing" and "symptomatic" approaches that search for a hidden essence.[15] As Shell's history documents, photography produces a surface within which layers can be sought.

Camouflage indicates a paranoia rooted in representation and visual- ity itself, rather than in something covered over. It suggests that within a person—like a tongue within a mouth—there exists not a well of authen- tic interiority to be expressed, but only a logic of militarized passing. The implications for an art that deals with militarism and surveillance is that its task is not to name the ways in which contemporary societies have "transitioned" to a wholesale police state logic or surveilled control.

Rather, it points to the fact that surveillance operates via surfaces (the voluntary uploading of information; barely disguised security agents). This may be the message of *Monte Rouge* as well: not that state security has become an outdated joke—*segurosos* remain a frightening bunch of people and repression of those who critique the state continues—but rather that the idea of more covert surveillance belongs to another era.

Humberto Díaz played with these questions in a performance he realized in Warsaw (*Paranoid Dreams*, 2013), where he lay on a bed with dozens of electric cables attached to his head, which flowed for some 600 feet throughout an empty apartment. In connecting his skull to the power supply and outlets, Díaz's performance—staged in a nation that had been subject to Stasi surveillance—suggested that machines or people outside might be listening in on, observing, or even affecting his brainwaves, recording or producing "paranoid dreams." The dreams are presumably contemporary, wired ones. Yet the terrain of earlier surveillance lent the piece, in 2013, a slightly anachronistic air. If, as surveillance studies argue, today's society of control is being masterminded from casino technologies, evocations of Soviet-era monitoring address an anxiety that has morphed. On the other hand, the connections between Soviet vigilance and its legacies in Cuba remain largely undisclosed.

The crudeness of these references can become a kind of material itself, as if the implosion of allegory were the point. Melis works with anachronism in *Moments that Shaped the World III—The East is Red* (2012), which runs images from contemporary China over an audio extract from 2008 of Raúl Castro singing a song about Chinese communism, "The East is Red." The series is designed to mine the difference between how people believed the world was being shaped in an earlier moment and how it appears now. The piece also highlights how little discrepancy may actually exist between earlier ideologies and what has come to pass: contemporary China as not a betrayal, but a consummation, of state capitalism.

Susana Delahante's *Paranoia* (2011–12) takes up the titular affect once again, projecting onto a screen infinitely nested images of the artwork's spectators looking at the screen. The vertiginous repetitions of the viewers watching themselves watch themselves reprises 1970s explorations of closed-circuit video.[16] Delahante, who is currently based in Cuba after a period in Germany, claims that a principal concern in all of her work is the paranoia common to contemporary society at large, in which one is

made to feel that there exists an "enemy who observes distantly and simultaneously nearby."[17] This toggling between scales both vast and intimate, far and near, as we shall see, constitutes a recurring characteristic in the systems-based work of Celia y Junior as well.

Delahante repeatedly explores not only how we visualize or apprehend paranoia, but also how we inhabit it. Enlisting participants/spectators as guinea pigs, *Time Based Land* (2011) consisted of holograms of a minefield that used motion sensors to simulate how people might successfully thread through an unpredictably mined space. Other of Delahante's works not explicitly about surveillance remain interested in exposure. In *Foundry* (2009), for instance, the artist made a work in a Montreal foundry turned artists' residence. Many workers had died in the space when it was an operative foundry, and Delahante wished to record her own bodily response to this morbid history. She projected a film of herself marching around the foundry naked, appearing, disappearing and reappearing around the corner in ghostly flashes across a series of hanging screens.

An argument that the philosopher and art critic Hito Steyerl advances in her essay "Is a Museum a Factory?" seems apposite here for grasping one intervention that Delahante effectively made.[18] Steyerl begins by reminding her readers that in the 1960s, explicitly political cinema such as the Argentine film *La hora de los hornos* (The Hour of the Furnaces, 1968) was made to be screened in factories.[19] She then observes the seemingly ironic way in which political cinema (or art) returns to factories today: films designed to engage factory workers now engage visitors to museums, often located in former factories in post-industrial North America and Europe, whose factory work has migrated to China and Southeast Asia. Yet as Steyerl argues convincingly, there is in fact no irony in this return. The new museums do not bury or paper over the old sites of production after all. Instead they rightly take over the industrial factory's place as the *new* factory of a post-Fordist sociality.[20] The new "social factory" manufactures those forms of labor termed affective. It is a factory that "pervades bedrooms and dreams alike, as well as perception, affection, and attention. It turns everything it touches into culture, if not art. It is an a-factory, which produces affect as effect. It integrates intimacy, eccentricity, and other formally unofficial forms of creation."[21] To participate in this post-Warholian factory one need not actually make art *about* intimacy and affect, though certainly much participatory art

has done just that. Delahante's work seems one illustration among many more of this tendency.

Delahante favors death and life as her raw materials. So much so that in *El escandalo de lo real* (The Scandal of the Real, 2006–7), she was artificially inseminated with the semen of a recently deceased man (she terminated the pregnancy after about a month).[22] Her interest in life, death, and biopolitics was the focus, too, of her series *Retratos/Portraits* (2005), in which she updated portraiture for a data-driven era. The series suggests that a subject's essence is no longer registered in the position of hands in a lap, the aquiline nature of a nose, a smile playing on the lips. Now our portraits are inscribed in biometric information, the kind Delahante imagines to inhere in the blood she collected from different corpses and placed on crystal plates. In microscopically visible letters she wrote in the blood her suppositions about the deceased: eating habits, illnesses, vices. Her work, like that of Celia y Junior, employs a minute scale to register details that might go unperceived by some Big Other, in order to offer a point of view "alternative to that of the power structure."[23] Yet, as is true for much systems art, whether Delahante works within or against the logic she temporarily uses remains up for discussion.

Power structures and voids are the target of various other works by Delahante's peers. Ever since the emergence of institutional critique—which in Cuba played out notably in the late 1980s, when ABTV "produced critical replicas and countersystems of distribution" including "*Homage to Hans Haacke*"—the art world itself has often been the target of art about systems.[24] Celia y Junior's *¿En medio de qué?* (In the Midst of What?, 2008), for instance, addressed exclusion by state-run art spaces. The artists recreated the interior of the touristic Havana bar *La Bodeguita del Medio*, known for the palimpsestic layers of customers' graffiti carved into its tables or scrawled upon its walls. The artists' friends were invited to tag the walls of the improvised, makeshift "bar" with the names of others artists and exhibitions that had been censored. *¿En medio de qué?* reflected on how some exhibitions (themselves of various different *medios*, or media, which echoes in the playful title) are not visible at all for having been censored. Like the duo's *Los amigos de mis amigos* (My Friends' Friends, 2011), which agglomerated Facebook profiles of young Cubans who have left the island, *¿En medio de qué?* essentially created a network of absence, recording what is not there: a dispersed generation.

Such registries of the emigrated, omitted, censored, or simply absent have their counterparts in a commissioned series of film posters by Cuban artists and designers for dozens of planned films never realized (Eduardo Marín and Agapito Martínez, *Ghost Poster* [2011–ongoing]).[25] Marín's curation is an elegiac testament to what Cuba's great *auteurs* such as Tomás Gutiérrez Alea and Sara Gómez planned to make, but for various reasons did or could not. It is also a kind of celebration of Cuba's storied film-poster tradition, gone the way of the waning national film industry.

Yet it is anti-elegiac, too. It acknowledges a post-cinematic moment in which, on the island, most media circulates via flash drives—a form of plenitude amidst infrastructural scarcity. The project is thus affirmative, a creation of something out of nothing, representations of films with no actual films to back them up. In 1969 the filmmaker and critic Julio García Espinosa predicted in his famous manifesto "For an Imperfect Cinema" that "Art won't disappear into nothingness. It will disappear into everything."[26] The essay today seems a strikingly (if perhaps inadvertently) prescient diagnosis of contemporary media use. As Cuba's state-run film industry slows or opens to European co-productions, digital productions multiply.

Art's Limit: Fidel García's Microsystems of Self-Collapse

While independent digital video fills (quite differently) the spaces left by a centralized national film industry, contemporary new media art fixes its sights on extra-aesthetic ends. In 2011 the artist Fidel García asserted that he was not interested in using art's instruments. Instead, he proclaimed, art was "at the edge of its evolution."[27] García didn't mean that art was evolving into philosophy, as Arthur Danto's reprisal of Hegel had it.[28] Rather, García meant that today art has merged with the knowledge systems that underpin contemporary governance, surveillance, and communication.[29] García works in "tactical media," proceeding from a hacker ethos that exploits bugs and loopholes in electronic systems: radio circuits, the internet, the global market. Intervening into these systems by releasing viruses or blocking transmissions, he works with control, transmission, distribution, and creation. If code is the hidden script for digital materials, García's art aims to make visible those circuits that are typically hidden from sight.

Auto organización (Self Organization, 2008), made for the Gwangju Biennial, generated a literal third territory beyond North and South Korea by cultivating a bin of earthworms that produce and excrete soil. Their waste generation was controlled by electric impulses whose variation was the result of an algorithm generated by processing the propaganda produced by each state about the other. The more ideological verbiage each state produced about the other, the more excrement the worms produced, the more a new soil came into being.

Auto organización built upon an existing interest in new or virtual *terrenos* (terrains) explored in García's *T. Error* (2006), a space the artist intended as a territory that radio emissions from Cuba's *Radio Rebelde* were unable to penetrate. For García, a space cut off from information today constitutes a non-space. *T. Error* is but one of a series of works focusing on the failure or success of closed systems of communications. *Bomba lógica* (Logic Bomb, 2008) took its name from the computing term for a piece of code that sets off a malicious function when certain conditions are met. The piece consisted of infiltrating and broadcasting the closed circuit of police control and vigilance in the colonial section of Havana. García hijacked the police's radio frequency and broadcast its

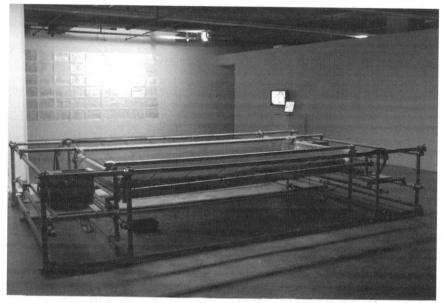

Figure 6.3: Fidel García, *Auto organización*, 2008. Installation: 2000 earthworms, organic material, computers, antennae and cards for TV-radio, circuits, cables, scaffolding, 150 cm x 300 cm x 700 cm.

communications in a gallery in Old Havana. Like Altunaga's "serious games," García's rerouted circuits depend on strategies of failure or exaggeration. *Bomba lógica*'s inscription as art depended on the necessarily irrelevant (to the state) audience in the art gallery: to succeed as art, it had to fail as political critique. In a moment of tight state control, it was striking that García's broadcast elicited no response from the police. Or perhaps it was not, since, after all, it's only art, which enjoys sizable governmental support and relative freedom. In any case, García wasn't interested in an easy fingering of Cuban state vigilance: *Bomba lógica* was intended as a response to the intensified militarization of information after 9/11.[30]

Hermetic spaces of communications technologies that are alternately hijacked and amplified, or barricaded and excluded, move outside the gallery and into spaces of un-networked "wilderness" in *Estática* (Static, 2011/13), twenty-four hours of ideology first broadcast into an otherwise silent zone in Alaska, then, two years later, in Death Valley. The notion of the pristine nature of such apparently remote, closed spaces here proves a red herring, since Alaska, for instance, far from existing beyond the ideological, is known for its "last frontier" discourse, its libertarian ethos of self-reliance.

T. Error and *Estática* evince García's interest in spaces bereft of signal or reception. Blocking or diverting transmissions makes obvious that which goes unperceived: the nonsensual aesthetic, the unfelt, the data that drives policy and power. García's work mines radio, telephone, and internet systems, but increasingly apprehends the globe—the planet and its geopolitics—as the ultimate system, and the global market, now centered in China, as one of its principal networks. *The Fourth Power* (2009), meant to be "a totalitarian model of the global economy," featured laconic black boxes of thick plastic, as if containers for the post-wreckage secrets salvaged from the cockpit of the 2008 economic crisis. Produced during a two-month artist's residency in Chongqing, *The Fourth Power* circulated lists of the world's GDPs over twenty years, and from this information generated futurological predictions about the planet's new global power, offering a "miniature system of the whole planet in economic terms."[31]

García's work thus updates systems critique for the present. Conceptual art of the 1970s reflected systems rooted in the world of science and business. Gargantuan computers were housed in state universities or

Figure 6.4: Fidel García, *The Fourth Power*, 2009. Installation: 197 software programs, 10 pcs, LCD monitor, router, 500 cm x 1000 cm.

private laboratories such as Bell Labs and Xerox Park. But is there anywhere today far enough outside the systems to gain a prospect onto them? Have the infra-spaces of viruses, bugs, and nanoseconds replaced the impossibly distant view of earth from space? García's work suggests that the forms available to systems art include generation (auto-organization), interruption (hacking), or parody.

Beyond the Panopticon

Surveillance produces both external and interior effects: observed by someone outside, subjects internalize the feeling of being watched. For a while, nothing seemed to emblematize this more than Jeremy Bentham's panopticon, despite its association in Gilles Deleuze's essay "Postscript on the Societies of Control" with an earlier disciplinary society, roughly coincident with industrial modernity.[32] These clarifications have done little to hinder invocations of the iconic power of panopticons as representations of a sinister power.

It is no surprise, then, that Presidio Modelo (Model Prison), a panopticon modeled on Illinois's Joliet prison and built in the late 1920s on Cuba's Isla de Pinos (now Isla de la Juventud or Isle of Youth), has

generated multiple essays, novels, documentaries, and now video game art. Presidio Modelo has proved a particularly evocative—indeed a "model"—panopticon, thanks in part to its siting in a series of expanding circles of incarceration, reminiscent of a penal colony. Presidio Modelo housed political prisoners successively under Gerardo Machado, Fulgencio Batista, and Fidel Castro, before being closed in 1967. It produced some famous prison memoirs, including Pablo de la Torriente Brau's *Presidio Modelo* (1969). In the late 1960s, the pioneering filmmaker Sara Gómez made three documentaries set on the island: *En la otra isla* (On the Other Island, 1968); *Una isla para Miguel* (An Island for Miguel, 1968), and *Isla del tesoro* (Treasure Island, 1969).[33] Today, the prison is the subject of a video game artwork by Rodolfo Peraza, *Jailhead. com* (2011–ongoing).

But we should pause before accepting the convenient symbol of the panopticon as meriting such explanatory or symbolic power. Scholars of surveillance have questioned the link between the panopticon and contemporary surveillance logics today.[34] David Lyon, for instance, finds the greatest surveillance technologies not in houses of correction but in sites of leisure and consumption: "Shopping malls, theme parks, casinos and sporting and athletic events."[35] David Rosen and Aaron Santesso, literary scholars interested in the links between surveillance technologies and changing notions of personhood, are similarly critical of unthinking, post-Foucauldian invocations of Bentham's panopticon.[36] Rosen and Santesso even claim, rather controversially, that Bentham's panopticon never intended prisoners to internalize a superego, never meant that surveillance would reach the innermost recesses of the human. Instead, in rereading Bentham's writings, they find that the panopticon was designed only to surveil surfaces.[37]

This revisionist rooting of surveillance in gaming technologies rather than biopolitical monitoring is complemented by revisionist histories of Bentham's process of inventing the panopticon. Political scientist Alessandro Staziani's rereading of Bentham's research into labor practices, and Farocki's film *Workers Leaving the Factory* (1995), which documents appearances of factories in the history of cinema, both remind us that the inspiration for Bentham's panopticon was a circular factory in Russia in which peasants were trained in British-style industrial work habits.[38] Stanziani argues that Bentham's panopticon was in fact a "system for controlling wage labor . . . the prison project, then, was

first of all a project for labor surveillance, and the unskilled serfs were less of a concern than the skilled foremen."[39] In other words, the paradigm of a disciplinary carceral society and of a sovereign power over free time migrated from the industrial factory to the prison, not the other way around. The factory does not merely ape a prison: the panoptic prison is indebted to forms of labor coercion.

The new media art of Camagüey-born Rodolfo Peraza, based in Miami since 2012, centers around such histories. Peraza's work explores connections between earlier, modernist forms of control and more diffuse contemporary circulations of power, often expressed through forms of play. He has spoken of the influence on his work of his upbringing as the son of a military leader.[40] Peraza opposes the rigid morals and beliefs of his father's generation by working in a ludic register. Like Altunaga, he makes video art games. In his *Play and Learn* (2008), players must shoot at text lifted from 1970s conduct manuals, still in use today, on how to be model communists and New Men. Passages describe how to behave at parties, when speaking with tourists, or in the classroom. The texts appear above the first-person shooter's tank, which must blast away the text in question before the vertical letters sprout tiny, searching canons that spray bullets down on the player. After successfully clearing away several levels of text, the words disappear and the player must gun down the sacred figures of José Martí, Lenin, and Ernesto "Che" Guevara.

Peraza's most ambitious piece, however, still in-process as this book goes to print, is the multiplayer, online art game entitled *Jailhead.com*. When the game is complete, players will be able to virtually enter half a dozen historic panopticons around the world, from the United States to Vietnam. To date, *Jailhead.com*'s only setting is a richly recreated digital Presidio Modelo. To reconstruct the prison complex, Peraza traveled to the site, which is now a museum, and photographed the interior of the prison's ruins.

In *Jailhead.com* players choose one of four avatars: prison warden, doctor, priest, or prisoner.[41] The goal of the "game" is to simulate some of the experiences of being inside a panopticon. Players experiment with different subjective positions of power, alternately inhabiting the position of warden or prisoner. Such experimentation is proper to the logic of video games more generally, which furnish players with infinite lives. Peraza's art game thus knowingly reproduces the logic that turned many

penal colonies into spaces of experimentation in the first place. The "game" introduces a crucial difference: *Jailhead.com* allows one to "do over" what real lives conscripted to carceral experiments cannot. The temporality restored by the art game belies the very finitude that radically defines carceral experience, or "doing time."

Michael Hardt has asserted that "prison time" is central to the contemporary social order.[42] It is "prison time"—outside of everyday life and numbingly repetitive—that is partially upended, and partially conserved, by Peraza's game version of Presidio Modelo, where each repeated entry into the space of the panopticon can introduce variety, within a limited set of possibilities. Recall Chris Marker's observation that video games give us the chance to do things over—even as they themselves are played in the unrepeatable time of finite life. Peraza's game builds in an "out" from the prison time captured in the game.[43]

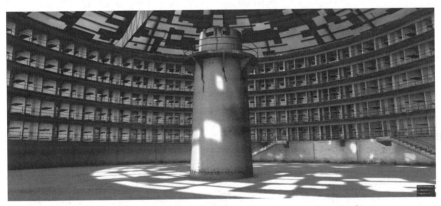

Figure 6.5: Rodolfo Peraza, *Jailhead.com*, 2011–ongoing. Online game.

The history of separating people out from society in order to reform them is part of an enlightenment tradition. It is common to a series of enclosed spaces that Foucault argued were structured around surveillance, such as prisons, workplaces, and schools.[44] But Peraza's choice of Presidio Modelo as a site for his game introduces specificities into those sweeping associations. The game's internal suffix ".com" suggests the contemporary business of prisons (of scandalous proportions in the United States, where Peraza currently resides) and capitalism's integral role in surveillance today, putting "*com*merce" on equal footing with the older form of subjectivity created by jail: "jailhead" is a term used by prisoners and former inmates to describe the mentality forged behind

bars. But more pertinently, *Jailhead.com* invokes a long and troubled history of carceral and labor practices in Cuba. This history dates to the island's colonial days, and has been treated in books and films.

Journalist and jurist Waldo Medina's book *Aquí, Isla de Pinos* (Here, Isle of Pines, 1971), for instance, is a collection of newspaper articles about the small island. Most were originally published in the 1940s and discuss the prison's relation to the larger economy and culture of the Isle of Pines. Medina discusses the historical treatment of Isle of Pines as a hinterland to which Cubans were sent when they were found to be on the wrong side of colonial law. To summon the long antecedents for the panopticon built in the 1920s, Medina cites an 1846 aphorism by the island's leading nineteenth-century educator, José de la Luz y Caballero:

> A passenger asked his carriage driver: How is the Isle of Pines going, that Siberia of the Island of Cuba? Answer: "Those they don't kill here are finished off there." Cuba's Siberia! How prophetic would be words of that Great Educator. In the first half of the nineteenth century was sealed, then, the atrocious destiny of this island. Site of human desolation, a factory of anguish, of mourning, of separation from one's loved ones, perhaps forever, of abandonment, of being forgotten, that is, of exile and of prison.[45]

From a nineteenth-century "factory of anguish" Medina imagined the Isle of Pines turned into a twentieth-century factory of usefully coerced agroindustrial labor. He called for overturning the outdated criminology and beliefs that drove early twentieth-century carceral reform. In its place, he argued for a kind of prison/agricultural complex relocated to mainland Cuba that would generate profit for the state.[46]

Medina also documented the voices of former prisoners, including a haunting lesson imparted by "Tatica el negro," a black man who had served his time at the prison and upon release went on to work as an agricultural laborer elsewhere on the Isle. "Tatica" cautioned against the de-individualization enacted by psychiatric institutions, hospitals, prisons, and the thoughtless treatment of animals. Presidio Modelo, Tatica declares in Medina's reportage,

> is just like the hospital or the Mazorra insane asylum, but with the difference that the crazy people and the bedridden don't have knives and they don't get together in small abusive groups. No prisoner, madman or

patient . . . is the same as another, we are all different. Just note . . . how I lasso ten newborn cows; of ten calves three or four don't need to be whipped on the neck, they are obedient and calm. On the other hand, there are others who must be subjected and given lashes, and even still, never learn . . . You can't treat everyone the same.[47]

Tatica—ironically saddled with the homogenizing, racialized nickname "the Black"—speaks against the standardizing logics of control that Foucault would outline in *Discipline and Punish*. Tatica anticipates the similarities between prisons, asylums, and hospitals.

In 1967, Presidio Modelo (renamed Reclusorio Nacional following the Machado era) was closed and turned into a museum. Now we are equipped to revisit Hito Steyerl's question "is a museum a factory?" It is not so much whether a museum is a factory, however, as whether the museum of a former prison is also a factory. Presidio Modelo's final years coincided with the conclusion of the first decade of the revolution and the 1968 "Revolutionary Offensive," which further abolished remaining forms of private business. The Isle became the site for a boys' reformatory. Rebaptized as the Isle of Youth in 1978, it would become the site of a large-scale program of free higher education for students from the Third World, primarily Africa.

Sara Gómez captured the simultaneous dismantling and establishment of the two institutions—prison and reform school/labor camp, respectively—in her trilogy. She movingly recorded prisoners' graffiti as the jail was closed down. Her camera captured wall drawings dating from the 1930s up through the 1960s; the content and form of their depictions morph accordingly with the passing eras. Some forty years later, Peraza returned to the museum/prison and documented the same drawings with the aim of incorporating them into his virtual prison. Both Gómez and Peraza seem to be interested in prisoner's art as an index of dreams, desires, and suffering beyond the forms of justice or injustice that imprisoned them, and beyond the systems of control that sought to shape them.

Gómez is best known for her feature-length film *De cierta manera* (One Way Or Another, 1974), which captured everyday life in marginal neighborhoods.[48] These neighborhoods challenged, to varying degrees, attempts by the revolutionary state to fold them into its project. In her shorts about Isla de Pinos, she sought to depict a revolutionary

Figure 6.6: Sara Gómez, *Isla del tesoro*, 1969. Film still.

liberation of formerly unjust regimes: she connects the American "pirates" operating on the island to earlier buccaneers. Yet even as her film endorses the revolution's aims, it also intimates connections between the reform school and the "model prison."

Una isla para Miguel focuses on the reform school/labor camp. The narrator speaks soberly on the process of "reeducation" to which the boys are submitted. They arrive with "the morals of the 'hood: 'Be a man, be macho, be a friend.' On the Island they will learn the work ethic."[49] As had been true for Bentham's idea of model prisoners, the reform school imagined that it could preempt delinquency altogether by targeting youth who were "predelinquents."[50] Again in the tradition of Bentham, the school's militarized work ethic was imagined as a humanitarian improvement in youth's lives. The project came under slightly greater scrutiny as Gómez's trilogy progressed. As Lillian Guerra has astutely observed, rather than wholly supporting or rejecting reformist processes, Gómez's films stand out today as a complex and ambiguous series that depicts "individuals caught up in a paradoxical nexus of alienation and liberation."[51]

In the intervening decades since Gómez's film, Foucauldian and Althusserian readings of institutions and discipline have colored readings of such reform sites. Intellectuals on and off the island have reflected upon the authoritarian nature of the state, on the militarized, masculine

asceticism of the New Man, and on the dark history of the UMAP camps, operative between 1965 and 1968. All of this makes it hard for contemporary viewers to avoid perceiving a lineage between Presidio Modelo and the reform school. Without invalidating these connections, however, we might add to them by returning to the labor history behind the panopticon. We then perceive yet another perspective in Gómez's films.

Both Presidio Modelo and the reform school emphasize production. Gómez includes scenes in *Isla del tesoro* of women working in a nationalized citrus factory (grapefruit boxes read "Treasure Island" and "*L'ile du tresor*"). At the time, the scenes presumably were meant to offer a redemptive image of a national repossession of resources and labor time after a long history in which the Isle of Pines was known as a paradise for piracy, forced labor, and US textile industries. What in 1968 may have communicated the overturning of formerly exploitative working conditions, however, today looks rather melancholic. The juxtaposition of workers with the histories of the prison and reform school suggests the limits of a productivist horizon for emancipation, while also documenting the eclipse of a certain era of productivity.[52]

How many subject positions—how many people—were subjected to modification on the real Isle of Pines? As Lillian Guerra has also noted, *Isla del tesoro* and *Una isla para Miguel* register the fact that most of the bodies being disciplined are not white.[53] When we see, for instance, black women boxing up citrus fruits from a conveyer belt in a factory, the meaning of the image is unstable. At the time it may, again, have been part of an optimistic project to eliminate forms of workplace

Figure 6.7: Sara Gómez, *Isla del tesoro*, 1969. Film still.

discrimination and exclusion that had characterized the pre-revolutionary period. It might have suggested a revolutionary victory over prior inequalities. It is also a 1960s embrace of industrious progress, as the documentary also depicts people happily picking fruits in the fields in a celebration of *trabajo voluntario* or "voluntary" work (the topic of Gómez's documentary *Sobre horas extras y trabajo voluntario*/On Overtime and Voluntary Work, 1973).[54] A decade earlier, Gómez had shot a short entitled *Fábrica de Tabacos* (Tobacco Factory, 1962), a hopeful celebration of the revolution's capacity to transform formerly oppressive work, often linked to Cuba's colonial slave regime, into laborers' ownership.[55] But such scenes also reveal the disciplinary continuities between the factory and the prison. And during the 1968 "Revolutionary Offensive" (as Gómez was shooting part of the trilogy) the entire nation was mobilized to cut cane, a further example of how non-voluntary *trabajo voluntario* often was.

There remains something rather Protestant about post-1959 celebrations of work. The sociologist Kathi Weeks has returned to Max Weber once more to trace the ways in which a drive to work and true economic utility diverged early on in the transition from feudalism to capitalism, yielding waged work, in which "the promise of additional wages for longer hours of more intense work was not originally an adequate incentive to adopt new work rhythms and routines."[56] In *Sobre horas extras y trabajo voluntario* workers complain of the truly pointless additional labor asked of them (one instance involved moving stones from one side of a plot of land to the other, then back again). The economy here is not capitalist but moral, as workers accrue "merits" for extra work. Yet Weber's assessment of capitalism here obtains just as well: such a work ethic "helps to render both the qualities of the work and the satisfaction of concrete needs irrelevant to the logic of now limitless production."[57]

It is significant that Gómez, a committed revolutionary, shot the films in a moment that saw the onset of state institutionalization, bureaucratization, and Sovietization. In other words, even as she documents the dismantling of the iconic prison in 1967, a prison logic may be seen extending outside its walls. Jean Genet was interested in emancipatory events of the same period—1968—and meditated on the kinds of time that characterized unusual, unforeseen moments of liberation. Building on Genet's theories, Hardt has elaborated that "Revolutionary time finally marks out escape from prison time into a full mode of living,

unforeseeable, exposed, open to desire."[58] Such a euphoric time is some-
times associated with the first decade of the revolution, the years Gómez
was filming. Hardt, however, still glossing Genet, observes that prison
time returns once constituted power is erected. Gómez's trilogy obliquely
records not only ebullient efforts to change lives, but also the return of
an extra-mural prison time as constituted state power is established.

Gómez's sustained attention to black Cubans and to their roles in the
revolutionary process, unusual at the time, also opens a discussion of
historical links between the surveillance state and racialized bodies. Of
the three films in the trilogy, *En la otra isla* is the most unambivalently
optimistic about its subject, the "process of transformation of conscious-
ness" that the revolution enabled. The film reveals the Isle of Pines to be
an experiment in mixing manual and more professional labor along the
lines that Che Guevara proposed (following Marx's dreams of a de-differ-
entiation of labor). Gómez interviews a hairdresser, a professional singer,
a theater director, and a former priest-turned-militant, among others.
The professionals all engage in agricultural labor: the theater director is a
ranch hand; the priest milks cows; the hairdresser works in the fields.

The film portrays the island as a space of new hope, new projects,
cultural education, and fewer experiences of prejudice. One of Gómez's
subjects encountered racial prejudice in his previous career as a singer
and finds the Isle of Pines a welcome respite from such discrimination.
This tenor, who formerly sang in the nightclub Tropicana and left
because of racial harassment, praises the island's more egalitarian envi-
ronment. But he misses singing. And a young laborer finds the discipline
imposed at the camp paternalistic and outdated: "longhaired" men were
not considered "revolutionary" by the management. To Gómez's
on-screen comment that the obligatory shearing may owe to concerns
with hygiene, lice, and so on, the young man objects with comedic and
truly revolutionary insight: if that were so, those responsible should cut
women's hair too!

The oversight of the workers on the Isle of Pines thus extended far
beyond the reform school. Recently, several scholars have traced contem-
porary surveillance practices to racialized slavery in the Atlantic world,
or to what Nicholas Mirzoeff calls the "plantation complex."[59] It is easy
enough to draw parallels with Cuban history, where literature, legal
codes, bounty-hunter diaries, records of specially trained dogs, and
testimonies about everyday life in a plantation society reveal an

obsession on the part of the white elite to surveil black associations and maroonage.[60] In Gómez's trilogy, black women smile as they work or take a break to smoke cigarettes: the scenes seem happy. Still, with their emphasis on disciplined black bodies, the documentaries leave open a possible critique of the links between the prison and the reform school, with its largely non-white wards.

A similarly understated link between racial logics and modern surveillance in Cuba is raised, albeit obliquely, in Ahmel Echevarría's 2013 novel *La noria*.[61] The novel is set in 2001, with flashbacks to the 1980s. Its writer-protagonist is researching the cultural politics of the 1960s and 1970s as fodder for a new novel. Already in the first pages the protagonist recalls a poetry recital from 1987 characterized by a motley audience of artists and functionaries, where aesthetic interests bled into "the obligation and order to listen, and the obligation to understand and decipher insanity too," a cryptic nod towards the novel's thematization of over-interpretation.[62] The novel's slow-building, *neopolicial* or thriller-like atmosphere anticipates Echevarría's explicit admission in an afterword about there having been "a certain whisper of Ricardo Piglia in my ear" as he wrote *La noria*.[63]

Piglia is an Argentine author known for his exploration of the detective genre, the conspiratorial plot, and paranoid reading. He is also known for his interest in forms of political activity, from anarchism to Maoism, experimented with in Argentina in the 1920s and 1960s and persecuted by the subsequent dictatorships of the 1970s and 1980s. In 2001 Piglia delivered a lucid talk entitled "*Teoría del complot*" (Theory of the Complot), in which he explored the relations among conspiracies, plottings, literature, finance, and the state. For Piglia, a "complot" or conspiracy is "a point of articulation between practices of constructing alternative realities and a means to decipher a certain functioning of the political."[64] He clarifies this statement: a complot is a place where people's desires to imagine new or alternative orders cross with their understanding of what is political. On the one hand a complot implies "the idea of revolution," he argues. Yet it can also describe the way that politics has been highjacked by economics as giant circuits of capital control states. Echevarría follows Piglia in an intimated but not spelled-out relationship between literature, conspiracies, and the political.

La noria follows a black, gay novelist—El Maestro—as he investigates literary and political positions taken by Cortázar, Sartre, and others in

the 1960s. El Maestro hasn't written a novel in a decade and a half, but he's inching towards a new one, driven by his research into the cultural politics of the early revolution. His solitary writing existence is punctuated by a fourteen-year-long affair, or relationship, that is resumed every Monday afternoon with a man named David. David, we learn, is spying on the older writer. But David also believes himself to be tailed. The novel, fittingly for a book about conspiracy or paranoia, never spells out any real reason for the surveillance of either man. El Maestro is, however, researching Cuban authors who, in the early 1960s, were deemed not sufficiently revolutionary—a weak clue to his paranoia.

El Maestro is also dogged by society's lingering hermeneutics of suspicion attached to homosexuality, according to which surface symptoms are scrutinized as indices to some inner essence. Such suspicion, recalled here in a flashback to El Maestro wrestling with his sexuality "in a city so small it was almost impossible to hide any secret," was a shorthand for more political paranoia in 1990s works such as Tomás Gutiérrez Alea's film *Fresa y chocolate* (Strawberry and Chocolate, 1993) or Leonardo Padura's detective novel *Máscaras* (Havana Red, 1997).[65] The paranoid reading embodied in deciphering sexualities spills over. Sleepless at night, the narrator reads Roberto Bolaño's *Nocturno de Chile* (By Night in Chile, 1999), intrigued by the novel's linking of literature and crime, and its settings in "Salons and long dinners in the very mansion where the repressive machine of the Government tortured prisoners." [66] El Maestro's incipient novel unfolds in pieces as Echevarría's progresses, and by the end he is wondering how to add a conspiracy to his plot, in which the character representing his male lover—whose name the writer has lightly changed from David to Daniel—kills his "maestro" . . .

In *La noria* blackness is not so much foregrounded as taken for granted. Like *Habana underguater*, the novel spares us the music, dancing or Afro-diasporic religious practices often wincingly marshaled to signify black Caribbean culture. Its protagonist is almost a caricature of opposite traits: a meditative, reclusive, and overweight writer, an aesthete in a crass city, seeking nothing but wine, classical music, and men. El Maestro flirts with two mysterious black hustlers who think he's from the US, and to whom the protagonist thereafter refers as "black panthers," gesturing towards some black Atlantic identity beyond the nation, but one that the protagonist already locates in an eclipsed past. These men,

he reflects twice, "want something more than land, bread, housing, education, clothing, justice and peace."[67] Later El Maestro spots the two men through his window and wonders "whom they are surveilling."[68] By reassessing the 1960s (the focus of the writer-narrator's research) and the 1980s (the period of the narrator's most formative memories) through the eyes of a black Cuban author, Echevarría—who is himself Afro-Cuban—restores to whitewashed histories the presence of a stubbornly resilient racialized thought in the post-revolutionary period, while working against an identitarian stance.

El Maestro's principal interest in reexamining the revolution's economies of literary and political value, which apportioned fame to this or that writer, again links to Piglia's reading of the relations between literature and plot, where literature operates within an economy parallel to and indeed intersecting with that of the state or market. The narrator's increasing unease with a number of shadowy figures who are possibly following him contributes to the novel's deepening mood of paranoia, conspiracy, and surveillance. These are the same sentiments featured in another forthcoming Cuban novel by Wendy Guerra, whose *La espía del arte* (The Art Spy) allegedly centers on fears of being watched and recorded.[69]

To render the narrator's ongoing research into the cultural politics of the early 1960s, *La noria* notably includes verbatim reproductions of actual, historical letters exchanged between Cuban cultural policy-makers of the 1960s and European writers alternately fascinated by, and censorious of, the revolution. These epistolary exchanges touch on the most famous cultural clashes of the era, such as the competition between Emir Rodríguez Monegal's CIA-funded literary journal *Mundo Nuevo*, a Cold War counterweight to the magazine *Casa de las Américas*, and the "Padilla Affair," in which an award-winning poet offered a coerced self-criticism that many saw as proof of a Stalinism at work (Padilla himself warned of a Stalinism present on the island).[70] At the end of the book Echevarría includes an index of historical characters featured in the narrative: Cortázar and Sartre appear alongside Antón Arrufat, Calvert Casey, Virgilio Piñera, all gay authors who suffered varying degrees of persecution, and Ana María Simo (the editor of the short-lived, experimental and independent *El Puente* publishing house; Simo endured "torturous treatment in an insane asylum for her association with homosexuals" and for defending the publishing house).[71] *La Noria*,

Echevarría confesses in a postscript, is an attempt to narrate the history of some victims of the 1970s Soviet-style cultural politics, whose victimizers are also, he insists, theselves victims.[72]

In Echevarría's novel the documentary referents for episodes from the *quinqueño gris*, the grey years of Soviet-style Socialist Realism and draconian cultural policy, do not illuminate the protagonist's plight. The mystery at the heart of the novel is that El Maestro's general paranoia, apparent surveillance and ultimate murder cannot be attributed to anything concrete: not to his revisiting of old feuds, not to his homosexuality, nor to any other possible reason. The novel thus has the trappings of a *neopolicial* without a cause. Instead, it suggests that a general culture of paranoia has hurt everyone.

Bereft of any concrete conclusion regarding the connections between the distinct decades of the revolution and its changing cultural policies, the novel may be more about the fact of such scrutiny or research itself. It also highlights the extent to which contemporary cultural production in Cuba is concerned with constellating fragments of the history of the past century in new ways. Thus the wheel in the book's title refers to a turn of the (ferris)wheel of history, a turning that yields a new perspective on a familiar landscape.

In a passage towards the end of the novel, Echevarría gestures towards such a meaning. El Maestro wanders Havana, coming upon the same places by habit, "like an old ox. Or an ass pulling a wheel [*noria*]."[73] The idea reminds him of a poem by Juan Carlos Flores about an ox wearily turning a wheel, dredging up water from a well. It is a wheel of repetition, labor, worldweariness.

> Doctor, your hoofprints in the
> grooves were the poem, where water fell
> from your nose the fingers, the heads
> of the poem's burning flowers opened up.
> O-X-E-N
> Your weariness is political
> you don't feel like getting up anymore
> you don't feel like marrying
> the poem's borders eaten
> with ox eyes you look at reality
> from the center of the poem.[74]

Here poetry is hard work, and the repetitive hard work of life is poetry, all of it somewhat bestializing, and lyrical—the weariness of half a century of mulish habits.

Today, epic narratives are read critically and multivocally. That *La noria*'s protagonist is an author looking into the revolution's early years suggests more than the familiar construction of a double for an author himself. It suggests that contemporary authors and artists are keen to comb through facets of the past half-century still under wraps, searching for new narratives.

The writer's work of searching for new interpretations seems to have its counterpart here—Piglia-style—in the observation, paranoia, and attention to detail undertaken by the state security. At the end of the novel, El Maestro is run over by the same white Ladas that have been following him ominously, one of which is driven by his lover—whom the other security agents call Daniel, the very name El Maestro thought he'd invented for David in his fictionalized version of their life. Since El Maestro's investigations into the 1960s and '70s do not, in the novel, turn up any significant content for the plot, the work of the security agents ironically is ultimately the more effective sleuthing. Two agents bring El Maestro—for reasons never fully clear—to his death. His research ends. But the unresolved questions from the '60s and '70s remain epistemologically rich and unanswered.

Why We Keep Looking for Details

Some systems art in the 1970s sought to reveal the massive accretion of information that codifies existence. Today, as the amount of metadata outstrips representation, artists turn to the infinitesimal to grasp elements of reality: recall the scrutiny of a map of capital flows in the opening pages of *La autopista*. The work of Celia y Junior likewise assembles details and deals in questions of scale, linking the infinitesimal with the overarching.

In 2008 and early 2009 the two artists produced a series of works of numbered "details" and diaries to register the texture of everyday life, which they labeled with the more formal term "ephemerides." Although *efemérides*, in Spanish, is a fairly common term for a kind of diary or the marking of an annual celebration, the word's technical,

astronomical denotation of a process for charting the orbit of stars resonates faintly. Ephemerides register daily the locations in space and time that give us our coordinates, evoking the shuttle between the minutiae of log books and protractors and the distant, extra-celestial orbit of the stars. Celia y Junior's ephemerides include ten pieces that "attempt to summarize the year 2008 more on the level of sensations than through its events" (2008, again, is the year that Raúl Castro formally took power).

Detalle No. 9, Efemérides: 2008 (Detail No. 9, Ephemerides: 2008 [2008]) is a design for a screensaver in which computer-drawn graphics of consumer goods decriminalized in 2008 (DVD recorders, computers, microwaves, cell phones, hotel visits, etc.) float against black space. In another piece from the series the artists reflect on the *Revolución Energética* (Energy Revolution) launched by Fidel Castro in 2006 to overhaul old thermoelectric plants and make Cuba an energy model for the world.[75] To better conserve energy, the state removed inefficient consumer electronics, incandescent light bulbs, and kerosene stoves from people's homes, replacing them with more efficient ones. It seemed an admirable campaign. But residential electricity consumption "actually increased by 34 percent as a result of the obligatory use of new 'energy-saving' electric utensils."[76] Celia y Junior's *Habana, 15 segundos* (Havana, 15 Seconds, 2008) documents one such mandated exchange of an antique Soviet air conditioner for a Chinese one. In the minutes between deinstallation and installation of the new unit, the square gap in the wall accommodating the air conditioners became a frame. Through it, a street scene could be glimpsed: "a few seconds of our reality," the artists called it. The apparent exchange was thus intended to document "not only a climatic change but above all an economic change that does not change our reality, and only cools us momentarily."[77] The imperial or influential powers to which the Cuban economy has been serially connected over the past centuries—Spanish, US, Soviet, Venezuelan, Chinese—register here only as changing brands.

Celia y Junior's interest in everyday details spans plant life (*Detalle No. 5*/Detail No. 5, about *marabú*), chatter overheard on a park bench (*Octubre del 2008*/October 2008), and desirable consumer electronics (*Detalle No. 9*/Detail No. 9), all from 2008. These interests are collectively theorized in the title for a video installation that the artists made

with Renier Quer, *Creo saber por qué sigo buscando detalles* (I Think I
Know Why I Keep Looking for Details, 2009). Four small bookshelves
lined a white wall in a gallery. On a wooden stepladder in front of the
shelves the artists propped a video projector, creating a phantom book
or source of information screened among the paper volumes. The video
portrays a panoramic view of Havana from the terrace of the University
of Havana's Economics Department. The camera periodically zooms in
on the landscape, "as if searching for information about the influence of
the Department in the (urban) context."[78] A text on the screen notes the
number of graduates from the Economics Department of the University
of Havana since its establishment (9,039 at the time of filming).

Figure 6.8: Celia y Junior, *Creo saber por qué sigo
buscando detalles*, 2009. Video installation.

The video projection, then, would seem to complement information missing from the bookshelf. But what information do the numbers provide? The abstract figure 9,039 doesn't correspond to changes perceived in the urban fabric. The sum seems to echo the state's fetishization of numbers and facts, or underscore its emphasis on education, in conjunction with the simultaneous paucity of concrete ways to put such education to work. The title, however, hints that there is a closer relation between the microscopic and the macroscopic. The viewer has to look closely at the details of the wall projection to find the information. But the figures cannot explain the reality, or they explain it as a disconnect between theory and practice.

Are the "details" in the title the 9,039 individuals who have received degrees, or are they the effects of economics training that have registered—or not—in the urban landscape? The more one dwells on the apparent confidence that the title announces the less it seems clear. Why indeed should the artists keep looking for details? Because a critical mass will illuminate, finally, a conundrum? This seems unlikely, since the sheer accumulation of details in Celia y Junior's artworks always points back to the same sources: a stifling, top-down state (though their own work explores precisely how much space for maneuvering exists within such structures); an everyday life defined by scarcity, measured unfavorably against memories of a prior abundance (either pre-1989 or pre-1959); the power of systems to channel masses of details and the potential to reprogram or redirect some of these parts.

But since the everyday and the minor are precisely the materials with which the artists work, details and banality are their bread and butter, not to be dismissed or lumped together as an aggregate proof of some state failure. The detail seems to be precisely *not* the 9,039 graduates. This or that example of urban development, similarly, does not seem to be the result of some economic theory.

Instead, the detail may be that texture of the everyday not captured by official rhetoric and statistics. The reason to keep looking for details, then, as in *La noria*, is to find resistances to the discourses of mastery, objectivity, and power in the material, sensual world. Details are not in opposition to bird's-eye views, but of a single piece with the big picture. *Creo saber . . .* returns us to the cognitive map that Jameson contrasted with Flaubert's laughably detailed one. Recall that a satellite map only apparently bridges these alternately cosmic or minute cartographies.

Contemporary Cuban artists and writers draft aesthetic maps that assemble past details in newly illuminating ways, laying out possible geographies for a future that would depart from received guides or frightening predictions.

Notes

Introduction

1 Jorge Enrique Lage, *La autopista: The Movie*, Havana: Colección G, Cajachina, 2014; Julio Cortázar, "La autopista del sur," in *Todos los fuegos el fuego*, Buenos Aires: Editorial Sudamericana, 1966; *Weekend*, 1967, directed by Jean-Luc Godard, France: 1967; New Yorker Video, 2005, DVD. The book's title may also be a reference to Cormac McCarthy's *The Road*, New York: Vintage, 2007.

2 *Era espeluznante. Era demencial. Era inconcebible. Tenía que ver con los flujos del dinero, con los desplazamientos del capital, con las economías de mercado. Tenía que ver con un mapa, si suponemos algo parecido a un mapa del tesoro donde el tesoro está moviéndose por todas partes o donde al final no queda claro qué es el tesoro. Los flujos del dinero son, en ese mapa, como autopistas. Hay intersecciones, rizos, desvíos; pero también velocidades, caídas abruptas, saltos de dimensión. Y hay como una trama oculta detrás de todo eso, una trama que salta a la vista como esas manchas bidimensionales y aparentemente caóticas en las que surge de pronto una figura con relieve cuando uno cambia el foco de la mirada. Y por supuesto, en los nudos o los nodos de esa gigantesca red laten los fetiches, las ideas fijas, los cuerpos apresados de todos nosotros. Sobre todos nosotros se están llevando a cabo experimentos que nunca seremos capaces ni siquiera de imaginar.* Lage, *La autopista*, 32–3. Here and in what follows all translations are mine, unless otherwise indicated.

3 Tim Jackson notes that since the mid-twentieth century, 60 percent of the world's "ecosystem services" have been degraded or over-used, while the global economy has grown five times, "totally at odds with our scientific knowledge of the finite resource base and the fragile ecology on which we depend for survival." As Jackson notes, while questioning growth is "anathema" to an economist, "the idea of a continually growing economy is an anathema to an ecologist"; he concludes, "economics . . . is ecologically illiterate." Tim Jackson, *Prosperity Without Growth: Economics for a Finite Planet*, Sterling, VA: Earthscan, 2009, 13–14; 123.

4 Lage, *La Autopista*, 76. This, too, recalls Cortázar's blueprints for the cinema, since his story "Las babas del diablo" (Devil's Drool, 1959) inspired Michelangelo Antonioni's *Blow-Up* (1966), where a photographer seems to have inadvertently captured a murder in a blurry detail of a photograph. Julio Cortázar, "Las babas del Diablo," in *Cuentos completos 1*, Buenos Aires: Alfaguara, 1994, 214–24; Michelangelo Antonioni, *Blow-up*, MGM, 1966. The quotation resonates with philosopher Beatriz Preciado's treatise on changing her body through the use of testosterone, which she claims is not a personal narrative but one that "emanates from the history of the planet, from the evolution of the living species, from economic flows, from the residuum of technological innocations, from the preparation for wars, from the traffic of slaves and goths, from the penitentiary and repressive institutions, from communication networks and surveillance . . . from the biochemical transformation of the senses, from the production and distribution of pornographic images. For some, this text might serve as a manual of gender bioterrorism on a molecular level." Beatriz Preciado, *Testo Yonqui*, Madrid: Espasa Calpe, 2008, 15–16.

5 Fredric Jameson, "Totality as Conspiracy," in *The Geopolitical Aesthetic: Cinema and Space in the World System*, Bloomington: Indiana University Press, 1992, 3; 9. See also Alberto Toscano's talk "Cartographies of the Absolute", at http://cartographiesoftheabsolute.wordpress.com.

6 Jameson, "Totality as Conspiracy," 9. Ariana Hernández-Reguant invokes the idea of cognitive mapping for a different argument—to define "late socialism." Ariana Hernández-Reguant, "Writing the Special Period," in *Cuba in the Special Period: Culture and Ideology in the 1990s*, ed. Ariana Hernández-Reguant, New York: Palgrave McMillan, 2009, 11.

7 David Graeber, "The Sadness of Postworkerism, or 'Art and Immaterial Labour Conference': A Sort of Review," *The Commoner*, April 1, 2008, at www.commoner.org.uk.

8 Ibid.

9 Franco Berardi, *The Uprising: On Poetry and Finance*, New York: Semiotext[e], 2012, 81–2. See also Berardi's 2011 talk "After the Future," June 21, at http://1000littlehammers.wordpress.com.

10 See Fredric Jameson, *Archaeologies of the Future: The Desire Called Utopia and Other Science Fictions*, New York: Verso, 2005, and *The Antinomies of Realism*, New York: Verso, 2013. Jameson argues that "the historical novel of the future (which is to say of our own present) will necessarily be Science-Fictional . . . To read the present as history, as so many have urged us to do, will mean adopting a Science-Fictional perspective of some kind" (*The Antinomies of Realism*, 298).

11 See Esther Whitfield, *Cuban Currency: The Dollar and "Special Period" Fiction*, Minneapolis: University of Minnesota Press, 2008.

12 See ibid. and Rafael Rojas, *Tumbas sin sosiego: revolución, disidencia y exilio del intelectual cubano*, Barcelona: Anagrama, 2006; Odette Casamayor Cisneros, *Utopía, distopía e ingravidez: reconfiguraciones cosmológicas en la narrativa pos-soviética cubana*, Madrid: Iberoamericana, 2013.

13 James Buckwalter-Arias, *Cuba and the New Origenismo*, Rochester, NY: Tamesis, 2010.

14 See Whitfield, *Cuban Currency*; Hernández-Reguant, ed., *Cuba in the Special Period*.

15 Jacqueline Loss, *Dreaming in Russian: The Cuban Soviet Imaginary*, Austin: University of Texas Press, 2013.

16 A number of art critics and even professors at the ISA have, however, questioned the continued caliber of its education, suggesting that students have increasingly oriented their work to sell to busloads of art tourists. (Rachel Weiss, personal communication, email, September 2014; Rewell Altunaga, personal communication, November 2014.)

17 "Collectors Rush for Cuban Art After New US Ties," *Los Angeles Times* video, January 19, 2015, duration 03:03.

18 Gerardo Mosquera, "History and Context," in *States of Exchange: Artists from Cuba*, ed. Gerardo Mosquera and Cylena Simonds, London: Iniva, 2008, 19.

19 Antonio Eligio Fernández, "Man Dancing with Havana: The City and its Ghosts in Twenty-First Century Art," in *The Spaces Between: Contemporary Art from Havana*, London: Blackdog Publishing, 2014.

20 See, for instance, the Museum of Contemporary Art, established in the Havana exurb of San Augustín and described enthusiastically by Rachel

Weiss in "Trusting the Public: the 11th Havana Biennial," *Art Nexus* 86, September/October 2012, 66–73; Samuel Riera's *Primera Comunidad Intelectual* (2006), discussed here in Chapter 2, or Adrián Melis's *Elaboración de cuarenta piezas rectangulares para la construcción de un piso* (2008), discussed in Chapter 5.

21 Fernández, "Man Dancing With Havana," 19.

22 See Rachel Weiss, *To and From Utopia in the New Cuban Art*, Minneapolis: University of Minnesota Press, 2011, 11. See also Luis Camnitzer, *New Art of Cuba*, Austin: University of Texas Press, 2003 (Revised edition), 13–14.

23 Ibid., 196–7.

24 Any snapshot of contemporary aesthetics culled from the abundance of recent literature, art and music is necessarily partial. I have focused here on a series of specific concerns. These exclude even some of the best-known of the island's artists and writers. Another study of the past decade might well center on the careers of artists such as René Peña, Cirenaica Moreira, Yoan and Iván Capote, Wilfredo Prieto, Carlos Garaicoa, Lázaro Saavedra, or Glenda Léon; or might analyze the writings of Wendy Guerra, Leonardo Padura Fuentes, or, outside the island, José Manuel Prieto and Abilio Estévez. A study highlighting contemporary poetics would surely include detailed analyses of work by Reina María Rodríguez, recent winner of both Cuba's National Prize for Literature (2013) and Chile's Premio Iberoamericano Pablo Neruda (2014), and of work by Juan Carlos Flores and the poetry/performance group OMNI Zona Franca.

25 See Emily Morris, "Unexpected Cuba," *New Left Review*, July/August 2014, 5–45 (31).

26 Erick Mota, *Habana underguater*, unpublished manuscript, forthcoming, Havana: Colección G, Cajachina, 2015; Fidel García, *Auto organización*, 2008; Samuel Riera, *Marbusal*, 2006; Rewell Altunaga, *Game and Scape*, 2008.

27 Ursula Heise, *Sense of Place and Sense of Planet: The Environmental Imagination of the Global*, New York: Oxford University Press, 2008, 65.

28 Castells proposed "a direct correspondence between the topics proposed by the ecological movement and the fundamental dimensions of the new social structure, the internet society, which emerged after the 1970s: science and technology as mediums and basic objectives of the economy and society; the transformation of space and time; and the domination of cultural identity by global flows and abstract riches, power and

information, that build real virtuality through communication networks." Manuel Castells, "El reverdecimiento del yo: el movimiento ecologista," *Ilé* 4 (2004), 19–20.

29 Lizabeth Paravisini-Gebert, "Caribbean Utopias and Dystopias: The Emergence of the Environmental Writer and Artist," in *The Natural World in Latin American Literatures: Ecocritical Essays on Twentieth Century Writings*, ed. Adrian Taylor Kane, Jefferson, NC: McFarland & Co., 2009, 114. Of course, Latin American art has long been activist, though only more recently has it addressed environmental questions. For a discussion of some relevant movements see Luis Camnitzer, *Conceptualism in Latin American Art: Didactics of Liberation*, Austin: University of Texas Press, 2007, and Mari Carmen Ramírez, ed., *Inverted Utopias: Avant Garde Art in Latin America*, New Haven: Yale University Press, 2004.

30 Timothy Morton, *Ecology Without Nature: Rethinking Environmental Aesthetics*, Cambridge, MA: Harvard University Press, 2007.

31 Lucy Lippard, *Weather Report: Art and Climate Change*, Boulder: Boulder Museum of Art, 2007, 4.

32 See Claire Colebrook, *Extinction*, at www.livingbooksaboutlife.org.

33 For works that compare various sites at once see Heise, *Sense of Place and Sense of Planet*; Rob Nixon, *Slow Violence and the Environmentalism of the Poor*, Cambridge, MA: Harvard University Press, 2011; Laura Barbas-Rhoden, *Ecological Imaginations in Latin American Fiction*, Gainsville: University Press of Florida, 2012; Gisela Heffe, *Políticas de la destrucción/ Poéticas de la preservación. Apuntes para una lectura (eco)crítica del medio ambiente en América Latina*, Rosario: Beatriz Viterbo, 2013, and, in art criticism, Pamela M. Lee, *Forgetting the Art World*, Cambridge, MA: MIT Press, 2012, or even in the context of the larger Caribbean: Lizabeth Paravisini-Gebert, *Troubled Sea: Ecology and History in 21st Century Caribbean Art*, forthcoming.

34 Jeremy Brecher, *Climate Insurgency: A Strategy for Survival*, Boulder: Paradigm Publishers, 2015, 75.

35 Dipesh Chakrabarty, "The Climate History: Four Theses," *Critical Inquiry* 35, no. 2 (Winter 2009), 197–222; Eduardo González, personal communication, October 2013.

36 Such tensions were already captured in poet and novelist José Lezama Lima's theory of international, affinities-based histories of imaginary eras, rather than linear, national genealogies. José Lezama Lima, *La expresión americana*, Havana: Instituto Nacional de Cultura, 1957.

37 Carlos Espinosa Domínguez used the term "posrevolucionaria" in a 2006 article on contemporary Cuban authors (including Lage), referring, in turn, to Jorge Fornet's description of "posrevolucionaria" literature as that which was not preoccupied with the past or future of the revolution. Fornet had used the term in 2002 to describe an emergent, twenty-first-century generation of writers who "do not seem disenchanted with anything, because they never managed to write works marked by enchantment. The majority of them realize, instead, a postrevolutionary literature, in the sense that the history and ends of the Revolution itself do not seem to concern them" (Jorge Fornet and Carlos Espinosa Domínguez, *Cuento cubano del siglo XX*, Madrid, Fondo de cultura de España, 2002, 25). Carlos Espinosa Domínguez, "Narrativa cubana contemporánea: cuatro cuentistas jóvenes," *Confluencia* 22, no. 1 (Fall 2006), 218.

38 *Carbono 14* was published by Ediciones Altazor in 2010, and by Letras Cubanas in 2013.

39 *Yo no recuerdo mucho de mi planeta.* Jorge Enrique Lage, *Carbono 14: Una novela de culto*, Lima: Ediciones Altazor, 2010, 42.

40 Alluding to Douglas Coupland's 1992 novel *Shampoo Planet*, itself often read as an indictment of consumer culture and environmental destruction, *Carbono 14* references Coupland's concerns and a style designed to capture the North American consumer culture of the 1980s, a moment suffering its own post-revolutionary flatness.

41 *Lo malo es que cuando uno se cansa de todas las ciudades no hay otro planeta adónde ir.* Lage, *Carbono 14*, 23.

42 *Cuba.—¿Qué es eso?—Así se llamaba mi planeta. Le dije que jamás había oído hablar de él.* Ibid., 51.

43 *Juan de los Muertos*, 2011, directed by Alejandro Brugués, Cuba: Producciones de la 5ta Avenida, 2011, DVD.

44 *Yo quiero irme pa'l carajo de aquí y darle una vuelta al mundo. Si me preguntan de dónde soy, diré que de Cuba. Si me preguntan qué es Cuba, diré una islita socialista del Caribe. Si me preguntan qué es el socialismo, les voy a decir que es un sistema instaurado por Fidel Castro hace 50 años. Y si me preguntan quién es Fidel Castro, ¡me quedo a vivir ahí para siempre!*

45 *Vienen ustedes de Cuba?—Da (sí)—¡Ah, la patria del Tscheguebara!— ¿Quién? . . . —¡Ah, el Ché Guevara! Sí . . . da . . . Ya Cuba no existe y el Ché está enterrado en otro lugar.* Mota, *Habana underguater*, 136.

46 *—Cuba—¿Qué es eso?—Así se llamaba mi planeta.—Lo conozco—mentí—. Una masa de tierra con océanos oscuros y salobres. Inmensas llanuras*

sembradas de agujeros, pero no para jugar golf. Cordilleras plegadas como intestinos, lanzando al horizonte destellos de luz mineral . . . Árboles que extienden sus raíces en la niebla. Grandes bestias atrapadas en sorprendentes cadenas alimenticias. Y unas cuantas lunas muy distantes. Lage, *Carbono 14*, 51.

47 Ibid., 81.

48 *maldita madrugada en que el clima se volvió loco.* Ibid., 163.

49 Julia Wright, *Sustainable Agriculture and Food Security in the Age of Oil Scarcity: Lessons from Cuba*, Sterling, VA: Earthscan, 2009, 233.

50 *su planeta es ahora, quizás, el único lugar donde ella estará a salvo.* Lage, *Carbono 14*, 158.

51 Sergio Díaz-Briquets and Jorge F. Pérez López, *Conquering Nature: The Environmental Legacy of Socialism in Cuba*, Pittsburgh: University of Pittsburgh Press, 2000, 21.

52 Omar Everleny Pérez Villanueva, "The Cuban Economy: An Evaluation and Proposals for Necessary Policy Changes," in *Cuban Economic and Social Development: Policy Reforms and Challenges in the 21st Century*, ed. Jorge Domínguez, Omar Everleny Pérez Villanueva, Mayra Espina Prieto, and Lorena Barberia, Cambridge, MA: Harvard University David Rockefeller Center Series on Latin American Studies, 2012, 25.

53 Antonio Benítez-Rojo, "Sugar and the Environment in Cuba," trans. James Maraniss, in *Caribbean Literature and the Environment: Between Nature and Culture*, ed. Elizabeth DeLoughrey, Renée K. Gosson, and George B. Handley, Charlottesville: University of Virginia Press, 2005, 50.

54 Daniel Whittle and Orlando Rey Santos, "Protecting Cuba's Environment: Efforts to Design and Implement Effective Environmental Laws and Policies in Cuba," *Cuban Studies* 37 (2006), 94.

55 Carmelo Mesa-Lago, *Cuba en la era de Raúl Castro. Reformas económico-sociales y sus efectos*, Madrid: Colibrí, 2012, 170–1.

56 Bill McKibben, "The Cuba Diet," *Harpers Magazine*, April 2005, reprinted in *The Bill McKibben Reader: Pieces from an Active Life*, New York: Saint Martins, 2008, 110.

57 See José Quiroga's discussion of transformation, which he prefers over transition, in *Cuban Palimpsests*, Minneapolis: University of Minnesota, 2005, 2. See too Hernández-Reguant, "Writing the Special Period," 1–18. Paloma Duong reiterates Boris Buden's critique of "transitology" in "Amateur Citizens: Culture and Democracy in Contemporary Cuba," unpublished dissertation, Columbia University, August 2014, 29.

58 Loss, *Dreaming in Russian*, 15.

59 To date, only 130,000 have been dismissed. Rafael Hernández and Jorge Domínguez, eds., *Cuba, la actualización del modelo Balance y perspectiva de la transición socialista*, Havana: Ediciones Temas, 2014. See "Cuba la actualización del modelo," at http://temas.cult.cu/blog.

60 Omar Everleny Pérez Villanueva, presentation at City University of New York, May 12, 2012.

61 Mosquera, "History and Context," 17.

62 Samuel Farber, *Cuba Since the Revolution of 1959: A Critical Reassessment*, Chicago: Haymarket Books, 2011, 129–30; "The Alternative in Cuba," *Jacobin Magazine*, December 22, 2014, https://www.jacobinmag.com.

63 Sergio Díaz-Briquets and Jorge Pérez-López, *Corruption in Cuba: Castro and Beyond*, Austin: University of Texas Press, 2006, 146.

64 Archibald R.M. Ritter and Ted Henken, *Entrepreneurial Cuba: The Changing Policy Landscape*, Boulder: First Forum Press, 2015, 32; 234.

65 Hal Klepak, *Cuba's Military 1990–2005: Revolutionary Soldiers During Counter-Revolutionary Times*, New York: Palgrave, 2005, 79–82. Some of these military-run businesses include GAESA (Grupo de Administración Empresarial, S.A.); Gaviota S.A. (tourism); Aero Gaviota (tourism); Cubanacán (tourism): Tecnotex (import/export); Almacenes Universal (free trade zones in Wajay, Mariel, Cienfuegos, Santiago); División Financiera (stores for recuperating cash); Sermar (Exploration of Cuba Waters and Naval Reparations); and GeoCuba (cartography, mining interests), to name just a few. See also Quiroga, *Cuban Palimpsests*, 7.

66 Díaz-Briquets and López-Pérez, *Corruption in Cuba*, 147.

67 Eusebio Mujal-Leon, "Survival, Adaptation, and Uncertainty: The Case of Cuba," *Journal of International Affairs* 65, no. 1 (2011), 153; Julia Sweig, *Cuba: What Everyone Needs to Know*, New York: Oxford UP, 2009, 72.

68 Juan Carlos Espinosa, "Vanguard of the State: The Cuban Armed Forces in Transition," in *Cuban Communism*, ed. I. L. Horowitz and J. Suchlicki, New Brunswick, NJ: Transaction Publishers, 2003, 11th edition, 372.

69 Klepak, *Cuba's Military*, 49.

70 Farber, *Cuba Since the Revolution of 1959*, 92–3.

71 Ibid., 290.

72 Mesa-Lago, *Cuba en la era de Raúl Castro*, 105.

73 Pérez Villanueva, "The Cuban Economy," 35.

74 Gloria Gómez, personal communication, October 2013; Anicia García

Álvarez, "Cuba's Agricultural Sector and Its External Links," in Domínguez et al., *Cuban Economic and Social Development*, 137.

75 Farber, *Cuba Since the Revolution of 1959*, 59; Mesa-Lago, *Cuba en la era de Raúl Castro*, 91. Emily Morris writes that by 2012 sugar accounted "for only 3 per cent of export earnings." "Unexpected Cuba," 31.

76 Ritter and Henken, *Entrepreneurial Cuba*, 182.

77 Following the normalization of relations with the US, new lines of credit seem imminent. See Yoani Sánchez, "Moody's vaticinia 'una nueva vida' para la economía cubana," *14YMedio.com*, January 23, 2015, at www.14ymedio.com.

78 Armando Nova González, "Cuban Agriculture and Necessary Transformations," Woodrow Wilson Center Update on the Americas, October 2010, at www.cubastudygroup.org.

79 *Antigonón, un contigente épico*, by Rogelio Orizondo, directed by Carlos Díaz, Trianón Theater, Havana, Cuba, Friday, October 11, 2013.

80 See Ana Vera Estrada, *Guajiros del Siglo XXI*, Havana: Instituto Cubano de Investigación Cultural Juan Marinello, 2012.

81 *una ruina y pertenecía a la época de la esclavitud.* Mesa-Lago, *Cuba en la era de Raúl Castro*, 75. See classic studies such as Ramiro Guerra, *Azúcar y población en las Antillas*, Havana: Impr. Nacional de Cuba, 1961; Manuel Moreno Fraginals, *El ingenio; el complejo económico social cubano del azúcar*, Havana: Comisión Nacional Cubana de la UNESCO, 1964, as well as more recent ones, such as Robert Paquette, *Sugar is Made with Blood: The Conspiracy of La Escalera and the Conflict Between Empires Over Slavery in Cuba*, Middletown, CT: Wesleyan University Press, 1988.

82 Mesa-Lago, *Cuba en la era de Raúl Castro*, 75–6.

83 Fernández, "Man Dancing With Havana," 38.

84 Mesa-Lago, *Cuba en la era de Raúl Castro*, 77.

85 Ibid., 149.

86 See for instance, Michael LaForgia and Adam Playford, "Wikileaks: Fanjuls among 'sugar barons' who 'muscled' lawmakers to kill free trade deal," *Palm Beach Post*, January 1, 2012, at www.palmbeachpost.com, Michael Bustamente, "'Alfy' Fanjul Eyes Cuban Sugar Despite Labor Allegations," North American Congress on Latin America (*NACLA*), February 16, 2014, at http://nacla.org, and Peter Wallsten, Manuel Roig-Franzia, and Tom Hamburger, "Sugar tycoon Alfonso Fanjul now open to investing in Cuba under 'right circumstances,'" *Washington Post*, February 2, 2014, at www.washingtonpost.com.

87 Peter Wells and Thaisa Faro, "Eco-efficiency, Self-sufficiency and Sustainability in Transport: The Limits for Brazilian Sugarcane Ethanol Policy," *Natural Resources Forum* 35, no. 1 (2011), 21–31. Monsanto is banned in Cuba because of opposition to genetically modified organisms, or GMOs, but such organisms probably enter in US food imports.

88 A. F. Alhaiji and Terry L. Maris, "The Future of Cuba's Energy Sector: Challenges and Opportunities," in M. Font (ed.), *Cuba Today: Continuity and Change in the 'Periodo Especial'*, 97–113, New York: Bildner Center for Western Hemisphere Affairs, 2004, 103; Marc Frank, "After Offshore Oil Failure, Cuba Shifts Energy Focus," Reuters, August 11, 2014.

89 Canadian companies have found high-quality oil in Cuba's Exclusive Economic Zone (EEZ), "a section of the Gulf of Mexico allotted to Cuba in the 1997 Maritime Boundary Agreement with Mexico and the United States." Robert Sandels, "An Oil Rich Cuba?," *Monthly Review* 63, no. 4 (September 2011), at https://monthlyreview.org.

90 Mesa-Lago, *Cuba en la era de Raúl Castro*, 105.

91 Sandels, "An Oil Rich Cuba?," 40.

92 See, for instance, Jorge Castañeda, "Los cambios que vienen de Cuba," *El País*, December 20, 2014, at http://elpais.com.

93 See in particular the work of Armando Fernández, Daniel Whittle, Mário Coyula, and the Fundación Antonio Núñez Jiménez.

94 Camilo Mora et al., "The Projected Timing of Climate Departure From Recent Variability," *Nature*, October 10, 2013, 183–7.

1. We Are Tired of Rhizomes

1 Ena Lucía Portela, *Djuna y Daniel*, Barcelona: Mondadori, 2008; Wendy Guerra, *Posar desnuda en la Habana: Anaïs Nin en Cuba*, Barcelona: Alfaguara, 2011.

2 Leonardo Padura Fuentes, *El hombre que amaba a los perros*, Barcelona: Tusquets, 2009; *Herejes*, Barcelona: Tusquets, 2013.

3 Luis Aguilar, ed., *Marxism in Latin America*, New York: Knopf, 1968, 185. Anarchist newspapers published in Havana include *¡Tierra!*, *Rebelión*, and *Rumbos nuevos*.

4 Camila Piñeiro Harnecker, ed., *Cooperativas y socialismo: una mirada desde Cuba*, Havana: Editorial Caminos, 2011.

5 See Rafael Rojas, *Tumbas sin sosiego* and *La máquina del olvido: mito, historia y poder en Cuba*, Mexico: Editorial Taurus, 2012.

6 Leonardo Padura, "La Habana 2012 (1º parte) entrevista del MST TV," August 4, 2012, at www.youtube.com.

7 María Cristina Vives, "El hombre, la tierra, el arbol y su imagen," *Cubaartecontemporaneo*, at www.cubartecontemporaneo.com; Corina Matamoros, "Todo el tiempo," *La jiribilla revista digital de cultura cubana*, October 21–27, 2006, at www.lajiribilla.cu, also reprinted in Corina Matamoros, *Mirada del curador*, Havana: Letras Cubanas, 2009.

8 It is worth noting that Cuba's first national park was also established in the 1930s. Daniel Whittle and Orlando Rey Santos, "Protecting Cuba's Environment," 87.

9 Trees and sugar thus constitute an alternate opposition to the "contrapunteo" of sugar and tobacco identified by Fernando Ortiz in *Contrapunteo cubano del tabaco y el azúcar*, Havana: J. Montero, 1940.

10 Gilles Deleuze and Félix Guattari, *A Thousand Plateaus: Capitalism and Schizophrenia*, trans. Brian Massumi, Minneapolis: University of Minnesota Press, 1987, 15.

11 T. J. Demos, "Contemporary Art and the Politics of Ecology," *Third Text* 27, no. 1 (2013): 1–9.

12 Gilles Deleuze, "Postscript on the Societies of Control," *October* 59 (Winter 1992), 3–7.

13 Rafael Villares, personal communication, email, September 28, 2014. Joseph Beuys launched what is arguably the best known tree-planting-as-art project in 1982, in which over a few years he planted in Kassel, Germany the *7000 Oaks* of the artwork's title. For a longer history of explorations of "nature" in Cuban art see Yolanda Wood, *Islas del caribe naturaleza-arte-sociedad*, Havana: Editorial Universidad de la Habana, 2012. For Mendieta's work with trees see Olga Viso, *Unseen Mendieta: The Unpublished Works of Ana Mendieta*, New York: Prestel, 2008, 111; 148–9. As Viso's collection of Mendieta's hitherto unpublished sketches and other ephemera reveals, Mendieta was very interested in trees and their parallels with the human form (118–25).

14 Cinthia Marcelle and Héctor Zamora, "Translated Conversation," in *Blind Field*, eds. Tumelo Mosaka and Irene V. Small, Seattle: Krannert Art Museum and Kinkead Pavilion, 2013, 78.

15 Timothy Morton, *The Ecological Thought*, Cambridge, MA: Harvard University Press, 2010, 33.

16 Ibid., 63–4.

17 Ibid., 153.

18 Anamely Ramos, Gretel Medina, and María de Loure Mariño, unpublished proposal for Pan y circo proyecto de exposición colectiva, 2013.

19 Ibid., 9.

20 Anamely Ramos, "Manual de instrucciones, Pan y Circo exposición colectiva," 2014.

21 For a reading of Milton Raggi's work *¿Cómo hacer crecer árboles en la arena?* (How to make trees grow in the sand?, 2009) see Wood, *Islas del caribe naturaleza-arte-sociedad*, 279.

22 Richard Grove, *Green Imperialism: Colonial Expansion, Tropical Island Edens and the Origins of Environmentalism, 1600–1860*, New York: Cambridge University Press, 1995, 30. Columbus's son's theory has been largely discredited. See Diana K. Davis, *Resurrecting the Granary of Rome: Environmental History and French Colonial Exploration in North Africa*, Athens, OH: Ohio University Press, 2007, 78.

23 Grove, *Green Imperialism*, 31.

24 Ibid., 486.

25 Reinaldo Funes Monzote, *From Rainforest to Cane Field in Cuba: An Environmental History Since 1492*, trans. Alex Martin, Chapel Hill: University of North Carolina Press, 2008, 9–11.

26 Ibid., 62.

27 Ibid., 128.

28 Ibid., 206.

29 Díaz-Briquets and Pérez-López, *Conquering Nature*, 143.

30 Alicia Melizundia and Joaquín Borges call *Cúspide* "the most important local magazine" after *Orto*, a literary journal published in Oriente. Alicia Melizundia Ramírez and Joaquín Borges, "*Cúspide*: evocación de un ayer con presente," Diploma, School of Journalism, Universidad de la Habana, 1986, 3; archived at the Instituto de Literatura y Linguística, Havana. *Cúspide* took on the better-known journals of its time from its position of the "interior," and even launched a biting critique of the coverage of "rural" themes in the leading avant-garde journal *Avance*. "Machacando," *Cúspide*, #6, August 1937, I.

31 Ramírez and Borges, "*Cúspide*: evocación de un ayer."

32 See "José Cabrera Díaz Colaborador de Gente Nueva" (*reproducción de semblanza publicada en la revista semanaria 'Gente Nueva' de Santa Cruz de Tenerife, Canarias, el 31 de agosto de 1900)," in *Cúspide*, August 1939,

n.p.; see also Lázaro Alfonso Gómez's unpublished history, *Obra patrimonial de José Cabrera Díaz*; personal communication October 2013.

33 Ramírez and Borges, "*Cúspide*: evocación de un ayer," 39.

34 Felix Muñoz, "José Cabrera Díaz in memorium," *Cúspide*, August 1939, n.p.

35 *Cúspide*, August 1938, 57. The *Club Mercedita*'s tree-planting program was conceived of to help forestry industries as well as less-managed forests. It borrowed from the United States the idea of an "Arbor Day," which was established in Cuba in 1925. Ramírez and Borges, "*Cúspide*: evocación de un ayer," 29; see also Alberto S. Fors's commentary in "La fiesta del árbol," *Cúspide*, June 1938, 1. Many of the trees planted during Cabrera's tenure, including plantings around the sugar mill, were later felled. According to residents of Melena del Sur, this occurred in the 1960–1970s and again in the 1990s. In informal interviews with residents, no reason was offered, other than vague allusions to the radicality and arbitrary nature of agricultural and ecological decisions at the time.

36 Jurors for *Cúspide*'s literary competitions included leading Cuban novelists Enrique Serpa and José Antonio Ramos.

37 Miguel Change Pérez, "Se acabó la zafra," *Cúspide*, no. 10, December 1937, extra pm-n.

38 Benjamin Muñoz Ginarte, "La cooperación agrícola," *Cúspide*, April 1937, viii.

39 The Cuban-Russian anthropologist Dmitri Prieto, raised partially in the former USSR before resettling in Havana, cautions that "During the so-called Perestroika ... cooperatives became incubators for future conglomerates of the Russian capitalist mafiosos." Dmitri Prieto, "Una victoria para Perucho y Camila, y seguimos pa'lante 'sacando más país,'" *Havana Times*, February 6, 2013, at www.havanatimes.org.

40 Alberto S. Fors, "El valor de los árboles (propaganda forestal especial para la revista Cúspide)," *Cúspide*, July 1937, X–XI.

41 *El niño que no amaba a los árboles y como aprendió a amarlos; La cana brava, factor industrial; Lo que son los árboles; En la fiesta del árbol; La fiesta del árbol; El elogio del árbol* and *El árbol.*

42 *La jocuma vieja de tronco limpio y ropa rala, está hablando, pero muy pocos la oyen y nadie le entiende, porque solamente los iniciados pueden interpretar el lenguaje de los árboles del monte.* Alberto S. Fors, "El grito de la jocuma," *Cúspide*, October 1937, X.

43 Carlos Rodríguez Casals, "Exortación del Arbol," *Cúspide*, January 1939, 44.

44 Oak, Eucalyptus, Caoba, Branch, Dileria, Poplar, Ceder, Inga, Jew's Ear, Walnut. "Poesía vegetal," *Cúspide*, no. 57, August 1938.

45 Morton, *The Ecological Thought*. *El monte* also was the name that ethnologist Lydia Cabrera later gave to her study of Afro-Cuban religious beliefs, several chapters of which are devoted to different trees, but which appeals to the more capacious sense of *monte* as a sacred space of wilderness. Eduardo González has suggested Cabrera's *El monte* as an important intertextual reference here to be read as a textual ecology beyond a description of religions' insertion into island ecologies. Lydia Cabrera, *El monte, igbo finda, ewe orisha, vititinfinda: notas sobre las religiones, la magia, las supersticiones y el folklore de los negros criollos y del pueblo de Cuba*, Havana: Ediciones C.R., 1954.

46 *desde el diminuto crustáceo . . . hasta la paloma alterosa, todos son miembros importantes de la gran sociedad forestal, unidos por vínculos naturales de mútua dependencia, cada uno necesario, en cierto modo, a la vida de los demás. Verdadero socialismo reflejado en cada hoja, en cada palmo de corteza y en cada metro cuadrado del suelo! Tal es la vida en el monte natural; el monte denso y turgente, sombrío y húmedo, sin hoquedades ni calvas, libre de violaciones y abusos culturales. No hay más que aislar los árboles, separarlos del resto de la vegetación, para verlos iniciar su retroceso, para desaparecer lentamente, sin relaciones y sin prole.* Alberto S. Fors, "Mutualismo en la vida del monte," *Cúspide*, February 1939, D–E.

47 *[N]o necesitamos que los árboles hablen para descubrir la historia natural del monte. Su fisonomía, las modalidades de su inflorescencia; las formas de sus semillas y sus hábitos, están expresando las múltiples y delicadas relaciones de mútua dependencia que los une con los demás árboles, con el viento, con los insectos, con los aves, con el río y con los microorganismos del suelo, en los distintos procesos de fecundación, diseminación y crecimiento.* Ibid.

48 *para describir todas estas relaciones; para comprender la vida del monte, no basta penetrarlo; es necesario llevar el corazón predispuesto.* Ibid.

49 *[a]lgo preconcebido. Algunas imágenes formadas. Entonces es cuando uno ve algo más que la forma de las cosas, sus colores y sus movimientos; ve también la razón de su existencia, sus relaciones.* Ibid.

50 Morton, *Ecology Without Nature*, 35.

51 The kind of parallel that Fors draws between the interdependence of humans and trees would be taken up decades later by one of Cuba's most

popular authors of the 1970s, Miguel Cofiño. His novel *La última mujer y el próximo combate* (The Most Recent Woman and the Next Battle), winner of the Casa de las Américas prize in 1971, is set amidst agrarian reform; a plan to collectivize peasant land is underway. The novel's backdrop includes a reforestation project like the kind that created Las Terrazas, now a tourist -oriented spectacle of an "ecological community" constructed in Pinar del Río for former coal producers. In Cofiño's novel a character sums up the construction of socialism with a commonplace analogy to forest ecologies: "in the end, without the pine forest there can be no single pine tree." Miguel Cofiño, *La última mujer y el próximo combate*, Havana: Casa de las Américas, 1970, 269. For a memoir of former coal producers' experience of reforestation see Reynaldo González, *Conversación en Las Terrazas*, Havana: Ediciones Boloña, 2010.

52 Eduardo Kohn, *How Forests Think: Toward an Anthroplogy of the Non-Human*, Berkeley: University of California Press, 2013. Kac adds to this common goal of overcoming subject and object the further goal of linking humans with animals and digital code. Eduardo Kac, *Telepresence and Bio Art: Networking Humans, Rabbits, and Robots*, Ann Arbor: University of Michigan Press, 2005.

53 *Y puesto que la visión de nuestros ojos ordinarios es tan superficial e imperfecta, ¿qué no veríamos si pudiéramos llevarnos algunos ojos adicionales, cuando vamos a hacer nuestras observaciones, abriéndolos sucesivamente? Con seguridad que no veríamos el olor de las flores ni los gérmenes que flotan suspendidos en el aire que respiramos; pero veríamos algo más que lo que implica el marco exterior de las cosas: su significado y sus causas. Al que conoce la forma, el tamaño, la coloración y los hábitos de la cigarra, por ejemplo, ¡qué poco trabajo le cuesta encontrarla cuando canta mimetizada sobre una rama gruesa de encina, después de doce años de vida subterráneo! ¡Pero qué difícil es hacérsela ver a otro que no cuenta más que con sus dos ojos ordinarios!* Alberto S. Fors, "Mutualismo en la vida del monte," E.

54 Another author, however, opposed a *"cursi"* (sentimental) "love of trees," condemning "the ridiculous and corny Tree Festival, in schools, the first days of April each year." "El amor al árbol," *Cúspide*, May 1937, editorial, I.

55 *popularizado en toda clase de almanaques y envases de comestibles.*

56 *pintura vanguardista o sea irreal, abstracta.* Nicolás García Vurbelo, "¿Ama a los árboles el guajiro cubano?," *Cúspide*, November 1937, XX–XXI.

57 Díaz-Briquets and Pérez-López, *Conquering Nature*, 21.

58 Ibid., 146.

59 "Cuba to Raise Forest Coverage Nationwide," China.org.cn, August 26, 2013, at www.china.org.cn.

60 Díaz-Briquets and Pérez López, *Conquering Nature*, 46. In 1976, COMARNA (the National Commission for Environmental Protection and the Rational Use of the Natural Resources) was founded. In 1981, Law 33 "On the Protection of the Environment and the Rational Use of Natural Resources," which Whittle and Rey Santos call "one of the pioneer environmental laws in Latin America," was approved in the National Assembly. By the 1990s environmentalists in Cuba recognized it had never been successfully enforced (Whittle and Rey Santos, "Protecting Cuba's Environment," 78–80). For the next eight years the Academy of Sciences developed a plan yielding decree-Law 118 of 1990, which placed COMARNA in charge of monitoring the environment (ibid., 78). Whether any of these laws were followed through on remains a question (ibid.; Díaz-Briquets and López-Pérez, *Conquering Nature*, 47). CITMA, a Ministry of Science, Technology and Environment, was established in 1994. Since the mid-1990s the Ministry has overseen the adoption of a number of progressive environmental laws, including one on forest conservation, Law 85/98 (Whittle and Rey Santos, "Protecting Cuba's Environment," 84).

61 William Gaud, "Address before The Society for International Development," Shorehan Hotel, Washington, DC, March 8, 1968, at www.agbioworld.org/.

62 Eudel Cepero reminds readers that an early attempt to dam all the island's rivers sounded all the notes of what Fidel Castro promised would be a "revolution against nature." Cepero cites Castro himself: "Let there be every year more and more rivers dammed, until there is not even a small stream undammed, until the promise is met that 'not a single drop of water make it to the sea', for that is the great goal of this organization, its final objective." Eudel Cepero, "Amnesia ambiental," *Cubaencuentro*, June 6, 2007, at www.cubaencuentro.com.

63 Wright, *Sustainable Agriculture and Food Security*, 58.

64 My thanks to Víctor Fowler for recommending that I examine these past campaigns in *Cuba Internacional*. See "Plan Ceiba," *Cuba Internacional*, March 1970, 3–15. The heady speed with which these projects sought to reshape the land is palpable in the constant present tense of the articles and the breathless announcement of violent change: "The boss's voice sounds, ordering withdrawal, and we all run. A few seconds later the morning fills with explosions, palm trees broken apart and clouds of smoke and red dust" (ibid., 4).

65 Enrique de la Uz, "No hay otro modo de hacer la zafra," *Cuba Internacional*, October 1970, 36–9.

66 "Arroz: un esfuerzo colosal," *Cuba Internacional*, October 1969, 30–5.

67 Quiroga, *Cuban Palimpsests*, 184. Kaira Cabañas discusses Mendieta's diminutive size as a factor in the modest scale of her works as opposed to the massive movement of earth in contemporary male earthworks. Kaira Cabañas, "Ana Mendieta: 'Pain of Cuba, Body I Am,'" *Woman's Art Journal* 20, no. 1 (1999), 12–17 (15).

68 These quotations are drawn from a larger discussion of the debatably "feminine" nature of Mendieta's art in Susan Best, "The Serial Spaces of Ana Mendieta," *Art History* 30, no. 1 (2007), 57–82 (67).

69 Viso, *Unseen Mendieta*, 8; 79.

70 See Mark Cheetham and Elizabeth Harvery, "Obscure Imaginings: Visual Culture and the Anatomy of Caves," *Journal of Visual Culture* 1, no. 1 (2002), 105–26 (110). Charles Merewether claims that Smithson's art provided Mendieta with a "tremendous sense of affiliation and source of inspiration for her new work." Charles Merewether, "From Inscription to Dissolution: An Essay on Expenditure in the Work of Ana Mendieta," in *Ana Mendieta*, ed. Gloria Moure, Barcelona: Ediciones Polígrafa, 1996, 83–131 (111). Merewether anchors his assertion of the link between Smithson and Mendieta in the following observations: he claims that Mendieta was introduced "to the work of Robert Smithson by both John Perrault and Hans Breder [sic]. Smithson had worked in the Mayan region, not far from where Mendieta herself had first gone. Her former teacher, John Perrault, had written about Smithson's work in the year when he was teaching at Iowa and Bredel had known him through Max Kansas' [sic] in New York. On July 20th of 1973, the summer of Mendieta's return to Mexico, Smithson died in a plane crash" (ibid., n72, 130). As Rosalind Krauss noted in her 1979 essay "Sculpture in the Expanded Field," earth art itself framed its interventions in terms of Neolithic or prehistoric interventions: "Stonehenge, the Nazca lines, the Toltec ballcourts, Indian burial mounds." Rosalind Krauss, "Sculpture in the Expanded Field," *October* 8 (Spring 1979), 33.

71 Viso, *Unseen Mendieta*, 283.

72 Laura Roulet, "Ana Mendieta as Cultural Connector With Cuba," *American Art* 26, no. 2 (Summer 2012), 21–7 (25).

73 Weiss, *To and From Utopia*, 18.

74 Ibid., 23.

75 *Los seres humanos, a veces, tratan a la naturaleza como algo sin valor, inerte. La estudian, la analizan, la dividen, la clasifican, como a cualquier objeto inanimado, pero también, la contaminan, la destrozan . . . [en un basurero] se puede encontrar lo que quiera . . . cualquier cosa a la que el hombre le ha dado mucho valor en determinado momento y cuando se rompe va a parar al basurero que se convierte en el retrato de quienes lo hacen. Jesuscristo decía: por su obra lo conoceréis, y se puede añadir: por su basurero lo conoceréis.* Quoted in Wood, *Islas del caribe*, 172.

76 Cristina Vives, "José Manuel Fors, La imagen," Galería Cubarte, September 2000, at www.galeriacubarte.cult.cu.

77 Camnitzer, *New Art of Cuba*, 175.

78 Matamoros, "Todo el tiempo," 146.

79 Vives, "José Manuel Fors," n.p.

80 Matamoros, "Todo el tiempo," 147.

81 Abelardo Mena Chicuri, "José Manuel Fors," at www.thefarbercollection. com; Timothy Wride, ed., *Shifting Tides: Cuban Photography After the Revolution*, Los Angeles: Los Angeles County Museum of Art, 2001, catalogue, 98–9. I owe the date of Fors's turn to photography to Cristina Vives ("José Manuel Fors, La imagen").

82 Matamoros, "Todo el tiempo," 148.

83 *En un espacio cerrado dentro de las salas del museo Fors desplegó una apoteosis de objetos: fotocopias de fotografías del abuelo, sus libros sobre tratados de botánica, muestrarios de maderas—parte de la colección formada por el científico—y tres mosaicos fotográficos de grandes dimensiones "Bosque de pinos," "Sombra bajo 5 billones de árboles" y "Homenaje a un silvicultor." Para construir esta instalación hurgó en las memorias familiares, en la colección fotográfica de la familia, estudió más científicamente sobre árboles y maderas, leyó cartas y documentos; en fin, logró atar los cabos sueltos de su propia obra anterior y estructuró la historia de una familia de cuyo legado era heredero y en la cual se había formado. Con esta obra Fors logró articular el discurso básico de su obra en el futuro: el hombre, su memoria y su historia personal como eje fundacional de la vida.* Vives, "José Manuel Fors, La imagen."

2. Marabusales

1 Raúl Castro, "Trabajar con sentido crítico y creador, sin anquilosamiento ni esquematismos," July 27, 2007, *Diario Granma*, at www.granma.cu.

2 Mesa-Lago, *Cuba en la era de Raúl*, 79.

3 *deMoler*, directed by Alejandro Ramírez Anderson, 2004, Havana: Producciones CANEK, 2004, DVD; *Model Town*, directed by Laimir Fano Villaescusa, 2006, Havana: EICTV, 2007, DVD.

4 *Melaza*, directed by Carlos Lechuga, 2012, Havana: Producciones de la 5ta Avenida, 2012, DVD.

5 *en la mentalidad de la gente; pensamiento espinoso.* Reading, Fayed Jamis Bookstore, Havana, September 2013.

6 Víctor Fowler, personal communication, October 2013.

7 Armando Fernández, personal communication, October 2013.

8 Ricardo Martín Prado Asef, personal communication, October 2013.

9 Helson Hernández, "Tania Vergara: A Different Creator," *Cubanow*, September 13, 2014, at www.cubanow.net.

10 Samuel Riera, personal communication, May 2012; July 2014.

11 Fernando Ravsberg, "Que el marabú os ilumine," *Havana Times*, June 24, 2010, at www.havanatimes.org.

12 Riera, personal communication, May 2012.

13 For a sustained reading of Riera's visual poetry see Lizabel Mónica Villares and Rachel Price, "Poesía digital cubana," in *Poesía y poéticas digitales / electrónicas / tecnos / new-media en América Latina: Definiciones y exploraciones*, eds. Luis Correa-Díaz and Scott Weintraub, Bogotá: Universidad Central de Bogotá Publicaciones, 2015.

14 Jacqueline Loss notes that numerous artists have similarly revisited Soviet cartoons. Loss, *Dreaming in Russian*, 180.

15 *En el más verde de los prados pacían los más orondos cerdos.*

16 *El pasto crece más verde en el patio del vecino.*

17 *HOY: La claridad empieza a parir claridad; HOY: En una huida eternal huyen los horizontes; HOY: La fijeza J.L Lima.*

18 Carlos Garaicoa, "Sin Solución," interview, *Galleria Continua* (Winter 2012), at www.galleriacontinua.com.

19 *reina destruye o redime; El volcán estallará, illuminados, esperamos; la General Tristeza negará placeres.*

20 Estrella Díaz, "La ciudad es el ecosistema del ser humano, asegura Garaicoa," *Arte cubano revista de artes visual* 2/3 (2012), 96.

21 José Ramón Sánchez, *Marabú*, Havana: Torre de Letras, 2012.

22 *Escribo como quien alza/ Hornos de marabú:/ Cada letra una espina/ Pues ya la inocencia/ Me sirve de poco./ (Las vacas que se lo comen/ dan leche buena.)* Ibid., 7.

23 *dos patrias tengo yo: Cuba y la noche/ o son una las dos?* José Martí, *Obras Completas*, Havana: Editorial de ciencias sociales, 1963–73, Vol. 16: 252; *la rubia y la mulata/ o son una las dos?* José Ramón Sánchez, *El derrumbe*, Havana: Letras Cubanas, 2012, 17.

24 *a vida a retazos, poesía de retazos; a paisaje de marabú, poesía de marabú.* Martí, *Obras Completas*, 22: 309.

25 *El culpable se escondió/ en los marabuzales/ del sur de la ciudad/ y lo sacaron de allí con perros.* Sánchez, *Marabú*, 36.

26 *Aunque era un presidiario/ y restos de su piel estaban/ en las uñas de la muerta,/ negó el crimen./ Otra historia esquemática.* Ibid.

27 Ibid., 30.

28 *Y la Isla?/ Ya sabemos:/ la Isla no existe./ El muerto es una isla./ El Cosmos está muerto y nosotros/ lloramos en su funeral./ Un funeral muy largo./ Lleno de interrupciones/ porque dicen que el funeral/ se expande infinitamente./ Como una flor carnívora/ que se abre para coger su presa . . . Esta flor no se detendrá/ va a seguir la derrumbe.* Sánchez, *Derrumbe*, 21.

29 *El árbol nacional.*

30 *Marabú, Aroma, Aroma francesa,/ Aroma blanca, Espina del diablo, Weyler. Dichrostachys cinerea./ Familia: lugimonsas./ Subfamilia: mimosáceas./ Del francés marabout y este/ Del árabe dialectal marbut./ Arbusto o árbol pequeño/ oriundo de África/ . . . / Fue introducida en el siglo XIX/ y hay varias versiones la señora/ Monserrate Canalejo, como ornamento/ En su finca La Borla, en las afueras/ de la ciudad de Camaguey; José Blain, en Taco-Taco,/ Pinar del Río, para estudiar las plantas;/ el ganado extranjero (Colombia)/ traído después de la Guerra Grande/ deyectaba las semillas luego de haber/ ingerido los frutos en sus lugares de origen.* Sánchez, *Marabú*, 71.

31 *Una vez establecida se expande y resulta/ difícil de erradicar porque sus largas raíces/ originan retoños dondequiera que emerjan/ a la superficie. Destruye la vegetación natural./ Su corte o quema aumenta el número de retoños./ Se propaga fácil y forma bosques impenetrables./ Sus raíces, numerosas y profundas, penetran/ en el suelo y facilitan que se ventile y divida.* Ibid.

32 *Protege grandes áreas contra la erosión . . . / Se utiliza como leña/ y es muy buena para fabricar carbón. Fija nitrógeno/ al suelo.* Ibid., 71–3.

33 *Llegó a ocupar más de 1 000 000 de hectáreas:/ El 10% del territorio nacional.* Ibid., 73.

34 *lo que más bonito estaba, lo que más resaltaba a mis ojos, era lo lindo que está el marabú a lo largo de toda la carretera.*

35 *CDR 11, zona 10 en circulación* (2005); *Estado civil* (2004–6); *Registro de población* (2004); *La clínica de buen contacto* (2009); *Notes on the Ice* (2011).

36 Dan Whittle, personal communication, email, September 2014. See also Dan Whittle, "Cuba: How We Work," *Nature Conservancy*, at www.nature. org.

37 Camnitzer, *New Art of Cuba*, 114; Weiss, *To and From Utopia*, 47.

38 Since the 1990s Oroza has collected and written about such objects. In a January 2014 interview he commented that when he left Cuba he found a body of literature that allowed him to understand the "objects of necessity" in Cuba within a larger tradition. This tradition included what the Soviet Productivist Boris Arvatov named a "Transparent object or *comradely* object: an open object that does not hide its code from the worker or the user but rather makes it fully accessible," and which Oroza renamed "Technological disobedience." Oroza dates the notion of a Cuban DIY manufacture freed from market forces to the early days of the revolution, when Ernesto "Che" Guevara exhorted: "worker build your machinery" (*obrero construye tu maquinaria*), a possibility that was quickly flattened by Cuba's adoption of standardization. "The phrase," Oroza wrote, "radical and revolutionary even today, called for the reinvention of relations of production and with it of society. But just a few days later, in September 1961, [Guevara] solicited, through the Ministry of Industries, Cuba's inscription in the International Organization for Standardization. On the one hand, he asked of workers the reinvention of the world, on the other, he acceded to the global capitalist order . . . fifty-two years later, this opposition has a new dimension, as the insurgent productive practices inhabit a fully standardized environment." Ernesto Oroza and Manuel Cullen, "Revolución de la desobediencia," interview, Buenos Aires, *Año* 14, no. 161 (December 2013), 9, at www.ernestooroza.com.

39 Weiss has also noted that in 1991 Gerardo Mosquera wrote of Adriano Buergo "that he worked 'with the world of odds and ends from the 1940s and '50s that have had to continue putting in a day's work in Cuba, the

world of objects adapted to new functions in a crude and utilitarian home-made bricolage of everyday things that have held up to the blockade, the auto-blockade. And scarcity.'" Weiss, *To and From Utopia*, 182–3.

40 *una enorme torta de excremento que cambiará el curso biológico de la isla para siempre. Y sobra decir que el cambio del curso biológico de una isla implica el desvío de todos los cursos posibles.* Oroza and Moreno, *Tabloid #26, Navidad en el Kalahari*, 2.

41 *Desde los campos de concentración de . . . Weyler, las miserias que dejó en los campos de Cuba la Guerra de Independencia, o más tarde la persistencia del monocultivo y la tierra mal distribuida, hasta los más de cincuenta años de tierras sin campesinos.* Ibid., 7.

42 *El marabú es "la tempestad." Una fuerza concentrada y homogénea que, indiferente, borra tanto a Calibán como a Ariel.* Ibid., 5.

43 The debates about Shakespeare's figures of Ariel and Caliban in Latin American studies are multiple and date to the turn of the twentieth century. See Roberto Fernández Retamar's *Todo Calibán*, Havana: Letras Cubanas, 2000, as well as Rafael Rojas's critique of it in *Tumbas sin sosiego*.

44 *Se trata de la inteligencia de una totalidad, embebida a nivel molecular.* Oroza and Moreno, *Tabloid #26, Navidad en el Kalahari*, 2.

45 *como un índice de otros patrones de captura y consumo de energía, que el ecosistema invadido no puede permitirse el lujo de emular.* Ibid., 4.

46 *el nuevo territorio como una fuente de alimentación, como un campo para la extracción de energía.* Ibid.

47 *Espirales, círculos perfectos y rotos, garabatos, líneas cruzadas y tangenciales, son las formas que toma la consolidación sobre la isla, de una invasión biológica aterradora. Con tal magnitud, sólo podemos remitirnos a un precedente histórico: la conquista española. Pero la nueva colonización parece venir desde el futuro, o al menos anticiparlo.* Ibid.

48 *colonialismo y estratificación de clases, de un capitalismo incipiente, de la primera globalización que se desarrolla mediante el "triángulo comercial de la esclavitud" (también conocido como Le Passage de Milieu). Pero también . . . demanda otra modalidad de pensamiento, una horizontalidad de multiplicidades.* Ibid., 5.

49 Vera Estrada, *Guajiros del Siglo XXI*, 200.

50 *El marabú produce una enzima del porvenir, presagia de los códigos organizativos del futuro; nos obliga a hablar de el en términos de vectores, de continuos, de multiplicidades, de redes e infinitudes.* Oroza and Moreno, *Tabloid #26, Navidad en el Kalahari*, 4.

51 *Para visualizar su expansión, hay que asumir puntos de vistas esquemáticos y extrapolar otros lenguajes de síntesis como el cine, la arquitectura de infraestructuras y de redes, la producción masiva de objetos genéricos, el espacio y tiempo informáticos.* Ibid.

52 *palma barrigona, el jagüey blanco, el aguacate cimarrón, la bruja negra. La genética de La Intrusa, evolucionada en tierras continentales, no encuentra competencia ni en la literatura más castiza . . . La manigua de marabú le cierra las visuales al "sensible zarapico". . . quedan algunos parajes donde no la menciona, pero en otros es evidente que la maldita acecha los pozos, se precipita hacia los pueblos, estrangula los caminos, las narrativas feijóoseanas se descompensan; las plantas endémicas absorben, a cada línea, menos tinta que la planta alienígena que ya atraviesa párrafos enteros con sus espinas.* Ibid., 5.

53 Oroza and Moreno cite the Italian architect Andrea Branzi, for whom "the torrent of industrial production, of prefabricated and generic things, has a continuous parallel in nature's torrent of production." Ibid., 7.

54 Peter J. Lu and Paul J. Steinhardt, "Decagonal and Quasi-Crystalline Tilings in Medieval Islamic Architecture," *Science* 315, no. 5815 (February 2007), 1106–10.

55 *casi todo mi trabajo tiende a la abstracción, a pesar de haberme propuesto una pintura figurativa, lo cual me hace pensar como cierta la metáfora de rizoma que propone Gilles Deleuze sobre la abstracción. Es, sin duda alguna, el tipo de planta que no se reproduce por semillas, sino de partes de sí misma que se exitenden continuamente en nuevas tierras.* Luis Enrique López-Chávez Pollán, "De las cosas que ceden 2008–2013," artist's catalogue.

3. Havana Under Water

1 James Hansen, *Storms of My Grandchildren: The Truth About the Coming Climate Catastrophe and Our Last Chance to Save Humanity*, New York: Bloomsbury, 2009, 42.

2 Nelly Richard, "The Graphic Model of an Advertising Identity," in *Cultural Residues: Chile in Transition*, trans. Alan West-Durán and Theodore Quester, Minneapolis: University of Minnesota Press, 2004, 116–17.

3 Hansen, *Storms of My Grandchildren*, 42.

4 Ibid., 83.

5 Dahr Jamail, "The Coming 'Instant Planetary Emergency,'" *The Nation*, December 17, 2013, at www.thenation.com.

6 Hansen writes that "Ice sheet growth is a slow process, inherently limited by the snowfall rate, but disintegration is a wet process, spurred by feedbacks, and once well under way it can be explosively rapid." Hansen, *Storms of My Grandchildren*, 85–6.

7 "Hot Spots: Global Temperature Rise," *Washington Post*, at http://apps. washingtonpost.com.

8 Jamail, "The Coming 'Instant Planetary Emergency.'"

9 *Varias ciudades se habían perdido sin remedio. De las pequeñas islas, antiguamente dispersas por los océanos, no quedaba ni mitad, y en las restantes se hizo casi imposible vivir, porque los maremotos, las inundaciones y los temporales has hacían inhabitables. El sol se tornó letal; causaba graves y dolorosas quemaduras. Además, derritió la zona congelada de hielos perpetuos en solo unos años. Muchos territorios tomaron medidas. Construir el Frontón fue una de ellas.* Nuria Dolores Ordaz Matos, *Entremundos*, Havana: Editorial Gente Nueva, 2010, 15.

10 Virgilio Piñera, *La isla en peso*, Havana: Ediciones Unión, 1998, 33.

11 Dan Whittle, personal communication, email, September 2014; Nature Conservancy, at www.nature.org.

12 Whittle and Rey Santos, "Protecting Cuba's Environment," 74.

13 Ibid., 75.

14 Ibid., 86.

15 Benítez-Rojo, "Sugar and the Environment in Cuba," 47. The Centro de Gestión e Inspección Ambiental oversees "5 research agencies on atmosphere and climate change, coastal areas, biodiversity, physical planning and soil and water resources." Whittle and Rey Santos, "Protecting Cuba's Environment," 76–7.

16 The *Gaceta Oficial de la Republica de Cuba* 26 from September 2013 claims that the renovation will "oversee the implementation of the results of the Strategic Environmental Evaluation realized by the Ministry of Science, Technology and the Environment for projects approved for the zone" (207). Héctor Fernándo Maseda Gutiérrez, "El proyecto Brasil-Cuba en el puerto de Mariel," *Miscelaneas de Cuba*, at www.miscelaneasdecuba.net; Whittle and Rey Santos, "Protecting Cuba's Environment," 89.

17 Humberto Díaz, personal communication, May 2012; artist's statement.

18 "Hokusai the Wave," *Private Life of a Masterpiece*, season 3, produced by Jeremy Bugler, London: BBC, 2004.

19 Weiss, *To and From Utopia*, 6.

20 See Jacques Khalip's chapter "Now No More" from his unpublished manuscript, *Dwelling in Disaster* (in progress) and Colebrook, *Extinction*.

21 Artist's statement.

22 Khalip, "Now No More," n.p.

23 Subhankar Banerjee, "Ought We Not to Establish 'Access to Food' as a Species Right?," *Third Text* 27, no. 1 (2013), 33–43 (34).

24 See, for instance, Sebastião Salgado, *Genesis*, ed. Lélia Wanick Salgado, Cologne: Taschen, 2013.

25 Vázquez Ley states he is interested in "death by cultural and informational obscolescence and physical death; accumulation as a symptom of death on a systemic level, death as reason for generating a multiplicity of links in a network referring to any event . . . Photography operates as a document of that reconstruction, a splintered allusion whose origin can be found buried in the informational referent." Artist's statement.

26 Castells, "El reverdecimiento," 23. Registering a changing environment in a more organic fashion, the young artist Liesther Amador has made works such as *Línea* (2007), a chalk line traced just above the waterline of a body of water. The line inscribed art in the landscape, capturing the shifting transition between water and earth in the single moment in which the line was traced on the cliff walls. Waves across the surface of the water and rainfall eventually rubbed away the chalk. The line suggested the water's retreat, as if the processes responsible for changing water tables, however invisible, were human-made too. Amador, surprisingly, was unaware of similar works by earlier Cuban artists such as Gustavo Pérez Monzón, who, in the 1970s and in collaboration with children, drew with pigment in streams, then watched the colors swirl away (Weiss, *To and From Utopia*, 24). Liesther Amador, personal communication, July 2012 and September 2014.

27 Mota, *Habana underguater*, 33.

28 See Enrique Rodríguez Sosa, *Los ñánigos*, Havana: Casa de las Américas, 1982; Ivor Miller, *Voice of the Leopard: African Secret Societies and Cuba*, Jackson: University Press of Mississippi, 2009.

29 Jameson, *Antinomies of Realism*, 301.

30 Ibid., 302.

31 *solo un mapa de ruta, un destino oculto en la Red*. Mota, *Habana underguater*, 87.

32 *la verdadera Habana Autónoma*. Ibid., 75.

33 *Zona corporada Miramar*.

34 Ibid., 29; 5.

35 Ibid., 21–2.

36 Ibid., 84.

37 Ibid., 61.

38 *Los problemas de las corporaciones no son los problemas de la Regla de Ocha.* Ibid, 35.

39 *tuvo que inventar para sobrevivir.* Ibid., 27.

40 Bruno Latour, *We Have Never Been Modern*, trans. Catherine Porter, Cambridge, MA: Harvard University Press, 2003.

41 Mota, *Habana underguater*, 84.

42 *El resto del cubo-web había sido programado intentando reproducir un fragmento del callejón de Hamel en la Habana de finales del XX.* Ibid., 34.

43 Ibid., 73. The mimetic suits seem to allude to a longstanding interest in Cuban culture—from mid-twentieth-century theorist and author Severo Sarduy back to nineteenth-century Abakuá practices—with theories of mimesis. See Severo Sarduy, *La simulación*, Caracas: Monte Avila Editores, 1982.

44 *No seré caballo de nadie ni aquí ni allá fuera. ¿Qué te crees, que por tan poco me dejaré poseer como un autómata por medio de una red inalámbrica?"* Mota, *Habana underguater*, 73.

45 Mota, *Habana underguater*, 41–2; 48.

46 See John Reider, *Colonialism and the Emergence of Science Fiction*, Middletown, CT: Wesleyan University Press, 2008.

47 Mota, *Habana underguater*, 49.

48 Ibid., 102. Lisa Yaszek charts branching currents in what has, in the Anglophone world, come to be called "afro-futurism." Yaszek echoes Kodwo Eshun's critique of a certain conflation of "blackness and catastrophe," whereby places "populated by descendents of the African diaspora—such as the Caribbean islands and the inner cities of North America"—receive a leveling treatment in futurist scenarios: "sites of absolute dystopia; imaginary spaces where the persistence of black identity signifies a disastrous failure in the ongoing progress of global capital itself." In contrast, Mota does not construct a wholly dystopian world, and African-descended Cubans are not an obstacle to global capital so much as an integral part of the new logic of the Net-driven society. Lisa Yaszek, "Afrofuturism, Science Fiction and the History of the Future," *Socialism and Democracy Online*, April 7, 2011, at http://sdonline.org. Kodwo Eshun, "Further Considerations on Afrofuturism," *CR: The New Centennial Review* 3, no. 2 (Summer 2003), 287–302.

49 *Cada Orisha codifica sus ofrendas siguiendo un algoritmo de cifrado diferente. Y nadie decodifica a un Orisha.* Mota, *Habana underguater*, 73.

50 *el que abre y cierra todos los caminos en la Red.* Ibid.

51 Ibid., 67; 31.

52 See Louis A. Pérez Jr., *Winds of Change: Hurricanes and the Transformation of Nineteenth-Century Cuba*, Chapel Hill: University of North Carolina Press, 2001, and Fernando Ortiz, *El huracán: Su mitología y sus símbolos*, Mexico: Fondo de cultura económica, 1957.

53 Henry Fountain and Justin Gillis write that "As the planet warms because of carbon dioxide and other heat-trapping gases, the difference between sea and air temperatures increases . . . [fueling] these kinds of cyclonic storms. 'As you warm the climate, you basically raise the speed limit on hurricanes.'" Henry Fountain and Justin Gillis, "Typhoon in Philippines Casts Long Shadow Over U.N. Talks on Climate Treaty," *New York Times*, November 11, 2013, at www.nytimes.com. See also Jakob Kronik and Dorte Verner, *Indigenous Peoples and Climate Change in Latin America and the Caribbean*, Washington, DC: The World Bank, 2010.

54 In Juan Plana y Sainz's 1920 novel *La corriente del golfo*, considered the first Cuban science-fiction novel, Mambises (independent fighters in the 1895 war against Spain) collude with US capitalists to use dirt moved from the building of Panama canal to divert the Gulf Stream, thus causing massive climate change. Spain dries out, populations starve and begin a mass migration through other parts of Europe; eventually the metropole grants the island its independence. This fantastical past is now a possibility, since it is possible that the Gulf Stream may actually disappear, or weaken substantially. See "Satellites Record Weakening North Atlantic Current," NASA.gov, April 15, 2004, at www.nasa.gov.

55 Mota, *Habana underguater*, 94–100.

56 *Las olas del mar batían contra los edificios a medio hundir. Infinidad de algas, erizos y cangrejos ocupaban los pisos interiores en espera de la marea alta.* Ibid., 10.

57 *Cuando Underguater pertenecía a Centro-Habana, y la Regla de Ocha tenía la batuta, las cosas iban mejor. A los santeros no les importaba lo que hiciéramos con la pesca. Cobraban una mensualidad y ya.* Ibid., 50.

58 Justin Corfield, "Cuba," *The Encyclopedia of Global Warming and Climate Change*, ed. S. George Philander, Los Angeles: Sage Publications, 2008.

59 *Pequeñas balsas de caucho y polímero flotaban en el azul de las aguas*

profundas. Los pescadores flotaban a la deriva más allá del límite de seguridad. Casi en el horizonte, las plataformas extractoras enarbolaban logos de Corporación Unión Católica y Testigos de Jehová. Algunos helicópteros de la FULHA surcaban el cielo, como grandes pájaros negros, en dirección al cosmopuerto de La Habana Vieja. Mota, *Habana underguater*, 10.

60 "*El sonido de las olas chocando contra la costa llegaba desde el norte. Las olas corrían entre los edificios del pueblohundido para morir en le muelle de peatones del Camilo Cienfuegos . . . Los botes de los pescadores hacían parpadear sus faroles chinos al ritmo del morse, en eterno regateo con los trabajadores de las plataformas de los Testigos de Jehová, sobre los precios del pescado en Underguater.*" Ibid., 37–9.

61 Hugo Grotius, *Mare Liberum* (The Freedom of the Seas, 1609), trans. Ralph Van Deman Magoffin, New York: Oxford University Press, 1916, digital edition Kitchener: Batoche Books Limited, 2000, 15.

62 *No son de este mundo. Ni del virtual ni del real.* Mota, *Habana underguater*, 43.

63 *Mientras el horizonte está negro y la niebla de la lluvia cae a lo lejos, las olas llegan hasta los restos de las casas y golpean las fachadas como un puño de salitre que se destroza. Las olas corren por las calles, desbordan el viejo alcantarillado y crean surtidores de agua en medio de las avenidas. Tú que has viajado por la red, dime si desde las consolas de todo el mundo puede escucharse el rugido del mar como un animal hambriento, sentir su calor de amante en celo . . . Estás preso en tu océano de pulsos binarios, como nosotros lo estamos allá afuera.* Ibid., 111.

64 Sigmund Freud, *Civilization and its Discontents*, trans. James Strachey, New York: Norton, 1961, 11.

65 Ibid., 12.

4. Post-Panamax Energies

1 Harvey O'Conner, *The Empire of Oil*, New York: Monthly Review Press, 1955, 47–8.

2 Emilio Morales writes that "the region is home to 49 percent of the hemisphere's crude oil production, and 59 percent of its refining capability." Emilio Morales, "The Mariel Special Zone: Economic Wagers and Realities," trans. Joseph L. Scarpaci, Miami, the Havana Consulting Group, posted on November 2, 2013 by Arch Ritter at http://thecubaneconomy.com.

3 Alexis Dudden, talk on Japanese extension of oceanic sovereignty, Princeton University, February 2014.

4 Vandana Shiva, *Soil Not Oil: Environmental Justice in a Time of Climate Change*, Cambridge, MA: South End Press, 2008, 5.

5 See Kathi Weeks's reflections on the distinction between life and work in *The Problem With Work*, Durham, NC: Duke University Press, 2011.

6 Matthew Huber, *Lifeblood: Oil, Freedom, and the Forces of Capital*, Minneapolis: University of Minnesota Press, 2013, 18.

7 Gilles Deleuze, *Francis Bacon: The Logic of Sensation*, trans. Daniel W. Smith, New York: Continuum, 2002. Philosopher and painter Megan Craig has discussed Deleuze's treatment of color, and specifically how it works as a force, in "Deleuze and the Force of Color," *Philosophy Today* 54 (2010), 177–85.

8 Gerardo Mosquera, one of the founding members of the Havana Biennial, is rather pessimistic about the Biennial's contemporary instantiation; Rachel Weiss remains more optimistic. See Rachel Weiss et al., *Making Art Global, Vol. 1: The Havana Biennial*, London: Afterall, 2012.

9 Alberto Toscano, talk delivered at e-flux, October 31, 2013.

10 Alberto Toscano, "Logistics and Opposition," Metamute.org, August 9, 2011, at www.metamute.org.

11 See Alan Sekula, *The Forgotten Space* (2010) and Peter Hutton's *At Sea* (2007). In *Forgetting the Art World*, Pamela Lee discusses containers in the work of Andreas Gursky, acknowledging that "containers play a recurring role in the iconography of globalization" (93; 95) and, referencing Sekula's *Fish Story*, that "the container has come to stand as a visual shorthand for the dynamics of transnational markets," which Sekula questions along with "the legend of what he calls a 'fluid world of wealth'" (95).

12 Barbas-Rhodan, *Ecological Imaginations*, 28.

13 See Antonio López's chapter on Mariel in *Unbecoming Blackness: The Diaspora Cultures of Afro-Cuban America*, New York: New York University Press, 2012.

14 Weiss, *To and From Utopia*, 9.

15 Antonio Eligio Fernández, "Ending the Century With Memories . . . : Paper Money, Videos, and an *X-Acto* Knife for Cuban Art," in Hernández -Reguant, *Cuba in the Special Period*, 179–95 (180).

16 The editorial page of *Mariel* suggests that it welcomed Latin American, North American and European contributors as well, so long as they shared the magazine's vision of a common rejection of "*cualquier sistema*

totalitario" (any totalitarian system). *Mariel*, "editorial," by the editors (Spring 1983), 2, at www.revista-mariel.com.

17 *no existe un arte mercantil, como no hay un arte doctrinario . . . Toda obra de arte es un desafío, y por lo tanto, implícita o explícitamente, es una manifestación—y un canto—de libertad.* Ibid.

18 *No la alegría propiamente,/ Sino el placer de contemplar las aguas que circulan.* Delfín Prats, "Aguas," *Mariel* no. 1, 1980, n.p.

19 *Incalculablemente más valiosas:/ cifra/ moneda/ energía/ divisa/ sombra/ oscuridad/ Las aguas escapando hacia Leonero,/ escapando hacia el mar.* Ibid.

20 Toscano, talk delivered at e-flux.

21 Karl Marx, *Capital*, Vol. 2, Chapter 6, III, "Costs of Transportation," at http://libcom.org.

22 Timothy Mitchell, *Carbon Democracy: Political Power in the Age of Oil*, New York: Verso, 2013, 37.

23 See Alberto Toscano's forthcoming *Cartographies of the Absolute*. In *The Undercommons: Fugitive Planning and Black Study*, New York: Autonomedia, 2013, Fred Moten and Stephano Harley assert that modern logistics "Was founded in the Atlantic slave trade, founded against the Atlantic slave . . . Logistics remains, as ever, the transport of objects that is held in the movement of things. And the transport of things remains, as ever, logistics' unrealizable ambition" (98).

24 Jean-Paul Rodrigue notes that "containerization has been the most dynamic physical component of globalization, far exceeding the growth of the value of exports and the GDP," and that additional GDP or export units are associated with greater flows of containers. Jean-Paul Rodrigue and David Guerrero, "The Waves of Containerization: Shifts in Global Maritime Transportation," at http://people.hofstra.edu.

25 Henrique Gomes Batista, "Aeroportos cubanos receberão milhões do BNDES," *O Globo*, January 7, 2015, at http://oglobo.globo.com/economia/infraestrutura/aeroportos-cubanos-receberao-us-150-milhoes-do-bndes-13439867.

26 See Lecio Morais and Alfredo Saad-Filho, "Neo-developmentalism and the Challenges of Economic Policy-Making Under Dilma Rousseff," *Critical Sociology* 38, no. 6 (November 2012), 789–98.

27 See Odebrecht's annual report, 2013–14, at http://odebrecht.com. Anthony Hall and Sue Branford note that while Brazil is internationally perceived to be a producer of "clean" energy, most of its energy comes from hydroelectric dams, making it also "the world's seventh largest CO2 emitter, caused

largely by forest burning." Anthony L. Hall and Sue Branford, "Development, Dams and Dilma: The Saga of Belo Monte," *Critical Sociology* 38, no. 6 (November 2012), 851–62 (859).

28 *La Gazeta* 26, September 2013, 205–7.

29 "Mariel Special Development Area Presented to Investors in Brazil," *Radio Rebelde*, November 21, 2013, at www.radiorebelde.cu.

30 Morales, "The Mariel Special Zone," n.p.

31 Ibid.

32 "Cuba pide préstamo a Brasil para puerto de Mariel," Yahoo! News, November 21, 2013, at http://news.yahoo.com.

33 Maristella Svampa, "Néo-'Développementisme' extractiviste, gouvernements et mouvements sociaux en Amérique latine." *Problèmes d'Amerique Latine* 81 (2011): 103–27. See also Paulo Arantes' claim that in Brazil, neoliberalism is a project continued by the left. Paulo Arantes, *O novo tempo do mundo*, São Paulo: Boitempo, 2014.

34 O'Conner, *The Empire of Oil*, 45.

35 Ibid.

36 Ibid., 45–6. Matthew Huber argues that using the law of *ferae naturae* led to overproduction, since those who believed they possessed oil had to pump as much as possible before it flowed onwards to their neighbors. Andrew Nikiforuk's rather speculative *The Energy of Slaves: Oil and the New Servitude*, Vancouver: Greystone Books, 2012, borrows from Buckminster Fuller the argument that oil and coal have replaced human bondage (117–18).

37 Grotius, *Mare Liberum*, 25.

38 Ibid.

39 Clifford S. Walton, *The Civil Law in Spain and Spanish America*, Washington, DC: W. H. Lowdermilk, 1900, 202–3. Excavations to discover minerals could be made by anyone, Spaniard or other nationality, up to 10 meters on public land (private land was restricted to its owner) (C. Civ. 1889: Chap. 2 Art. 426, 427).

40 O'Conner, *Empire of Oil*, 45–6.

41 Daniel Yergin, *The Prize: The Epic Quest for Oil, Money, and Power*, New York: Simon and Schuster, 1991, 232. Yergin writes that Porfirio Díaz changed these laws, "giving over ownership of the subsoil resources to the farmers and ranchers and the other surface landowners, who, in turn, welcomed foreign capital, which eventually controlled 90 percent of all oil properties" (232).

42 Erasmo Dumpierre Arenas, *El Esso en Cuba*, Havana: Editorial Ciencias Sociales, 1984, 3.

43 Ibid.

44 Antonio Calvache, *Minería y desarrollo de la minería en Cuba*, Havana: Editorial Neptuno, 1944, 80. This was the same year as the Pennsylvania Supreme Court case establishing the law of capture as applicable to oil (130 Pa. 235, 18 Atl. 724 [1889]).

45 Ibid., 86. Antonio Núñez Jiménez wrote in 1954 that "petroleum concessions, the property of powerful North American companies, cover nothing less than ten percent of the national territory. Many of those concessions, according to reports by the Department of Mountains, Mines and Waters in our Ministry of Agriculture, were given over by Presidential decree no. 768, June 7, 1930. The very director of Mines in Cuba publicly declared that 'By virtue of this Decree almost a million hectares of national subsoil including all the possible petroleum structures in the nation passed into the hands of great and some private businesses, the majority of them foreign companies, freely and as concession in perpetuity, without the obligation to perforate.'" Antonio Núñez Jiménez, *Geografía de Cuba*, Havana: Editorial 'Lex', 1954, 182.

46 Calvache, *Minería*, 5. Mariano Sánchez Roca, *Legislación de minas y minerales combustibles Ley decreto-Ley de Bases y Reglamento Orgánico para la Minería Cubana.—Ley y Reglamento de Minerales Combustibles.— Expropiación forzosa en Minería y numerosas disposiciones complementarias. CONFORME A LOS TEXTOS OFICIALES Concordada, puesta al día, anotada con numerosas Resoluciones administrativas y Sentencias del Tribunal Supremo y dos minuciosos Sumarios Alfabéticos e Índices Legislativos*, Havana: Editorial Lex-Librería, 1942, 24; 204.

47 "Mexico Campaigns in Latin America," *New York Times*, Thursday, June 23, 1938, 9.

48 Victor Bulmer Thomas, *The Economic History of Latin America Since Independence*, New York: Cambridge University Press, 1995. An article published in the anarchist newspaper *Rumbos nuevos* in 1939 by "R. Rocker" (probably Johann Rudolf Rocker) warned that it is pure chance that a given people have a certain territory in which later are discovered natural treasures "in the form of coal, minerals, petroleum, etc."; a happenstance that in no way entitles a people to exploit people bereft of such resources. R. Rocker, "Economía mundial; No explotación mundial," *Rumbos nuevos órgano libertario publicación mensual*, Año 1, Habana, August 1, 1939, 3.

49 Sweig, *Cuba: What Everyone Needs to Know*, 77.

50 Calvache, *Minería*, 5.

51 Núñez Jiménez, *Geografía de Cuba*, 183. See also José M. Álvarez Acevedo, *El petróleo cubano y sus problemas: breve resumen histórico, la realidad científica, un examen económico, somero análisis crítico*, Havana: Editorial Ucacia, 1957.

52 Mitchell, *Carbon Democracy*, 54.

53 Calvache, *Minería*, 6–7; Díaz-Briquets and Pérez-López, *Conquering Nature*, 186.

54 Calvache, *Minería*, 6.

55 Carlos Piñeiro Loredo, "Al encuentro con el petroleo escondido," *Cuba Internacional*, April 1971, 3–4.

56 That same year K. K. Shaposhnikov and K. I. Shaposhnikova published the brief document, "Nova Rayon Na O Kuba, Perspekrivny Na Neft" (New Region on Cuba, Promising for Oil), *Doklady AN SSSR* 190, no. 1 (1970), trans. Techtran Corporation, US Department of Commerce National Technical Information Service.

57 *Arriba, el agua pasó por encima/ de todas las cabezas. Abajo, el cisma/ artificial sondeó las posibilidades/ de que aquí, mañana, surja el petroleo.*

58 *En ese pequeño fragmento del mundo que se llama Cuba, un grupo de hombres quiere apresar el futuro mirando hacia el subsuelo; hombres jóvenes y viejos, soviéticos y cubanos, se apresuran por arrancar de la profundidad de la Tierra la respuesta definitiva.*

59 Díaz-Briquets and Pérez-López, *Conquering Nature*, 186.

60 Cuban civil code Chapter II, "Formas de Propiedad Sección Primera: Propiedad socialista de todo el pueblo Artículo 136."

61 See US Energy Information Administration, "Mexico," April 24, 2014, at www.eia.gov.

62 Amanda Boetzkes, *The Ethics of Earth Art*, Minneapolis: University of Minnesota Press, 2010, 18.

63 *activismo como quien habita dentro de un sistema y por lo tanto actúa como la consciencia del sistema.* Artist's statement.

64 Ibid.

65 Lage, *La autopista*, 125.

66 Ibid., 91.

67 Ibid., 43.

68 Ibid., 33.

69 Ibid., 67.

70 Ibid., 42.

71 *La autopista necesita contructores* [sic]. *Los nativos necesitan dinero.* Ibid., 40. See Serge Gruzinski, *L'aigle et le dragon: démesure européenne et mondialisation au XVI siècle*, Paris: Fayard, 2012, and André Gunder Frank, *ReOrient: Global Economy in the Asian Age*, Berkeley: University of California Press, 1998.

72 Lage, *La autopista*, 41.

73 Ibid., 54.

74 Thanks to Calvin Hui for this translation.

75 Omar Everleny Pérez Villanueva, *Cincuenta años de la economía cubana*, Havana: Editorial de Ciencias Sociales, 2010, 121.

76 *Comparta con ellos las penas del día de no hacer nada, de nada esperar.* Lage, *La autopista*, 14.

77 Ibid., 86–7.

78 Ibid., 87.

79 *Pierdo unos cuantos millones en unos pocos meses, pero luego vuelvo atrás y debido a la abstinencia las ventas se disparan en los meses siguientes. Los tengo a todos cogidos por el cuello.* Ibid.

80 *todos salimos ganando.* Ibid., 89.

81 Ibid., 77.

82 *¡y muchísimo! La isla como una gran plataforma.* Ibid., 143.

83 *me di cuenta de que Cuba no era lo que yo esperaba. Reinaba el caos. Lo militar se confundía con lo civil. No había costumbre de propiedad privada, contratos, impuestos . . . Era un territorio sin ley . . . Se perforaron pozos por todas partes; Las milenarias rocas generadoras de crudo (resultado de la descomposición de organismos marinos), la necesidad de combustible para ir en busca de más combustible.* Ibid., 143–4.

84 Nixon, *Slow Violence*, 69.

85 Mitchell, *Carbon Democracy*, 12.

86 Black *era tristeza líquida . . . Melaza espesa. Caldo acumulado durante siglos en los inmensos receptáculos del agotado petróleo. El subsuelo acogiendo, transformando los desperdicios.* Juan Abreu, *Garbageland* (Barcelona: Mondadori, 2001), 24. Thanks to Raul Aguiar, Erick Mota, and Evelyn Pérez for this and other references to ecologically oriented science fiction.

87 *Residuos de guerras, de ciudades, de campos, Bibliotecas y arsenales. Años de excrecencias traídas de New York, California y otras regiones de Tierra Firme. Generaciones de robots que resultaron demasiado inteligentes y hubo que desechar. Sueños de máquinas espléndidas, invencibles. Clonaciones fallidas.* Ibid., 24.

88 *Lo que fue La Habana. Lo que nunca fue. Lo que sea que haya sido. La auto-pista lo ha borrado del mapa. En su lugar, el inabarcable asfalto que llena nuestras pesadillas.* Lage, *La autopista*, 107.

89 Ibid., 107–9.

90 *Si lo tuyo es el indigenismo, el subdesarrollo o alguna mierda similar, franca-mente, te recomiendo que no sigas leyendo.* Lage, *La autopista*, 150.

91 *un pozo inagotable.* Ibid.

92 Ibid., 91.

93 *La mala suerte, la suerte nuestra ... Llegar siempre tarde. ¿Pero llegar adonde?"* ibid., 31.

94 Artist's statement.

95 Colebrook, *Extinction*.

96 Walter Benjamin, *The Origin of German Tragic Drama*, trans. John Osborne, London: New Left Books, 1977.

5. Free Time

1 Rafael Almanza, *Eliseo DIEgo: el juEgo de diEs?*, Havana: Letras Cubanas, 2008. The book's themes were first explored during the 1990s, but the volume was edited and published at the urging of friends in the late 2000s.

2 Rafael Almanza Alonso, *En torno al pensamiento económico de Martí*, Havana: Editorial Ciencias Sociales, 1990. Almanza now identifies with more Christian frameworks for interpretation (personal communication, July 2014).

3 Jasper Bernes, Joshua Clover, and Juliana Spahr, "Elegy, or the Poetics of Surplus," *Jacket2*, February 25, 2014, at http://jacket2.org.

4 Ibid.

5 Roger Caillois, *Man, Play, and Games*, trans. Meyer Barash, 1961; repr., Urbana: University of Illinois Press, 2001; Johan Huizinga, *Homo Ludens: a Study of the Play-Element in Culture*, trans. R. F. C. Hull, London: Routledge and Kegan Paul, 1949.

6 Ibid., 5.

7 Ibid.

8 See Heise's reading of Beck's idea of "world risk society" as it intersects with environmental concerns. Heise, *Sense of Place*, 119–60.

9 Caillois, *Man, Play, and Games*, 50.

10 Personal communication, July 2014. Almanza's position anticipates other recent, more optimistic stances such as Doris Sommer's claim that "it is play understood as artistic creativity that offers the only sure, if indirect, conduit to liberty." Doris Sommer, *The Work of Art in the World: Civic Agency and Public Humanities*, Durham, NC: Duke University Press, 2014, 138.

11 *Al afianzamiento del capitalismo y al laboralismo del siglo XIX, en el que la tradicional oposición juego-trabajo, que viene de Aristóteles, se "resuelve" en favor del trabajo, al concebir al juego como cosa infantil, indigna de los hombres serios, y a lo sumo como entrenamiento para el trabajo mismo. Spencer afirmará que "el juego es una dramatización de la actividad del adulto," y Wundt: "El juego es el niño del trabajo, no hay forma de juego que no encuentre su modelo en alguna ocupación seria que le precede en el tiempo." Todavía en 1896 Karl Groos insistía en conceptos semejantes.* Almanza, *Eliseo DIEgo*, 32–3.

12 Ibid., 33; 35.

13 Mechthild Nagel, *Masking the Abject: A Genealogy of Play*, Lanham, MD: Lexington Books, 2002, 2.

14 Ibid., 59.

15 Ibid., 2.

16 Julia Bryson-Wilson, *Art Workers: Radical Practice in the Vietnam Era*, Berkeley: University of California Press, 2009.

17 Duong, "Amateur Citizens," 97.

18 A number of studies of post-1970s capitalism have attempted to theorize the new nature of work, beginning with the 1970s Workerist theories in Italy and finding recent reformulations in Michael Hardt and Antonio Negri, *Empire*, Cambridge, MA: Harvard University Press, 2000; Luc Boltanski and Eve Chiapello, *The New Spirit of Capitalism*, trans. Gregory Eliott, New York: Verso, 2005; Jonathan Crary, *24/7: Late Capitalism and the Ends of Sleep*, New York: Verso, 2013; Alessandro Fornazzari, *Speculative Fictions: Chilean Culture, Economics, and the Neoliberal Transition*, Pittsburgh: University of Pittsburgh Press, 2013, among others.

19 Noelle Stout, *After Love: Queer Intimacy and Erotic Economies in Post-Soviet Cuba*, Durham, NC: Duke University Press, 2014, 72.

20 Ibid.

21 Henken and Ritter note that Cuba's second, informal economy has become "the country's real economy . . . just as employment in that 'second'

economy often constitutes many Cubans' *real* jobs even as they may continue to labor in official occupations in the first economy." Ritter and Henken, *Entrepreneurial Cuba*, 22.

22 Fornazzari, *Speculative Fictions*, 12.

23 Nagel, *Masking the Abject*, 2.

24 For how play industries are deeply emeshed in contemporary capitalism see Nick Dyer-Witherford and Greig de Peuter's *Games of Empire: Global Capitalism and Video Games*, Minneapolis: University of Minnesota Press, 2009.

25 Herman Hesse, *The Glass Bead Game (Magister Ludi)*, trans. Richard and Clara Winston, New York: Holt, Rinehart and Winston, 1969.

26 Rafael Almanza, press release, forwarded by Lester Álvarez, December 2013, email.

27 Eliseo Diego, *Divertimentos y versiones*, Montivideo: Arca, 1967; *Muestrario del mundo o libro de las maravillas de Boloña: La Habana 1836–1967*, Havana: Instituto del Libro, 1968.

28 Almanza, *Eliseo DIEgo*, 100.

29 *un risueño y cubanísimo desafío cultural.* Ibid.

30 Ed Halter demonstrates convincingly that a 1960s collusion between games and military strategy underpins the entire history of video games. Halter also documents the Rand Corporation's use of "politico-military games" at the Pentagon in a period in which game theory was taken up by businesses and beyond in the popularized form of J. D. Williams' book *The Compleat Strategyst: Being a Primer on the Theory of Games of Strategy*. He adds that the "vast computer game that was the Cold War could be seen as a perverse fulfillment of H. G. Wells's wish to replace the deadly rituals of the battlefield with the fantasy of leaders playing with models." It comes as no surprise, then, that surveillance operations have resorted to mining online game playing for potential terrorist conspiracies. Ed Halter, *From Sun Tzu to Xbox: War and Video Games*, New York: Thunder's Mouth Press, 2006, 92; Mark Mazzetti and Justin Elliott, "Spies Infiltrate a Fantasy Realm of Online Games," *New York Times*, December 9, 2013, at www. nytimes.com.

31 *Único y curioso libro del ajedrez.*

32 *No estar y estar, luz y tiniebla, siempre/ la tristeza cediendo a la alegría/ y otra vez a la muerte, que se acerca/ como el rostro de un niño a los cristales/ y nos mira, secreto, desde afuera.* Eliseo Diego, *Muestrario del mundo o libro de las maravillas de Boloña.*

33 *Pues al fin de las idas, ¿no es el juego/ lo que importa a las vueltas?* Ibid., 131.

34 *el juego militar, ¿quién lo inventó,/ quién ideó sus maniobras vastas/ como los movimientos de los cielos,/ sus idas y venidas por la escarcha?* Almanza, *Eliseo DIEgo*, 157.

35 *El tiempo del Paraíso es el suave gotear del agua, cuando acaba/ de llover, entre las hojas del plátano./ El tiempo del Infierno es la humedad que encontramos debajo/ de las grandes piedras, manchando la mañana./ El tiempo del Paraíso es la transparencia del agua./ El tiempo del Infierno es la transparencia de un espejo./ El tiempo del Paraíso es el Rey Mago de barro que está en los/ Nacimientos./ Y el tiempo del Infierno es el Rey de la Baraja.* Diego, *Divertimentos y versiones*, 68–9.

36 *Si pudiéramos empadronar las personas entregadas a este vicio infame, y computar el valor de lo que ganarían trabajando, durante el tiempo que emplean en el juego: si pudiéramos saber, aunque fuese aproximadamente, a cuánto ascienden las cantidades perdidas, y seguir la larga cadena de desastres que necesariamente acarrea, entonces conoceríamos nuestra deplorable situación, cesaríamos de llamarnos opulentos y felices.* José Antonio Saco, *Obras completas* Vol. 1., ed. Eduardo Torres-Cuevas, Havana: Imagen Contemporánea, 2001, 269.

37 Ibid., 281.

38 Ibid., 300.

39 Julio Ramos, "Cine, cuerpo y trabajo: los montajes de Guillén Landrián," *Pensamiento de los confines*, no. 28 (2012), 146, republication of the same article in *La Gaceta de Cuba* 3 (2011), 45–8.

40 Christopher Taylor has also recently linked Lafargue's Caribbean origins, and specifically the question of slavery, to his political thought, arguing that "Caribbean histories of slavery and emancipation constitute the political unconscious of anti-work Marxism." Christopher Taylor, "The Refusal of Work: From the Postemancipation Caribbean to Post-Fordist Empire," *Small Axe* 44: 18, no. 2 (July 2014), 2.

41 Pablo Lafargue, *Textos escogidos*, Havana: Ediciones Ciencias Sociales, 2007.

42 Francisco Domenech, *Tres vidas y una época: Pablo Lafargue, Diego Vicente Tejera, Enrique Lluria*, Havana: Ediciones de la Revista Índice, 1940, 3.

43 Paul Lafargue, "L'exode nègre," *La Revolution Francaise*, May 22, 1879, quoted in Leslie Derfler, *Paul Lafargue and Flowering of French Socialism, 1882–1911*, Cambridge, MA: Harvard University Press, 1998. Although "L'exode nègre" is more descriptive of a great northward post-emancipation migration, it does conclude about post-emancipation southern white

planters "*En fait, ils l'ont déjà rétabli en certains endroits où les services des hommes de coleur sont vendus pour un certain temps pour liquider leurs dettes réelles ou fictives, et ils ne peuvent comprendre pourquoi si un homme de couleur peut être vendu pour six mois ou un an, il ne soit vendu pour la vie entière.*" Lafargue, "L'exode nègre," 2. See also Raúl Roa, "Evocación de Pablo Lafargue," *Cuba socialista* 6 (February 1962), 57–8.

44 Iván de la Nuez, *Fantasía roja: los intelectuales de izquierdas y la revolución cubana*, Caracas: Debate, 2006, 127.

45 Ibid., 143.

46 Paolo Virno, *The Grammar of the Multitude*, trans. Isabell Bertoletto, James Cascaito and Andreas Casson, New York: Seimotext[e], 2004, 103.

47 *Maud es la jamaiquina regia, de túnico nevado, que cuida la casa. Los dueños no vienen nunca. Apenas se sabe de Maud viendo los cristales con sus visillos pulcros, eternamente cerrados contra el polvo. Cierta tarde un niño cruza solo a la casa pequeña y pega su cara a los cristales. Allí adentro todo está quieto, aunque afuera el aire mueve los grandes árboles de la Colonia. Y de pronto el niño ha huído, porque ha visto abrirse una puerta allá en el mundo de vidrio, y la mano dorada de Maud, la jamaiquina regia, sobre el pomo dorado de la puerta.* Diego, *Divertimentos y versiones*, 67–8.

48 Katya Kazakina, "Nine Days Cooking on 90,000 Budget Draw Performa Artist," *Bloomberg News*, November 8, 2013, at www.bloomberg.com.

49 Corina Matamoros, "Un método para reparar utopías (a los ojos de la escultura)," in *Mirada de curador*, Havana: Letras Cubanas, 2009, 33–4.

50 Ramón de Perseverancia, *Los chinos y su charada*, Havana: Imprenta 1a de Belascoaín, 1894, 1.

51 Caillois, *Man, Play, and Games*, 150.

52 "La revista católica 'Espacio Laical' pide el regreso de la Lotería Nacional," *Diario de Cuba*, January 8, 2015, at www.diariodecuba.com.

53 *colarse en las fallas del sistema y dotar de utilidad a lo que está llamado al fracaso.* Artist's website.

54 Víctor Fowler, personal communication, September 2013.

55 Camnitzer, *New Art of Cuba*, 116.

56 Julia Bryan-Wilson, "Occupational Realism," *TDR* 56 (2012), 45–6.

57 Ibid., 46.

58 Jacques Rancière, *Nights of Labor: The Worker's Dream in Nineteenth-Century France*, trans. John Drury, Philadelphia: Temple University Press, 1989.

59 Federico Galende, *Modos de producción Notas sobre arte y trabajo*, Santiago: Editorial Palinodia, 2011, 20.

60 Víctor Fowler, personal communication, October 2013.

61 Artist's statement.

62 Bernes, Clover, and Spahr, "Elegy, or the Poetics of Surplus," n.p.

63 Ernesto Hernández Busto has also addressed the echoes of Saco in Melis's work. Ernesto Hernández Busto, "El arte de no trabajo y el trabajo del arte," February 24, 2012, at www.penultimosdias.com.

64 *los cubanos se han dedicado a refinar el ejercicio de no hacer nada hasta el punto de convertirlo en un arte.* Artist's statement.

65 *El sueño es, en contraposición a la baja productividad del trabajador, el momento más productivo de ese individuo.* Artist's statement.

66 Bryan-Wilson, "Occupational Realism," 43.

67 Artist's statement.

68 Ibid.

69 *y el tiempo de los juegos pertenecen a otro orden, a duras penas avizorado por los mutantes.* Juan Carlos Flores, *Distintos modos de cavar un túnel*, Havana: Ediciones Unión, 2003, 26.

70 *Hay, al sur de La Habana, entre el verdor y el oro, un lugar destinado a los juegos. Es un sitio tranquilo, dicen, muy bueno para las mutaciones. Yo, nunca he ido a ese lugar, sólo por temor a no volver. Tú, nunca has ido a ese lugar, sólo por temor a no volver. Él, nunca ha ido a ese lugar, sólo por temor a no volver. Hay, al sur de La Habana, entre el verdor y el oro, un lugar destinado a los juegos. Es un sitio tranquilo, dicen, muy bueno para las mutaciones.* Ibid., 24.

71 *No tenemos nada, pero tenemos un balón de fútbol. En lugar de quedarnos tranquilos viendo un partido de fútbol o viendo la serie Lost, nos vamos a correr y a darle patadas al balón. Sentados a la sombra, unos niños nos preguntan si pueden jugar con nosotros. Yo les digo que no estamos jugando . . . Definitivamente no es un juego . . . Nos destrozamos los zapatos y los tobillos, empezamos a deshidratarnos, a considerar el cansancio, la desesperación.* Jorge Enrique Lage, *Vultureffect*, Havana: Ediciones Unión, 2011, 5.

72 Laura Reduello has also read twenty-first-century Cuban literature as depicting a ferocious society. Laura Reduello, "Touring Havana in the Work of Ronaldo Menéndez," in *Havana Beyond the Ruins: Cultural Mappings After 1989*, ed. Anke Birkenmaier and Esther Whitfield, Durham, NC: Duke University Press, 2011, 229–48.

73 Lage, *La autopista*, 134.

74 See also my exploration of the special import of the amusement park in Cuban historiography in Rachel Price, "From *Coney Island* to *La Isla del Coco*," *Journal of Latin American Cultural Studies* 20, no. 3 (Autumn 2011), 217–31.

75 Antonio José Ponte, *La fiesta vigilada*, Barcelona: Editorial Anagrama, 2007, 67.

76 *una montaña rusa que se cayó en pedazos, carruseles donde gira el óxido, desarmados puestos de venta . . . columpios estrangulados en sus propias cadenas.* Lage, *Carbono 14*, 103–4.

77 *Cuando veo todos estos aparatos de tortura en lo que menos pienso es en el pasado que pueden contener, la diversión y la gritería que pueden haber presenciado . . . sin duda alguna, los tiempos habían cambiado y ahora los niños tenían otras diversiones en que invertir el tiempo. Frank siguió:—Es como si aquí no se lograra recordar ningún pasado. Automáticamente se piensa en el futuro. Y si hay algo que no conviene olvidar es el futuro. Remember the future!, dijo Ronald Sukenick.—¿Quién?—Haría falta poner en varios canales de esta zapping city carteles que avisen: FUTURO . . . Frank terminó confesándome que un parque de diversiones destruido (o un parque de diversiones destruidas) tampoco le hacía pensar en niños:—Aunque algo queda de la atmósfera de juego, de orden desordenado, de dar vueltas y marearse o perderse. Pero ahora con criaturas distintas.* Ibid.

78 *Cada level es un ecosistema extraño. De todas formas no se sabe bien en qué planeta estamos.* Ibid., 177–8.

79 Rebecca Carlson and Jonathan Corliss, "Coding Culture: Video Game Localization and the Practice of Mediating Cultural Difference," in *Utopic Dreams and Apocalyptic Fantasies: Critical Approaches to Researching Video Game Play*, ed. J. Talmadge Wright, David G. Embrick and András Lukács, Lanham, MD: Lexington Books, 2010, 165.

80 Shuen-shing Lee, "'I Lose Therefore I Think': A Search for Contemplation Amid Wars of Push-Button Glare," *Game Studies* 3, no. 2 (December 2003). Lee's article has been much quoted in discussions of serious games, "counter-gaming," etc., and in studies such as Alexander R. Galloway's *Gaming: Essays on Algorithmic Culture*, Minneapolis: University of Minnesota Press, 2006, and Ian Bogost's *Persuasive Games: The Expressive Power of Videogames*, Cambridge, MA: MIT, 2007. It takes up "ludologist" Gonzalo Frasca's proposal in his now canonical 2001 thesis "Video Games of the Oppressed—Video Games as a Means for Critical Thinking and Debate," at www.ludology.org.

81 Lee writes: "I tend to assign these works, critical or arguably sensationalistic, to a subgenre called art games, following Tiffany Holmes' suit, mainly because of their reconception of gaming form, their alternative goals, such as meditative play or off-gaming engagement, and their appeal to new audiences in cyberspace." Lee, "'I Lose Therefore I Think,'" n.p.

82 Ibid.

83 Artist's statement.

84 McKenzie Wark, *Gamer Theory*, Cambridge, MA: Harvard University, 2007.

85 Dennis Redmond lauds the humor of the GTA series and gamemaker Rockstar's spotlight on "the dank underbelly of the U.S. Empire"; but the dank underbelly might better be seen as a byproduct of the *erosion* of empire. See Dennis Redmond, "Grand Theft Video: Running and Gunning for the U.S. Empire," in *The Meaning and Culture of Grand Theft Auto*, ed. Nate Garrelts, North Carolina: McFarland & Company, 2006.

86 *Cuban Virtualities: New Media Art From the Island*, September 5–December 8, 2013, at http://artgallery.tufts.edu.

87 See Víctor Fowler's November 6, 2013, letter to various institutions critiquing the implicit regulation of cultural consumption and taste, specifically, of "banality," at http://cinecubanolapupilainsomne.wordpress.com.

88 *un país que siempre había estado avantgarde en las artes plásticas contemporáneas*. Artist's statement.

89 Mark Tribe, Reena Janan, and Uta Grosenick, *New Media Art*, Los Angeles: Taschen, 2006, 11.

90 Galloway, *Gaming*, 84. See also Patrick Crogan's *Gameplay Mode: War, Simulation, and Technoculture*, Minneapolis: University of Minnesota Press, 2011, and Halter, *From Sun Tzu to Xbox*.

91 Andrea K. Scott, "Futurism: Cory Arcangel Plays Around With Technology," *New Yorker*, May 30, 2011, 30.

92 For a lengthy discussion of the recent use of *The Musicians From Bremen*, see Loss, *Dreaming in Russian*, 130–2.

93 Dara Birnbaum and Cory Arcangel, "Do It 2," *Artforum* (March 2009), 191–8 (193).

94 Alexander Galloway argues that in mods "the game engine persists . . . but it is repurposed to serve the same sort of modernist formal experiments that the avant-garde has pursued for decades." Galloway, *Gaming*, 118. Media scholar Mark Tribe, similarly noting modernist references for certain digital media, lists a number of digital artworks that update

neo-avant-garde pieces from the 1970s. Tribe, Jana, and Grosenick, eds., *New Media Art*, 7–8.

95 Artist's statement.

96 Galloway, *Gaming*, 28.

97 Galloway, *Gaming*; Wark, *Gamer Theory*.

98 Chris Marker, "A Free Replay: Notes on Vertigo," at www.chrismarker.org.

99 Rewell Altunaga, personal communication, December 2011.

100 Galloway, *Gaming*, 56.

101 *¿ha cambiado la ciudad o he cambiado yo?*

6. Surveillance and Detail in the Era of Camouflage

1 See Gerardo Mosquera, "Cuba in Tania Bruguera's Work: The Body is the Social Body," in *Tania Bruguera, On the Political Imaginary*, ed. Helaine Posner, Gerardo Mosquera, and Carrie Lambert-Beatty, Milan: Edizioni Charta, 2009, 23–7.

2 Ibid., 31.

3 Ibid., 27; personal communication, 2010.

4 Deborah Bruguera, "Nuestro nuevo vecino," Facebook post, 7:34 a.m., January 20, 2015, at https://www.facebook.com/deborah.bruguera?fref=ts.

5 José Quiroga, *Cuban Palimpsests*, Minneapolis: University of Minnesota Press, 2005, 52.

6 Esther Whitfield has analyzed an ambitious new poetry project by José Ramón Sánchez addressing the United States' prison at Guantánamo, and presented on contemporary art about Guantánamo at the March 2014 American Comparative Literature Association annual meeting. She also organized a conference held at Brown University in September 2014, "New Perspectives on Guantánamo: Art, Activism, and Advocacy."

7 Lillian Guerra, *Visions of Power in Cuba: Revolution, Redemption, and Resistance, 1959–1971*, Chapel Hill: University of North Carolina Press, 2012, 207. Suggesting how these local systems are themselves inevitably enmeshed in larger, more international ones, José Quiroga points out that the formation of the Cuban Dirección General de Inteligencia (Cuban Intelligence Bureau) was a response to "constant spying by the United States." Quiroga, *Cuban Palimpsests*, 64–5.

8 Wride, *Shifting Tides*, 68; 73.

9 Antonio José Ponte, *Villa Marista en plata: arte, política, nuevas tecnologías,* Madrid: Colibrí, 2010.

10 For a discussion of a number of such works see Cylena Simonds' "Armed With a Mirror: Exploring Cuba's States of Exchange," in *States of Exchange: Artists From Cuba,* ed. Gerardo Mosquera and Cylena Simonds, London: Iniva, 2008.

11 See Evgeny Morozov's *The Net Delusion: The Dark Side of Internet Freedom,* New York: Public Affairs, 2011, and David Lyon's *Surveillance Studies: An Overview,* Cambridge: Polity Press, 2007. Lyon writes, "As far as the causes of contemporary surveillance are concerned, they may be traced to the growth of modern forms of capitalist and bureaucratic practice, but they also acquire some distinctive characteristics of their own." Lyon does acknowledge, however, Anthony Giddens's insistence "that surveillance (and militarism, the other neglected factor) must be seen in its own right and not merely as a product of capitalism or bureaucracy" (68; 53).

12 Elvía Rosa Castro, *El observatorio de línea,* Havana: Ediciones Unión, 2008, 108.

13 *El lenguaje contemporáneo está plagado, en un por ciento altísimo, de la obsesión guerrerista y de vacuos fundamentalismos y nacionalismos, haciendo de la paranoia uno de nuestros atributos.* Ibid.

14 Hanna Rose Shell, *Hide and Seek: Camouflage, Photography, and the Media of Reconnaissance,* New York: Zone Books, 2012, 14.

15 Stephen Best and Sharon Marcus, "Surface Reading: an Introduction," *Representations* 108, no. 1 (2009), 1–21.

16 Dörte Zbikowski, "Bruce Nauman: 'Live/Taped Video Corridor,' 1969–1970; 'Video Surveillance Piece: Public Room,' 1969–1970," in Levin, ed., *Ctrl (space),* 64.

17 Artist's statement.

18 Hito Steyerl, *The Wretched of the Screen,* Berlin: Sternberg Press, 2012.

19 Octavio Getino and Fernando Solanas, *La hora de los hornos,* Argentina, 1968.

20 See, for instance, Pascal Gielen, *The Murmuring of the Artistic Multitude: Global Art, Memory and Post-Fordism,* Amsterdam: Antennae Valiz, 2010.

21 Steyerl, *The Wretched of the Screen,* 6.

22 Claire Bishop calls this piece "archetypical" of the kind of work made by students in Bruguera's Taller de Arte de Conducta. Claire Bishop, *Artificial Hells: Participatory Art and the Politics of Spectatorship,* New York: Verso, 2012, 247.

23 Artist's statement.

24 Weiss, *To and From Utopia*, 80; 83.

25 For a description see Andrés Abreu, "Curación 04," *Arte Cubano* 1 (2011), 30–3.

26 *El arte no va a desaparecer en la nada. Va a desaparecer en el todo.* Julio García Espinosa, "For an Imperfect Cinema," in *New Latin American Cinema Vol. 1*, ed. Michael T. Martin, Detroit: Wayne State University Press, 1997, 82.

27 Artist's statement.

28 Arthur Danto, *After the End of Art: Contemporary Art and the Pale of History*, Princeton: Princeton University Press, 2013.

29 In rejecting "retinal art" García affirmed his inscription within what Jacques Rancière more censoriously terms the aesthetic regime of art, in which "art is art to the extent that it is something else." Jacques Rancière, "The Aesthetic Revolution and its Outcomes: Emplotments of Autonomy and Heteronomy," *New Left Review*, no. 14, March–April 2002, 137.

30 Artist's statement.

31 Artist's statement. More recently, in yet another attempt to visualize the stock market, Adrián Melis has made *Lights Off* (2013), in which a program that he wrote controls the lighting up or falling dark of a series of translucent red, blue or green cubes, the different colors and illumination indexing the changing fate of Spain's stock market, Ibex 35.

32 In this earlier era of more overt discipline, Deleuze suggests, spaces of confinement, rather than today's networks, structured power. See *The Routledge Handbook of Surveillance Studies*, ed. Kirstie Ball, Kevin Haggerty, and David Lyon, New York: Routledge, 2012.

33 *En la otra isla*, directed by Sara Gómez, 1968, Cuba: ICAIC, 1968; *Una isla para Miguel*, directed by Sara Gómez, 1968, Cuba: ICAIC, 1968; *Isla del tesoro*, directed by Sara Gómez, 1968, Cuba: ICAIC, 1969.

34 See David Rosen and Aaron Santesso, *The Watchman in Pieces*, New Haven: Yale University Press, 2013, and Kevin Haggerty, "Tear Down the Walls: On Demolishing the Panopticon," in David Lyon, ed., *Theorizing Surveillance: The Panopticon and Beyond*, Cullompton: Willan, 2006, 23.

35 Lyon, *Surveillance Studies: An Overview*, 108.

36 Rosen and Santesso, *The Watchman in Pieces*, 54.

37 Ibid., 103.

38 Katrin Kaschadt, "Of the Power of the Gaze," in Levin, ed., *Ctrl (space)*, 114.

39 Alessandro Stanziani, "The Political Economy of Bondage. Russian and

Indian Perspectives, From the Enlightenment to Global Utilitarianism," Unpublished paper, 11–12.

40 Rodolfo Peraza, personal communication, May 2013.

41 Peraza is not the first to turn such material into game art. Peter Weibel's 2001 artwork "The Panoptic Society or Immortality in Love With Death" offered a rather primitive computer rendering of a prisoner in a cell who "turns the horror of his criminal existence into a public spectacle, thus acting as an accomplice to the surveillance tactics of the state." Ursula Frohne, "The Panoptic Society of Immortality in Love With Death," in Levin, ed., *Ctrl (space)*, 77–8.

42 Michael Hardt, "Prison Time," *Yale French Studies*, no. 91 (1997), 64.

43 See Dyer-Witheford and de Peuter, *Games of Empire*.

44 Michel Foucault, *Discipline and Punish: The Birth of the Prison*, trans. Alan Sheridan, New York: Vintage, 1995, 59.

45 *Preguntaba un carruajero a un calesero: ¿Cómo va la Isla de Pinos, la Siberia de la Isla de Cuba? Respuesta: "Los que no matan aquí, acaban de matarlos allá." ¡Siberia de Cuba!, qué proféticas habían de ser las palabras del Gran Educador. En esa primera mitad del siglo XIX se selló, pues, el destino atroz de esta isla. Destino de human desolación, de fábrica de angustia, de duelo, de lejanía de los seres queridos, quizá para siempre, de abandono, de olvido, es decir, de destierro y de prisión.* Waldo Medina, *Aquí, Isla de Pinos*, Havana: INRA, 1961, 35.

46 Ibid., 74.

47 *el Presidio es igualito al hospital o al manicomio de Mazorra; pero con la sola diferencia de que los locos y enfermos en las camas no tienen punzones y cuchillos ni se reúnen en pequeños grupos abusadores. Ningún preso, loco o enfermo . . . es igual al otro, todos somos distintos. Fíjese no más . . . como yo amarro diez vacas paridas; hay diez terneros y de éstos tres o cuatro no necesitan que se les pegue la soga al pescuezo, son obedientes y tranquilos, y, en cambio, otros hay que sujetarlos y darle cuerazos, y así y todo nunca escarmientan . . . No se puede tratar a todo el mundo igual.* Ibid., 92.

48 *De cierta manera*, directed by Sara Gómez, 1974, Cuba: ICAIC, 1977, 16mm.

49 *la moral del barrio, del ambiente. Ser hombre, ser macho, ser amigo. En la Isla aprenderán la ética del trabajo.*

50 Guerra, *Visions of Power*, 266.

51 Ibid.

52 Farocki underscored these same connections in *Workers Leaving a Factory*,

when female prisoners move from the prison to the factory, announced as "a kind of house of correction." Harun Farocki, "Workers Leaving the Factory," YouTube video, 32:00, 1995.

53 Guerra, *Visions of Power*, 268.

54 *Sobre horas extras y trabajo voluntario*, 1973, directed by Sara Gómez, Cuba: ICAIC, 1973.

55 *Fábrica de Tabacos*, 1962, directed by Sara Gómez, Cuba: ICAIC, 1962.

56 Weeks, *The Problem With Work*, 44.

57 Ibid.

58 Hardt, "Prison Time," 78.

59 Christian Parenti, *The Soft Cage: Surveillance in America From Slavery to the War on Terror*, New York: Basic Books, 2003; Nicholas Mirzoeff, *The Right to Look: A Counterhistory of Visuality*, Durham, NC: Duke University Press, 2011; Simone Browne, "Everybody's Got a Little Light Under the Sun," *Cultural Studies* 26, no. 4 (July 2012), 542–64; "Race and Surveillance," in Ball et al., eds., *The Routledge Handbook of Surveillance Studies*, 72–9.

60 The Archivo Nacional Cubano contains documents of laws outlawing black Cubans from working in *boticas* or pharmacies in the wake of the 1844 "escalera" uprising, likely for fear of poisoning; see also Cirilio Villaverde's second-hand diary of a bounty-hunter, *Diario del ranchador*, Havana: Letras Cubanas, 1982, and an entire literature on fears about the spread of the Haitian Revolution, including Sara E. Johnson, *Fear of French Negroes: Transcolonial Collaboration in the Revolutionary Americas*, Berkeley: University of California Press, 2012; Ada Ferrer, "Noticias de Haiti en Cuba," *Revista de Indias* 63, no. 229 (2003), 675–94, and Sibylle Fischer, *Modernity Disavowed: Haiti and the Cultures of Slavery in the Age of Revolutions*, Durham, NC: Duke University Press, 2004.

61 Ahmel Echevarría, *La noria*, Havana: Ediciones Unión, 2013.

62 Ibid., 20.

63 *cierto susurro de Ricardo Piglia en mi oído*. Ibid., 169.

64 Ricardo Piglia, "Teoría del complot," talk delivered July 15, 2001 at Fundación START, Buenos Aires, Argentina, *Plácidos domingos*, 4–15.

65 *Sabía que en una ciudad tan pequeña era casi imposible ocultar cualquier secreto*. Echevarría, *La noria*, 12.

66 *Literatura y crímenes. Tertulias y ágapes en el mismo caserón de donde la maquinaria represiva del Gobierno torturaba prisioneros*. Ibid., 76.

67 *Algo más que tierra, pan, vivienda, educación, vestido, justicia y paz.* Ibid., 99.

68 *¿A quién podrían estar vigilando?* Ibid., 123.

69 Yoani Sánchez, interview with Wendy Guerra, "Cuban Author Wendy Guerra: I'm a Demon Who Writes What She Feels," *Huffington Post*, December 10, 2014, www.huffingtonpost.com.

70 Guerra, *Visions of Power*, 355.

71 Ibid., 232.

72 Echevarría, *La noria*, 170. Jorge Fornet's recent *1971: Anatomía de una crisis* (1971: Anatomy of a Crisis, 2013) argues that many of the cultural battles of the period, including the "Padilla Affair," were as much performed for a global stage as for the specific debates at stake in Cuba. Lillian Guerra's recent unearthing of additional confidential documents on the case confirms this in ways Fornet may not have meant, in that she argues that knowledge of the case was suppressed on the island. Jorge Fornet, *El 1971: Anatomía de una crisis*, Havana: Letras Cubanas, 2013.

73 *como un viejo buey. O un asno de noria.* Echevarría, *La noria*, 153.

74 *Doctor, las huellas de sus patas por los/ surcos eran el poema, donde caía el agua/ de su nariz abrían sus dedos, sus cabezas/ las flores quemantes del poema./ B-u-e-y/ Su cansancio es politico/ ya no se quiere levanter/ no se quiere desposar/ comidos los bordes del poema/ con ojos de buey mira a la realidad/ desde el centro del poema.* Ibid., 153–4.

75 Mesa-Lago, *Cuba en la era de Raúl*, 82.

76 Ibid., 84.

77 Artists' statement. Celia y Junior had earlier lived without electricity for six months, Weiss notes, in response to the government's exhortations to save energy. Weiss, *To and From Utopia*, 238.

78 Artists' statement.

Illustration Credits

2.5 Ernesto Oroza and Gean Moreno, *Modelo de expansión: marabú*, 2013. Paper and ink, marabou seeds. Courtesy of the artists.

2.6 Ernesto Oroza and Gean Moreno, *Tabloid #26, Navidad en el Kalahari (el continuo molecular)* (detail), 2013. Paper and ink. Courtesy of the artists.

3.1 Roberto Fabelo Hung, *Aire Fresco*, 2012. Steel billboard and digital print on mesh. Courtesy of the artist.

3.2 Luis Enrique Camejo, *La isla del día después acuarela #4*, 2013. Watercolor. Courtesy of the artist.

3.3 Liudmila y Nelson, *Absolute Revolución: La isla*, 2003–9. Video still. Courtesy of the artists.

3.4 Humberto Díaz, *Tsunami*, 2009. Installation: expanded polyurethane, paint, wood, 250 cm x 340 cm x 750 cm. Courtesy of the artist.

3.5 Harold Vázquez Ley, *Avistamiento #7*, 2010, "Tutorial" series. Oil on canvas. Courtesy of the artist.

3.6 Harold Vázquez Ley, *Untitled*, 2010, "Dèmodé" series. Oil on canvas. Courtesy of the artist.

3.7 Harold Vázquez Ley, *Cook*, 2010, "Entropomorfía" series. Lightjet print on archival paper. Courtesy of the artist.

3.8 Rewell Altunaga and Yusnier Mentado, *Havana Strike*, 2007. Modified video game. Courtesy of Rewell Altunaga.

4.1 Edgar Hechavarría, *La causa de muchas cosas ocultas. Espectro*, 2007. Courtesy of the artist.

4.2 Edgar Hechavarría, *Energía*, 2006. Installation. Courtesy of the artist.

4.3 Edgar Hechavarría, *Memorias*, "Apuntalando" series, 2008. Courtesy of the artist.

4.4 Edgar Hechavarría, *Espectro*, 2007. Installation. Courtesy of the artist.

4.5 Edgar Hechavarría, *Elemento contenedor*, 2009. Installation. Courtesy of the artist.

4.6 *Cuba Internacional.* "Al encuentro con el petroleo escondido," *Cuba Internacional*, April 3, 1971, p. 3. Photograph by Carlos Piñeiro Loredo. Courtesy of the Biblioteca Nacional José Martí.

4.7 Humberto Díaz, *Afluente No. 1*, 2009. Installation: Ford Maverick '74, concrete, paint. Courtesy of the artist.

4.8 Glenda Salazar, *Línea negra*, 2008–11. Mixed media, variable dimensions. Courtesy of the artist.

4.9 Alexis Esquível, *Live President Subtitled in Chinese*, 2011. Acrylic on canvas, 85 cm x 200 cm. Courtesy of the artist and the Howard and Patricia Farber Collection.

4.10 Harold Vázquez Ley, *Camino Largo*, "Memoria de la era del carbón" series, 2012. Lightjet print on archival paper. Courtesy of the artist.

5.1 Adrián Melis, *Vigilia*, 2005–6. Video still. Courtesy of the artist.

5.2 Adrián Melis, *Plan de producción de sueños para empresas estatales en Cuba*, 2010–12. Installation: wood, paper. Photograph by Roberto Ruiz. Courtesy of the artist and ADN Galería.

5.3 Rewell Altunaga, *Shoot in War*, 2008–ongoing. Screen shots. Courtesy of the artist.

6.1 Adonis Flores. *Lenguaje*, 2005. Digital print, 90 cm x 67.5 cm. Courtesy of the artist.

6.2 Adonis Flores, *Maleza*, 2005. Chromogenic print, 9.5 cm x 134 cm. Courtesy of the artist.

6.3 Fidel García, *Auto organización*, 2008. Installation: 2000 earthworms, organic material, computers, antennae and cards for TV-radio, circuits, cables, scaffolding, 150 cm x 300 cm x 700 cm. Courtesy of the artist.

6.4 Fidel García, *The Fourth Power*, 2009. Installation: 197 software programs, 10 pcs, LCD monitor, router, 500 cm x 1000 cm. Courtesy of the artist.

6.5 Rodolfo Peraza, *Jailhead.com*, 2011–ongoing. Online game. Courtesy of the artist.

6.6 Sara Gómez, *Isla del tesoro*, 1969. Film still.

6.7 Sara Gómez, *Isla del tesoro*, 1969. Film still.

6.8 Celia y Junior, *Creo saber por qué sigo buscando detalles*, 2009. Video installation. Courtesy of the artists.

Index